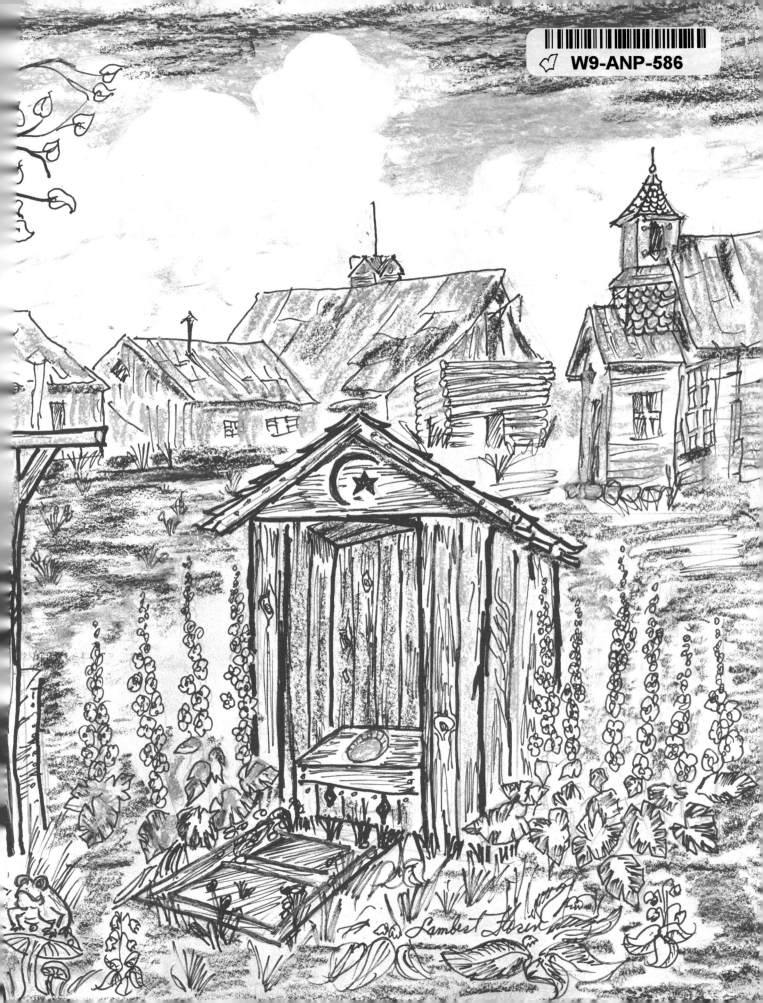

Lambert Florin

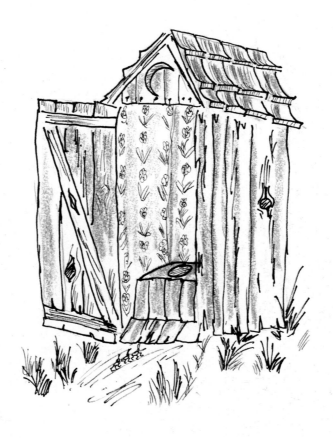

BACKYARD CLASSIC

An Adventure in Nostalgia

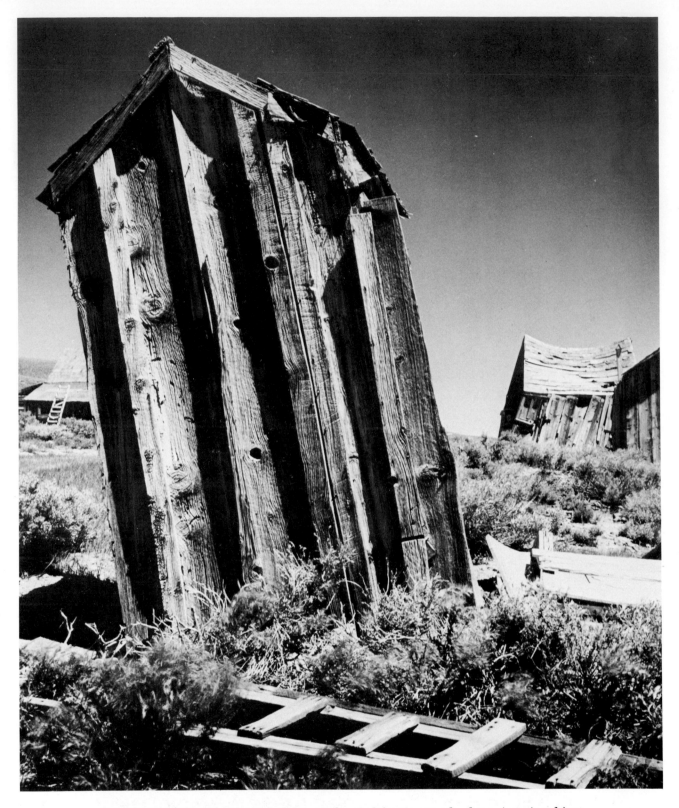

TIPSY TURVY OLD BUILDINGS in Bodie, California, stand askew. Area is subject to heavy winter snows, late melting often forming green meadows with many swampy spots. Grass and blue wild iris grow profusely in summer. Area was once heavily built up but now reverts largely to natural condition among relics still standing. (Photo Lambert Florin)

BACKYARD CLASSIC

An Adventure in Nostalgia

by

Lambert Florin

with an assist from

Ralph W. Andrews

SUPERIOR PUBLISHING COMPANY, SEATTLE

DEDICATED TO

David C. Mason, M.D.
whose help and encouragement
have made this book possible

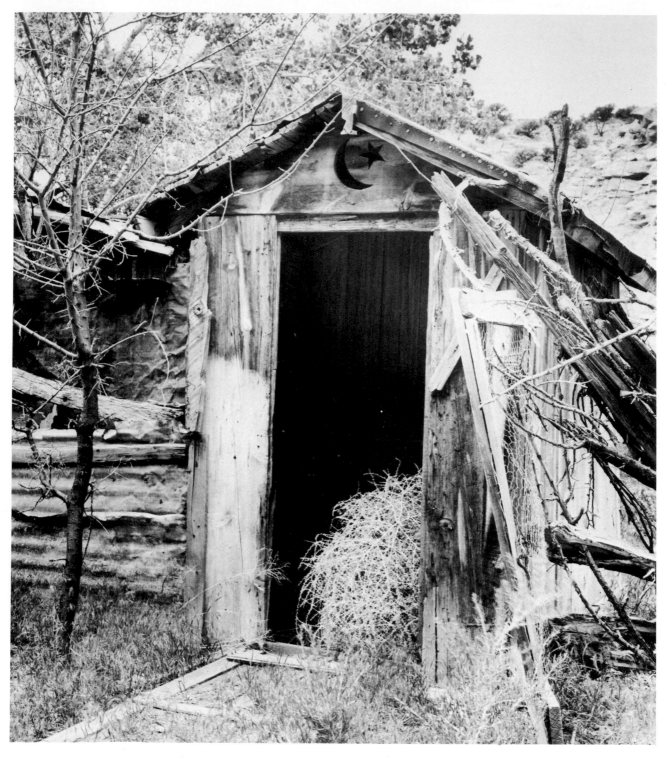

STAR AND CRESCENT CLASSIC in Sego, Utah, defunct coal mining camp. Author considers this prime exhibit, utilizing all the best features of old time outdoor privy. Coal veins in ground here have been burning for years, plumes of smoke rising from many places in town. Burned out caverns below make prowling extremely dangerous. *(Photo Lambert Florin)*

FOREWORD . . .

There is an abundance of literature pertaining to architecture along many lines and on many subjects yet it has by-passed one of the most important structures known to man—the simple but essential little building we know as the outhouse.

There is no lack of material and photographs of the Pyramids, the Leaning Tower of Pisa, Acropolis, and other ancient edifices. But while most impressive in historical meaning and for their stubborn resistance to time, they lack the homey touch, that endearing quality exemplified by the little house out back.

The gracefully soaring minarets and spires of the Taj Mahal, gem of Mohammedan architecture, mirrored in its reflecting pool, are very pretty indeed but how impractical. Consider instead the welcome sight of the little privy when time is on a fast march.

Primitive man had no need for the backhouse since he moved around so much, leaving behind all evidence of his short stay. Even the comparatively modern Indians of this country knew not the dooley, merely moving their entire camps when things got too bad. Perhaps after a season of sun and rain the tribes would move back again.

Even more migratory were the trappers and traders who followed Lewis and Clark. They found the nearest clump of bushes or tall rye grass adequate enough.

No, it was when the pioneers made permanent homes that the outhouse came into being to serve as a place of refuge from the storms out of the sky, from those in the cabin or farm house, for relief in more ways than one.

The builder of the outhouse had to consider several factors. It must be placed close enough to the main house to be reached quickly and handily, yet far enough away so as not to be objectionable in hot weather. If it was hidden in the woods the trail to it would soon be well worn, often conspicuously marked by rows of rocks. One outhouse, near a marble quarry in Colorado, was bordered by chunks of gleaming marble, making the route plainly visible on the darkest night or to the most inebriated visitor. Another at the edge of Owens Lake, California, was clearly marked with wads of snowy asbestos, waste from the mine on the cliffs above. Another such pathway near the ocean was in soft, mouldy soil and worn a foot deep by the owner who was said to have his heavy shoes soled with aluminum. And in many areas of heavy snows covered walkways were used.

Most certainly there was variety in the structures themselves. Most primitive privies were—and are—those along mountain trails, built of whatever materials might be at hand—brush, bleached driftwood, rocks, gunnysacks or whatever. Seldom was there a comfortable seat, only a modicum of privacy for a climbing party. (Farther up on the open snow or glacier slopes modesty is more difficult to preserve and in dire need often abandoned.)

The typical outhouse was the classic, simple structure of 2 x 4s and siding or small logs if more plentiful, usually roofed with shakes or shingles. And from there builders went into many other styles—the sedate or the ornate type or elaborately decorated ones with cupolas and "gingerbread" where a person might almost expect lace curtains. Some of these exist today, especially in the remnants of Colorado's old mining camps.

Whatever their location or construction, the little house out back was of prime importance. It is our purpose here to present studies of varied groups of outhouses that could truly be called historic, having played an essential part in the lives of those hardy souls who built the West.

Note the phrase "our purpose". My friend Ralph Andrews, with a string of books of his own, has helped me considerably on former books of mine, and now sparks up this one with a fine sense of whimsy. He says the photographs and sketches make the book, but it's a better one because of his "fancy Dan" touch with words.

Now one last word, and one that is going to disappoint all those fellas named "John". Contrary to rumor the publisher is not sending any of them free books.

Lambert Florin

7

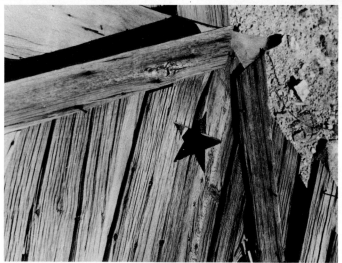

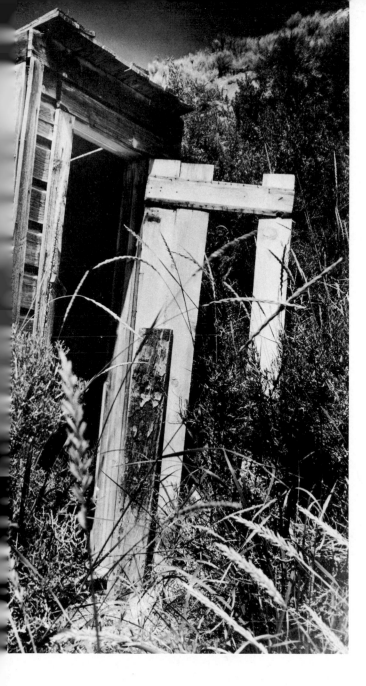

SURVIVAL OF THE FITTEST on Maupin Ranch (opposite top left) in arid climate of eastern Oregon, half day's canter from Ashwood. Howard Maupin is credited with killing Chief Paulina, head of murderous band of Snake Indians, not far from his ranch, in 1880s.

CONSIGNED TO THE DEAD PAST is this old privy (left) behind small store in the Mormon settlement and fort of Lemhi Valley, Idaho.

STAR OF THE WEST. Did this symbol (opposite bottom) in old privies signify the male side? Who knows. This one in Sutro, Nevada, is still clear-cut although building lies flat on the ground.

Saved from speedy rotting by dry air of Nevada desert, boards will remain a long time unless burned for firewood. Famed Sutro Tunnel gave access to lower levels of some of Virginia City's deepest mines. (Photos Lambert Florin)

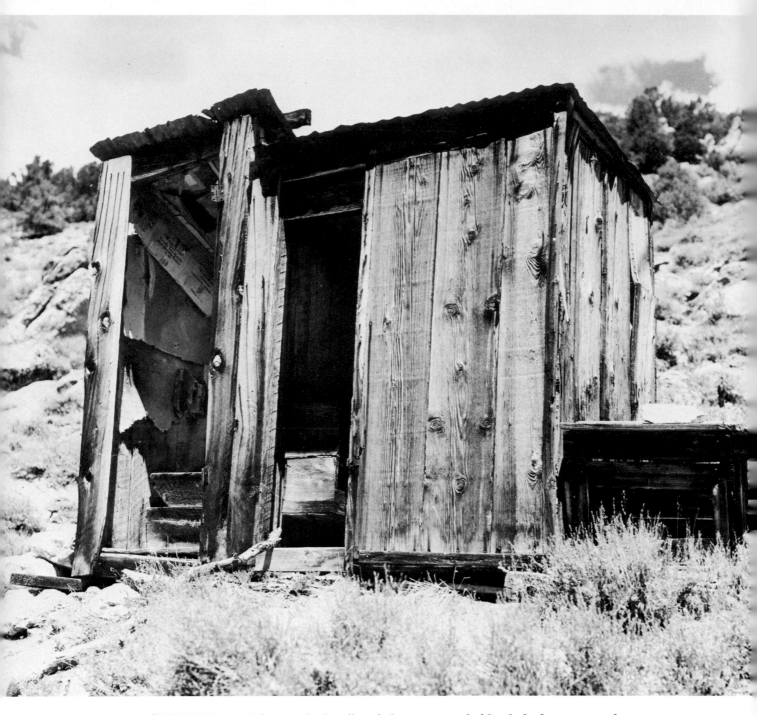

"NOBODY HERE but us chickens" and they were probably glad of company when somebody used this one-holer. Even rough-sawn boards were costly in Masonic, California (not far from Bridgeport), and a partition between people and chickens was too much of a luxury. There was roosting space for six birds and for recreation they had the little run at right. Pieces of carpet and cardboard on walls helped keep out wintry blasts.

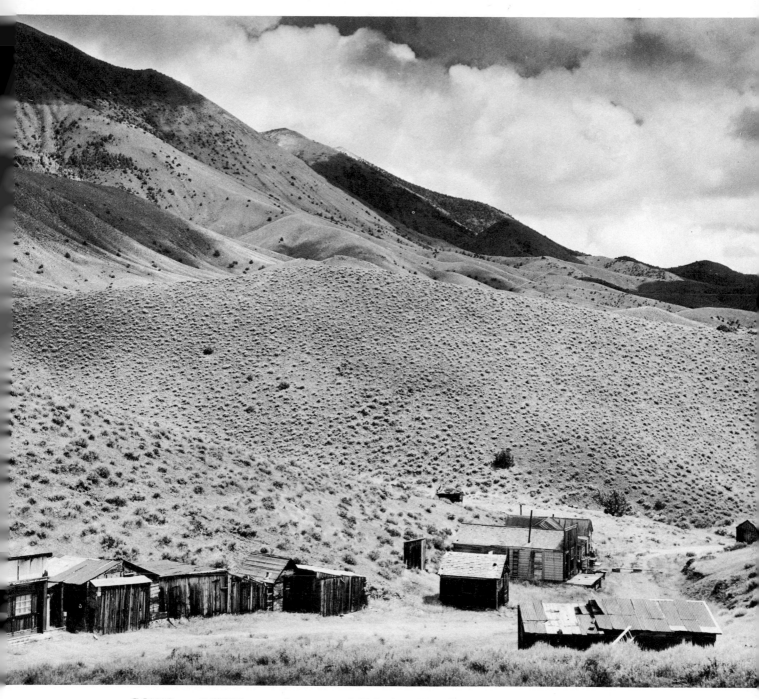

GOING . . . GOING . . . and now gone is Fairview, Nevada, uppermost of three settlements of that name. In photo outhouse is prominent behind house of Ed and Sylvia Stratton, last residents of once extensive town and now deceased.

"PRITHEE, SIR . . . can yon structure be a privee?" "When Georgetown's big mills were all producing, railroad was built to haul ore to market," relates Muriel Sibell Wolle in her book about Colorado's mining camps – Stampede to Timberline. "Near the head of Argent Street is one of Georgetown's mansions – the Hammill House, built in 1880 by W. A. Hammill who made much of his money in the Pelican-Dives mine at Silver Plume. Large frame house is set back from street and is surrounded by low stone wall. It was quite the town showplace. Just behind mansion was outhouse whose white clapboard sides, carved, cupolaed roof and walnut appointments were in perfect keeping with lavish interior." Three different sized walnut seats were reserved for the family, servants using three holes in pine plank. (Photo Denver Public Library, Western History Dept.)

"UNBURIED, UNHALLOWED, UNSUNG" . . . but not unnoticed by prying photographer (above left). Lying like wounded gladiator, outhouse pleads for absolution of Leland Claim, "suburb" of McCabe, Arizona, one of the most obscure, hard to reach ghost towns in state. Many decorative symbols in outhouses were cut half in one board, half in adjoining. This diamond, whatever its significance, was started at corners by brace and bit.

SWIRL AND SWEEP of nature's artistry is here (above right) enhanced by weathering of wood. Man adds his touch to beauty of texture by jack knife trimming of door button. Old outhouse is in Silver City, Idaho (Photos Lambert Florin)

Superior Books
by
Lambert Florin

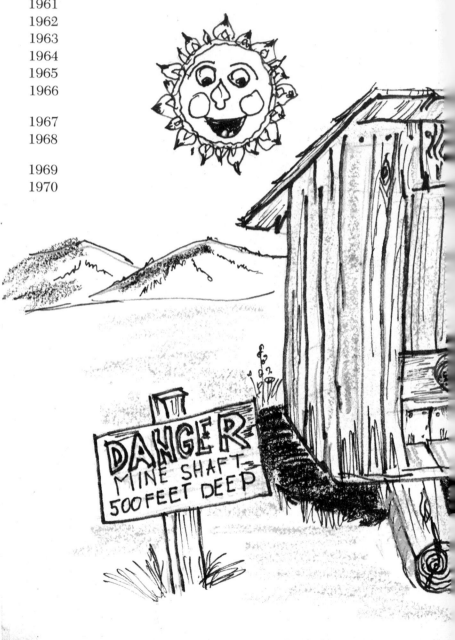

CONTENTS

Sketches throughout the book
are by the author

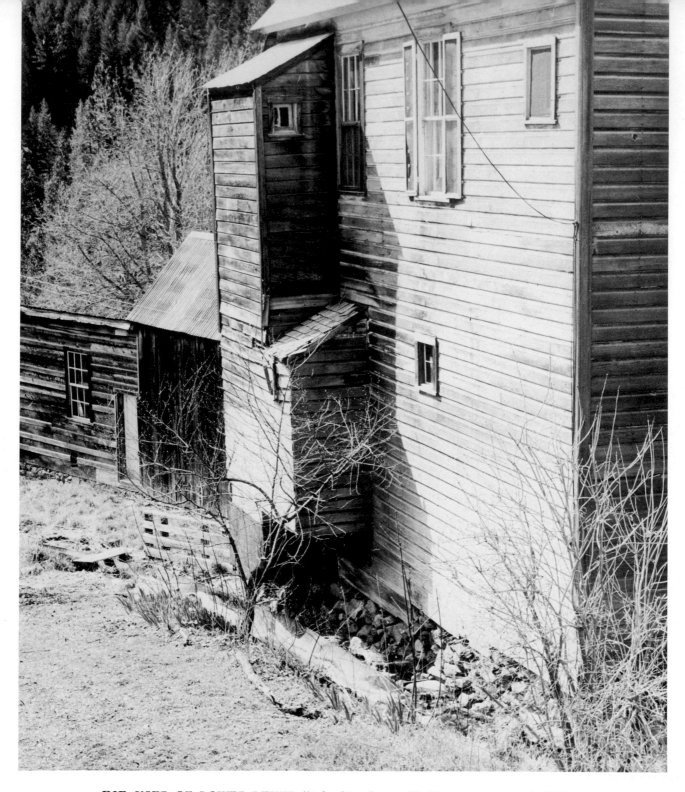

DID USER OF LOWER LEVEL *"take his chances"? Most permanent buildings in Sierra City, California, were tall with steep roofs. This hotel was built that way with outside toilets in two-story fashion. Was there dividing wall in lower section or did occupant lean carefully to right or left? Creek carried deposits into Yuba River at bottom of hill. Sierra City is near north end of California's golden chain of Sierra mining camps on north fork of Yuba. In contrast to camps in southern area where hills are gentler, cliffs here tower directly above town, often allowing destructive avalanches. (Photo Lambert Florin)*

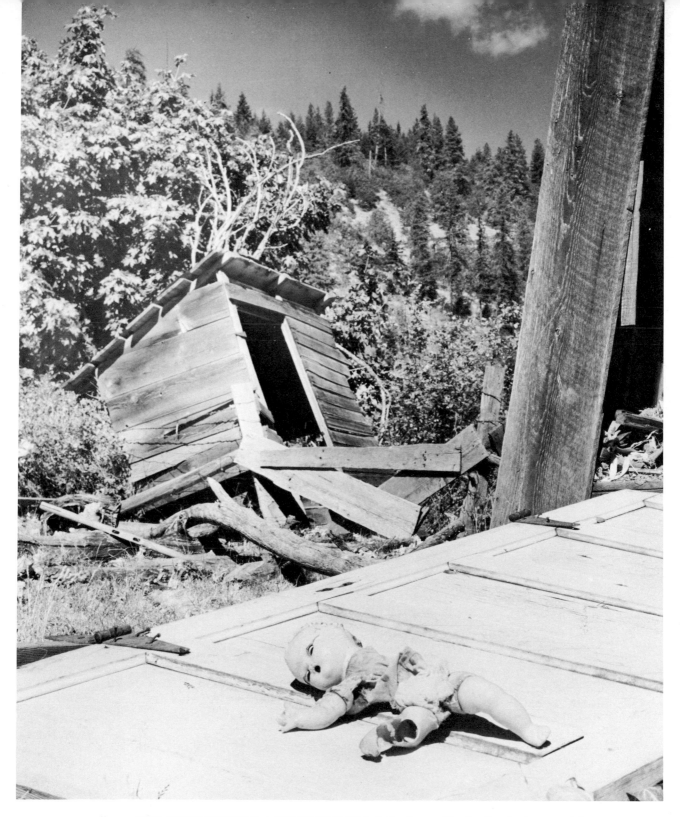

" . . . AND LEFT BEHIND A BROKEN DOLL." Outhouse lies in desolation on old deserted farm some miles from Wahkiacus, Washington, on turbulent Klickitat River. (Photo Lambert Florin)

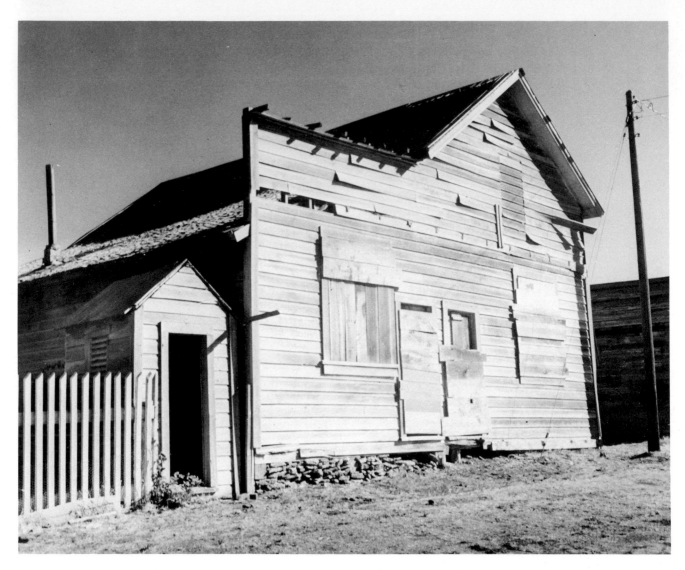

MAIN STREET MAINSTAY. *Isolated ghost town, Hardman, Oregon, retains many buildings in good condition. Once an important stage stop through high desert country with several hundred citizens, Hardman is now completely deserted. Civic pride was high, this public facility on Main Street with three holes (above), offering accommodation for most patrons. Fortunately for present day visitors far from regular "rest areas," this public privy is solidly functional, even displaying clump of wildflowers at door. However . . . be informed . . . BYOTP.*

HARD TIMES FOR HARDMAN. *Two privies are in evidence here (opposite top), well preserved in eastern Oregon town of Hardman, in Heppner area. False front structure at left served community as meat market, with beef at 15¢ a pound. Once thriving, Hardman fell upon hard days when pine forests were logged off.*

BACKYARD CLASSIC *in Hardman, Oregon. Outhouse (opposite bottom) displays traditional star, serving also for ventilation. Building in center was cooler and winter storage shed, several desiccated slabs of bacon still hanging from racks. Doors and walls are foot thick, temperature here often dropping to below zero. Collapsing windmill leans on old house. (Photos Lambert Florin)*

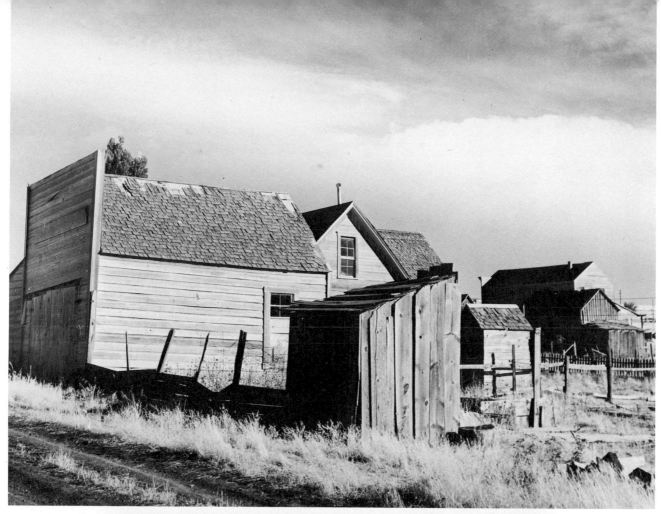

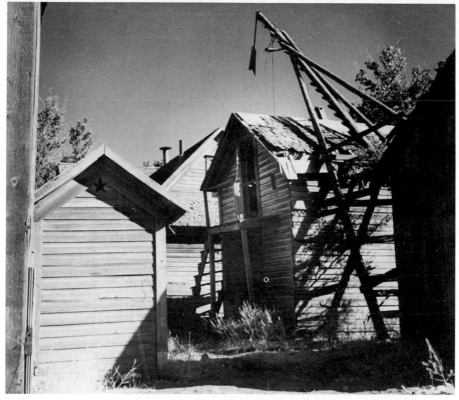

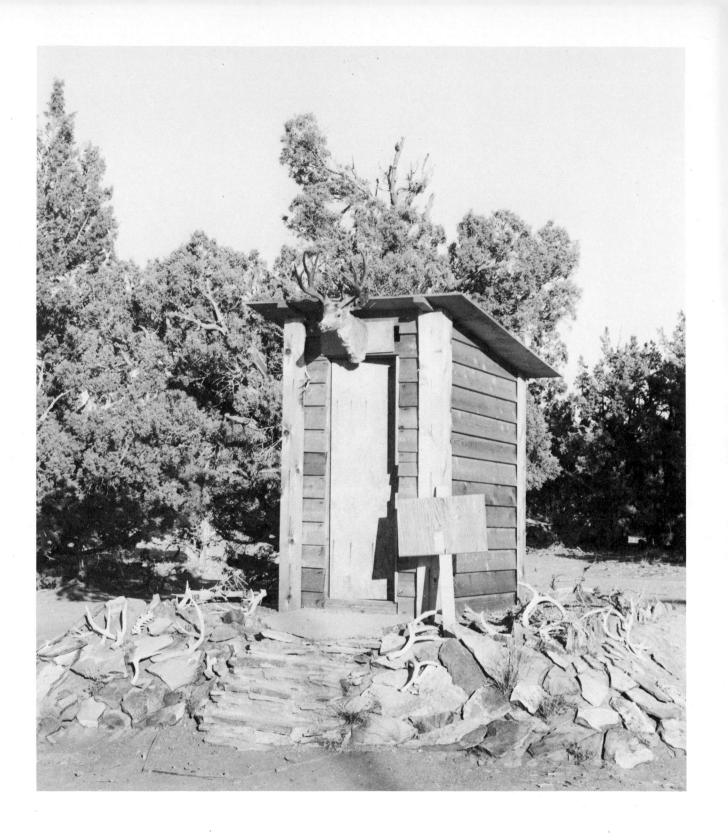

FIRST HIGH RISE PRIVY in Oregon. That's what the sign says – "Central Oregon's First High Rise Outhouse." Donald Coogan of Portland states this facility (opposite) was built by workers on power line near California Intertie, not far from historic natural formation of Fort Rock. It seems ground here was much too rocky to allow digging of pit so structure was set up on foundation of stones, loose surface sand pulled up around it.

Mr. Coogan does not know where the deer head came from but he has an imagination. "Can't you just see a half dozen construction stiffs getting loaded in a bar somewhere in the outland and making off with that mounted head while the barkeep is getting another case of gin from the cellar?" (Photo courtesy Elliott Smith, Portland)

HISTORIC BACKDROP for humble outhouse. Flat area (below) is Beulah Lake, Oregon, near Juntura, in what was early known as Agency Valley. Lake was formed when forced Indian labor built dam across north fork of Malheur River in early 1880s. After ditch digging, canal building and suffering other indignities, Indians refused to surrender and were killed.

Prominent rock, partially concealed behind mountain, called Castle Rock, was landmark for members of unfortunate "Lost Wagon Train" in 1845. One encampment was in draw on opposite shore and here is gravesite of first woman to die on trail, Serepta Chambers. Another few days saw party at site of fabled "Blue Bucket Mine." (Photo Lambert Florin)

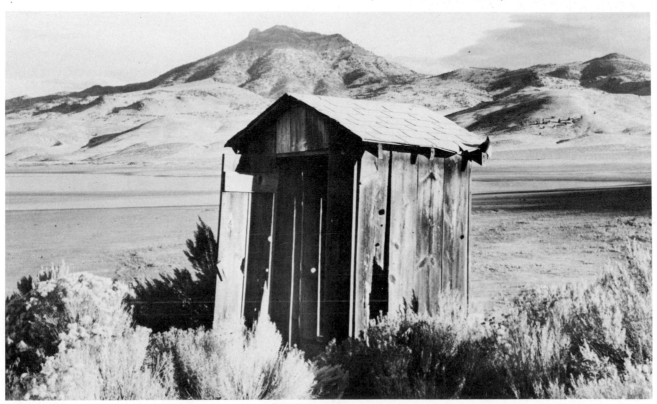

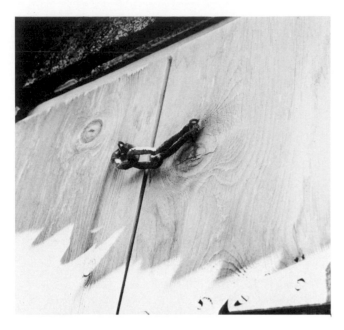

"LOVE'S GOLDEN LINKS are beautiful but friendship's links are steel." Is there a symbolic message in these links on "Ladies" behind I.O.O.F. Hall in Silver City, Idaho?

VICTIM OF BOTTLE HUNTERS. Still standing (below) are ruins of largest mill in area around Grantsville, Nevada. Bottle diggers have overturned large privy to paw around in exposed pit. First comers usually strike rich pay dirt. Mill workers often carried bottles of liquor, emptying them in privy. Glass tends to turn iridescent after some years in pit.

Mill, like most, was operated with help of gravity, ore dumped into bins at top levels. Fairly well preserved, five-stamp crusher is seen at right. Small trees, scantily placed, are pinon or nut pines, first growth specimens sacrificed to fuel mill and cabins. Small size now indicates slow growth in dry climate, rigorous winters. (Photos Lambert Florin)

The Outhouse Comes Out of Hiding

If you travel around with the right kind of people and keep the conversation away from tight ecological controls and women on the loose, heady with their new-found freedom, the subject of outhouses is bound to come up. They have a certain fascination for people today because they were at the very core of early American life and however unpleasant they might have been to people living today who had to use them, the passing years have laid a cobwebby film of romance about them. Then too, they represent the days when everybody worked hard, had few luxuries and that's what people today like to tell the youngsters who have everything and make a good show of appreciating nothing.

Older people like to go back to the farms and little towns and find their youth beckoning to them from dried up creek beds and uncovered cellars filled with broken bricks and rusted bed springs. They're apt to be pretty disillusioned about it all, settle down in the grass, stare at the tree tops and think about all the ifs and buts of their younger days. Poet Alfred Noyes had the word for it . . . "and yet if his mind run back to the honey of childhood's Paradise, his heart is not wholly black."

Back there is where the outhouse was and the memory of it is a powerful force to a lot of people trying to capture the peace and quiet of the old days once again. Most of them have about the same picture and describe it with a ghoulish flourish . . . "Do I remember those old privies? I'll say I do. Talk about fun on Hallowe'en. There was one over on the east end of town that we'd had our eye on for a week. Boy, did we ever knock that over! I'll never forget it. We went through a patch of corn stubble and three of us leaned hard on the rickety old shed and when it went over a big yelp came out of it. By golly, it was an old man in there—somebody's grandfather, I guess. (Story varies—from a Chinaman to the town's Harvest Queen.) That old privy went flat on its side and we cleared out of there right now." If the brave man is a good story teller he'll have you believing somebody got after the little brats with buckshot.

Yet there are softer, more wistful memories of those carefree days, a most appealing one in the private papers of one Anson Garrett, son of a Colorado pioneer, who wrote of youthful pranks too but had kinder thoughts about the old family outhouse. He wrote:

"I associate it now with pigs because in those days we had a few Poland Chinas and inside the privy I could hear them rooting and grunting around in the scrub pines. Actually they couldn't get any closer because there was a little stream in between that had water running in it spring and fall. It ran down to a slough where Ally Thomas and some other chums of mine got crawdads (crayfish) and built dams and used the clayey mud to make images and once we built an African mud hut village.

"Next to the privy toward the house, my grandmother had her herb garden and woe be it to any of us who scuffled up her lungwort and colt'sfoot. I considered rigging up something that would squash out the whole lot of it because I hated the tea she made out of comfrey leaves and the sassafras poultices she used to put on my chest when I had a bad cold.

"The privy path went past that and the hen house and the hollyhocks and morning glories that grew along the fence. When the bees weren't working on those they were buzzing around the privy, getting into it through the square ventilating hole near the roof. My father kept a homemade fly screen swatter handy to the sitter and it served another purpose for me too. I made a lot of them myself after school and after my chores were done and sold maybe a hundred of them for a nickel apiece.

"In the privy also was a bucket of ashes with a shovel father made out of a flattened-out lye can. Then every once in a while he would come home with a sack of quicklime so we never had too much trouble with odor. Nor did I ever hear too much grumbling about going out back even from the girls and women and even on those bitter cold mornings. Well it was all we had and hardly anybody we knew had anything better. We seemed to be satisfied with what we had. My mother was forever saying that was the only way most people got anything better. If you don't appreciate your lot, she said, you aren't ready to receive what the Lord is ready to give you. I get a little misty-eyed when I think of all the privations people had in those days and also all the simple pleasures and healthful duties they had that most everybody today tries to buy with money."

Money. There is a delightful story that comes in here, about a man who went back to the Nebraska town of his boyhood and could find not one solitary thing that remained. Everything, everybody was different and their unfriendly, shoulder shrugging attitude was something he couldn't understand.

The stranger in the midst of all this "I-could-care-less" business remembered the lines of the poem . . . "How dear to our hearts are the scenes of our childhood" . . . but by the Lord Harry, there weren't any. "Okay, okay," he said, "I'll show these granite-faced birds that I remember what my old home town looked like. I remember exactly what the house I grew up in looked like and that privy, why I can see every crack and knot in it. I can remember the wasps nests, the places where the rain came through the roof, the hole where the bullet went through the board when I tried to hit a skunk with my .22. The way to it went past the rain barrel and the old grindstone. I used to hide out

in the privy and smoke cubebs and read Diamond Dick nickel novels. These people in this burg don't know anything and I'm going to show them the place I grew up in and it'll open their eyes."

He went to the bank for a loan and when they asked him what he did for a living he said he was unemployed but was going to get something to do. He wasn't exactly broke, he said. The bank refused the loan but the man went back to Denver or Omaha or somewhere to get some money and started building his house, bossing a crew of carpenters himself.

The banker came by one day and remarked that it was a pretty funny, old fashioned house he was building. "Have you got an architect?" the banker asked. "No, I haven't got any architect," the house builder said. "The plans are in my head." The banker told him if he did have an architect and he was well known he might help the man get a loan. "Guess maybe I'll have enough to finish the house," he was told.

He did too. It had little dormer windows, cupolas and all including an exact replica of the little old 2-hole privy where he could sit and feel that nothing was going on in the world that he needed to know about. Everything important was right here at the old home stand.

Pretty story. Wait . . . it's not finished yet. Just before the carpenters drove the last nails, a gaggle of hard-faced men showed up in the town, bought up all the outstanding loans and mortgages the bank had, started a new bank and the house builder came out of the privy long enough to look into the president's office of the new bank, saw his own name on a brass plate, dictated a letter to the other bank president, inviting him to come out to the new house some day and use his privy. He added a postscript. "Dig out that loan application of mine and bring it with you. You might need it. I don't keep toilet paper out there in the privy. Never had it when I was a boy. Now it's too modern."

Legend, tall tale or whatever, the story illustrates that outhouses had a vital part of living in the days long ago that a lot of people are trying to get glimpses of today. They were the stuff heroes are made of. There were many different styles of privies but there was no class distinction in any of them. They served everybody—captain, Lady Vandeveer and whore. All privies had the same function and it brought some people who were riding too high on the clouds right down to earth.

Yet is was also true that outhouses—privies, backhouses—had personalities and in a way reflected those of the home owner. If he was considerate of the modesty of the women of the house, he might set the privy out behind the wood pile or in a grove of trees or some other secluded spot or maybe let ivy or honeysuckle or wistaria vines run up the near side to shield it a little. And he might put a partition inside, maybe half way up, so two people could talk but not have to look at each other.

But it would not be a person considerate of other people's sensitivities who would wallpaper a privy and put carpet on the floor and around the holes. This would be an affectation, either of humor or done in the same spirit a person would put gold paint on a dog house. In a few cases it was done but the homesteaders and pioneers of the West rarely

saw such extremes of temperament. There were a few, notably one in Georgetown, Colorado, that sported among other features gold-plated door knobs and a mirror on the wall. The perpetrator of such an aberration could well have tacked a placard on the door—"Lola Montez stopped here briefly."

Of course ventilation was of some importance, as were gestures toward offensive odors. Some privies, especially in dry areas, were equipped with stove pipes, and in a great number of them moons, suns and stars were cut in the upper part of doors and sides. Historically these may have had a meaning—moon for female, sun for male—but the main purpose was to let the air in even if they did say, "This way, fellas," to curious flies and wasps that could scare a lot of people but also offer extra diversions during long sessions on the seats.

Ah, the seats. Here was the real insight into the character of the builder. Was he trying for a speed record and whacked up a flimsy four walls that any wind or rain could get into and for seats used rough boards full of slivers? Did he have good tools and skill in using them? Could he bevel the sides of the holes properly? Don't ever think all the holes were round or oval. Some were too small or too big. Some holes were sawed out square and made octagonal by nailing short strips of lath around the openings. Some holes were lidded and some were covered with loose boards that had a habit of disappearing between trips.

Now in some places boards were hard to come by and other materials were handier. One informant, cruising the old Colorado mining camps, stepped into one outhouse and yelped to her husband to come and tell her if what she was seeing was for real. It wasn't a rattlesnake curled up on the floor or a litter of rats in the corner. But it was something next to lethal to anybody on one of those 25 below Colorado mornings. In place of a plank with holes cut into it, the ingenious builder had saved himself all that trouble by using the ready-made top of a 4-hole iron cook stove. With lids and lifter even. What could be neater and more natural? But just don't try to sit down on that iron on an icy 6 a.m. The devil will see to it that when you stand up you'll leave a tender strip of hide behind.

The same lady informant tells of the winter and summer privy she came across. It may have been in Leadville or Salida where the snows sometimes buried the buildings. To outwit them was a 2-story affair—one door on the ground level for summer use, the other 8 feet up, reached by a ramp and cat walk. All facilities inside were duplicated. When the big snows came, the lower door was boarded shut and up the ramp you went.

And this outhouse could well be termed a "Chamber of Horrors." It looked all right there in the old Colorado mining camp which was in the throes of some rejuvenation. But once inside you saw a flight of steps leading up to the functional seat—all this smack in the middle of the room. There seemed to be no purpose to the arrangement until on close inspection a half dozen peep holes could be spotted. The Throne Room, it was named by the lady that covers the old camps.

It is a positive fact that as far as outhouses went—and go—any twist of fancy was possible. There was the one near Elko, Nevada where the men's door was labeled MEN and on the women's door were two words—PATIENCE and FORTITUDE. And alongside an eastern Oregon road a few years ago could be seen a sign in front of a well built outhouse—"COMFORT STATION—Picnic here and use this privy. Leave quarter in cigar box. Maybe I'll get my money back."

And no dissertation on outhouses would be complete without the yarn about the city man who bought a small farm which included a "chambre de necessitee" behind the house. A year later the farmer came around and saw the city man had built a gasoline filling station beside the road. "Doin' any good here?" he asked. The new owner shook his head. "Can't make the farm pay. Too much work. But I have fun."

A big car pulled up at the gas pump about then and a plump little woman bounced out. "Have you a rest room?" The owner threw an arm toward the privy and the lady galloped thither.

"What do you mean—fun?" asked the farmer. The other man glanced toward the privy, waited a second or two, then flipped a switch on the counter. "Watch now," he said.

The privy door suddenly burst open, lady running out, frantically brushing down her skirts. "Fun, yeah," the gas station owner said. "Only reason I stay here on a farm I can't make pay. I got an electronic speaker under the seat out there. When I switch on the juice a voice comes up from below whoever's sitting there. It says—'Say, lady, will you move over to the other hole? I'm trying to get this job of painting done down here."

Such is fiction but in all the chronicles of pioneer life the subject of outhouses was very studiously avoided. Can anybody find even vague references to it in the detailed historical narratives of Bernard de Voto, Washington Irving, Lewis and Clark or even in the bittersweet memoirs of Henry David Thoreau? If anyone wants to take on the job of finding bits and pieces about outhouses in historical literature, including the hay field accounts by the pioneers themselves, let him take spear and digging hook and hop to it. He will return limp and listless with not one one-holer in hand.

There has to be a reason—psychological or altruistic—for all the published annals and journals of those roving reporters of the western movement to omit comment about that noble necessity of early life which is just now emerging into public attention. Was the reason some misguided sense of good or bad taste? But these writers were eminent journalists—admittedly writing for money and a living which doesn't come very much into consideration these days with friends and relatives of publishers covering the land like plagues of grasshoppers. They were keen observers, erudite and conscientious informers. How could they have overlooked the stark facts that the Nobs of Newport, Rhode Island, and the hangabouts of Philadelphia's grog shops would have been more interested in the outhouse situation at Astor's Landing than they were in Parson Weems' ink horn? Somehow somebody dropped a turkey off the stagecoach.

Of course in a way you can't blame scholarly historians for not including privies in their intense drive to establish facts about land grabbing, Golden Spikes and the comic opera attempts of the U.S. Army to keep Geronimo from stealing cattle. Bancroft and other observers at that time were engaged with the larger issues and outhouses had little to do with, say, the Modoc War.

But they did have something to do with early living and you can certainly blame every one of those loudly acclaimed chroniclers for flagrant oversight. In his book *The World of Washington Irving*, Van Wyck Brooks says this: "For Irving possessed the art of making the dryest of bones live. From the drabbest of factual records he could evoke the unexpressed feelings of adventure that lay behind them." Yet the outhouses that Irving encountered in his western travels must have been so far away from "drab" that he passed them up before many a shaking head.

And take that fine old trooper, Mark Twain, who never hesitated to speak his mind about anything. You can blame him too for not giving some attention to that house, shed or shack so necessary to decent life in his time. Can't you just see Mark Twain's pen flowing copiously over some essay on a gold-studded outhouse on Jackass Hill? Then what in the name of the devil's advocate did he do with some such immortal prose? No—don't answer that.

In all reason and fairness it has to be supposed that a number of Amy Busybodys or Snickering Sams across our great land have, in a dutiful and forthright spirit, tried to see the outhouse objectively, as a part of human progress, and write bravely about it for various Boondock Banners. And you know what probably happened. Rising up in moral indignation, repressed to the point of rancor, the editors watched and warded their local correspondents into early retirement.

There is one splendid exhibit that dared to lift its head above the smog of public disapproval. It is *The Passing of the Old Backhouse*, very likely but not officially acknowledged as the work of the Hoosier Poet, James Whitcomb Riley. It is reproduced on a succeeding page.

But this is latter day stuff, of this century, in what is loosely termed "an enlightened age." It has produced also *The Specialist* by Chic Sale, a phenomenon in its way, and in later years several homespun, privately printed booklets of photographs and leering captions of one kind and another.

There must be an answer somewhere for the neglect of the outhouse in historical literature but better diggers than this one will have to find it. He is left holding an empty bag which he will hand to anyone who has enough orange or apple wrappers to fill it and enthusiasm enough to take it down the well worn path to that little old house behind the big old house and hang it on the rusty nail somebody drove in the wall 70 years ago. Sears Roebuck catalog pages used to hang on it along with some old dress patterns stamped "Front" and "Back."

The Lambert Florin Selection

All photographs in this section were made by the author. Historical accounts of many settlements, mining camps and towns shown in this section are detailed in his Ghost Town series of books – Western Ghost Towns, Ghost Town Trails, Ghost Town Shadows, Ghost Town Album, Boot Hill, Tales the Western Tombstones Tell, Historic Western Churches.

SCALE MODEL . . . 12 feet to the inch? Warren, Idaho, looks like it here in photo taken from old mine dump. But it is real enough and again demonstrates that early mining camps were constructed out of material at hand, whether adobe, stone or logs, as here. Although boom days are long gone, Warren refuses to lie doggo. There is still mineral to be found in small quantities (deeper hard rock mines may some day yield another bonanza) and a scattering of prospectors and summer campers give it a semblance of life. There is no modern convenience here except telephone service. Each cabin has its own old fashioned privy, several in evidence here.

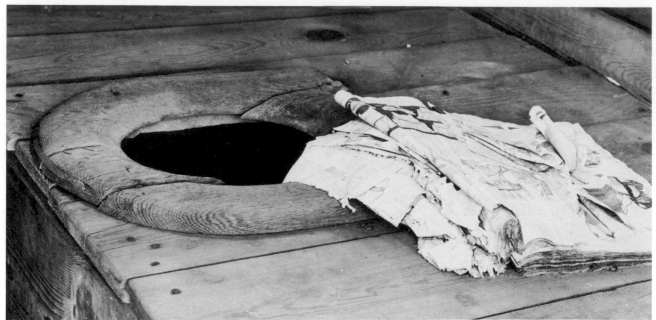

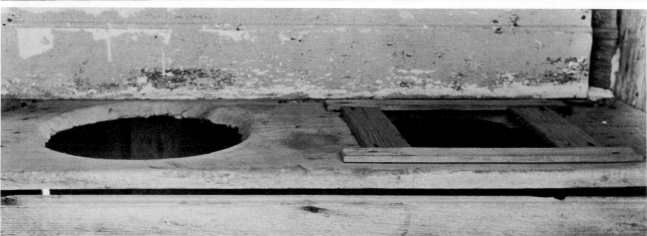

GOOD SEATS STILL AVAILABLE. *Don't let the old Sears Roebuck catalog in this Sandon, B.C. outhouse discourage you (top). The fitted seat gives promise of more modern comfort with slight chance of a pinch. In Bodie, California facility (center), some do-gooder squared circle to keep you from falling through but badly misjudged shape of your fundament. Or did Ma lose weight or was the new tenant real square? Not very inviting is this Goodsprings, Nevada, rest stop (left) but there was no front wall to stop author from photographing interior. Three choices, folks. Step right in.*

SCHOOL PRIVY LIES FLAT. *In arid, barren section of southeastern Oregon two brackish lakes lie almost connected, narrow neck of land between. Tiny town, almost vanished now, was set on strip and called Narrows. Well built outhouse served school but succumbed to vandals, probably bottle hunters. Lone resident nearby told author he was about to destroy all historic buildings to discourage trespassers.*

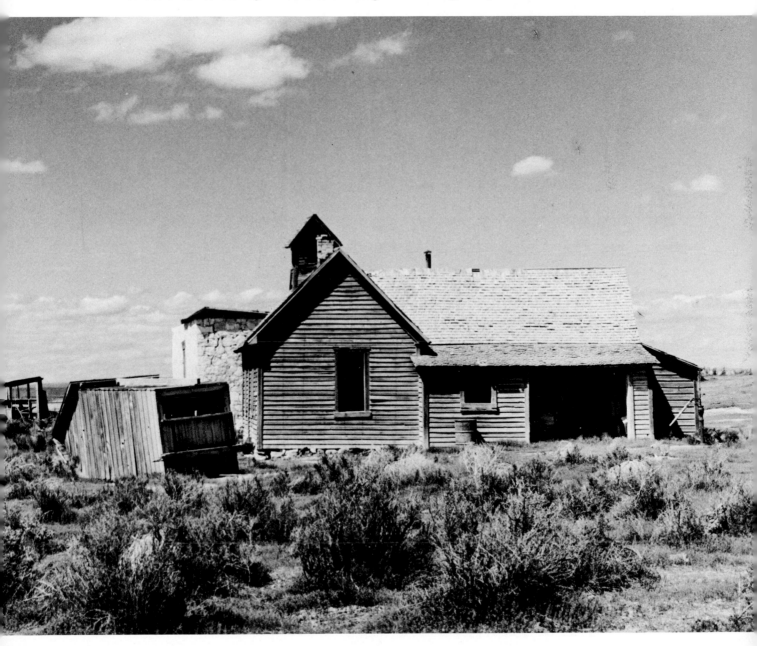

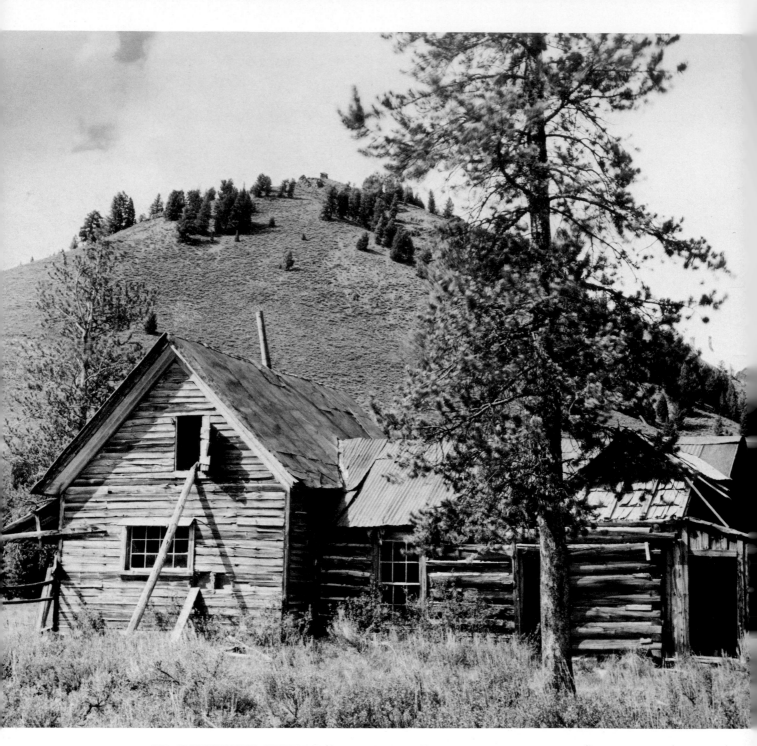

NO SNOWSHOES NEEDED for morning walks. Bonanza, Idaho, near "River of No Return," famed Salmon, is in area of bitter winters, deep snows. To keep "Dot, the miner's daughter" and others from having to go "out back," privy was attached to main building. Bonanza and neighboring Custer were large silver mining camps in "Land of the Yankee Fork."

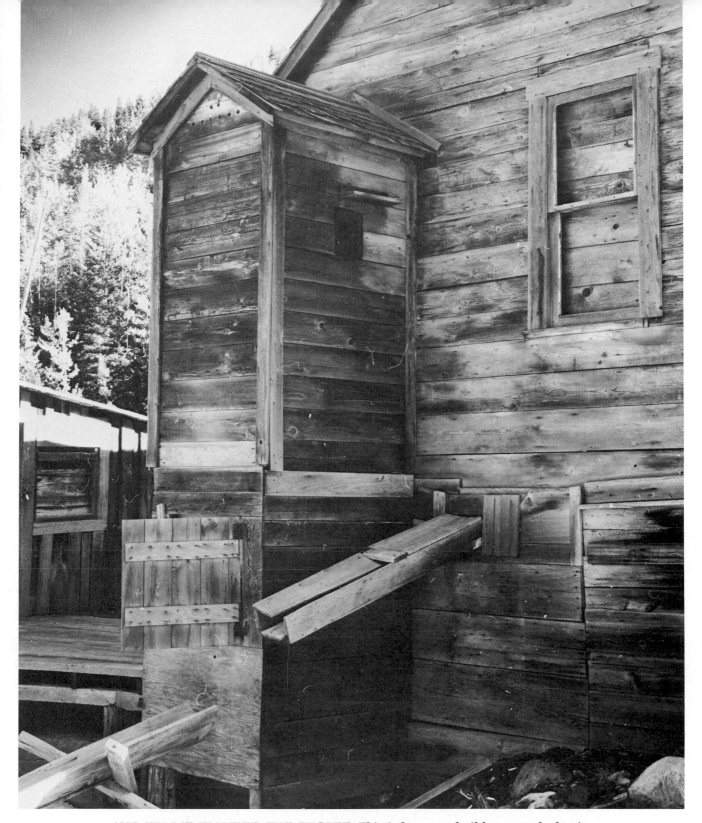

AND WILLIE EMPTIED THE BUCKET. *This is how you build an attached privy if there's running water behind the house handily serving as depository for buckets of privy waste. Here in Sandon, B.C. fluids from sink were sluiced directly into creek, all wastes carried downstream through town far below.*

Sandon was built along both sides of Carpenter Creek and melting snows often sent raging torrents through town, tearing out most buildings in center. This home near lower end was spared by rocky bank which shunted surging waters aside.

33

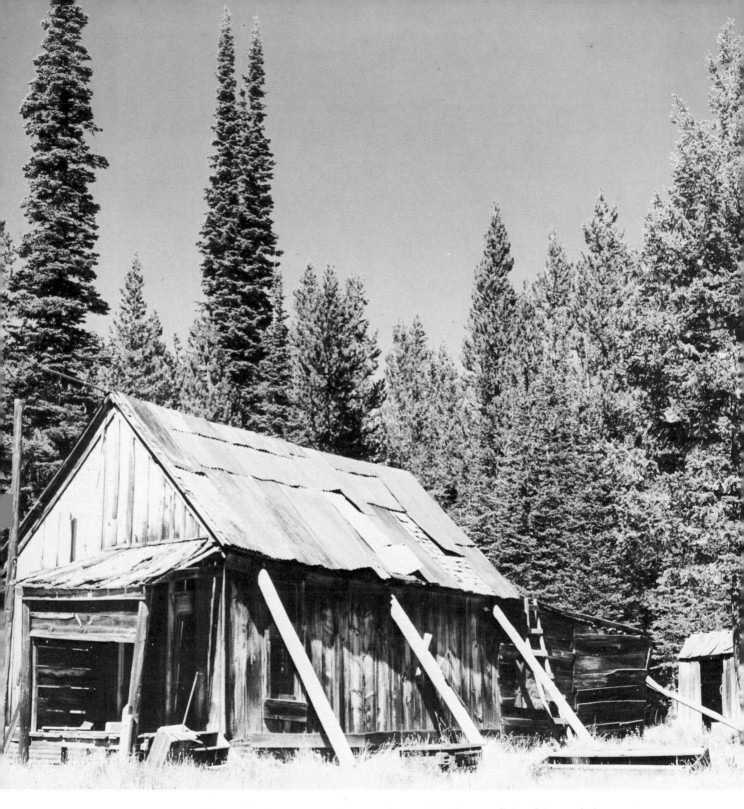

LITTLE OLD HOUSE OUT BACK stands proudly alone as big cabin needs bracing against heavy snows of Greenhorn, high in Oregon's Blue Mountains. Origin of name?

Story is often told – total greenhorn, starting to prospect, asks miners where to start digging. "Well, why don't you try over there?" pointing to a most unlikely spot, whereupon miners have big laugh. Of course novice always strikes it rich. Something like that happened here, it is said, and place was named Greenhorn. Altitude favors growth of true alpine firs so characteristically slender.

34

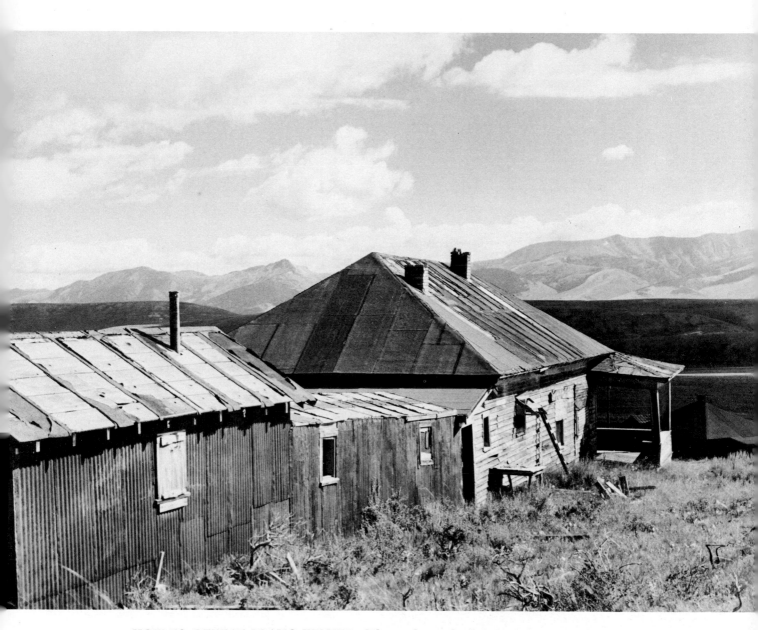

HOW TO DEFEAT IDAHO WINTER. Gilmore house had sheltered walk to privy to outwit winter snows and wind. Bathroom with tub is in room at left, privy under vent pipe in extended hall.

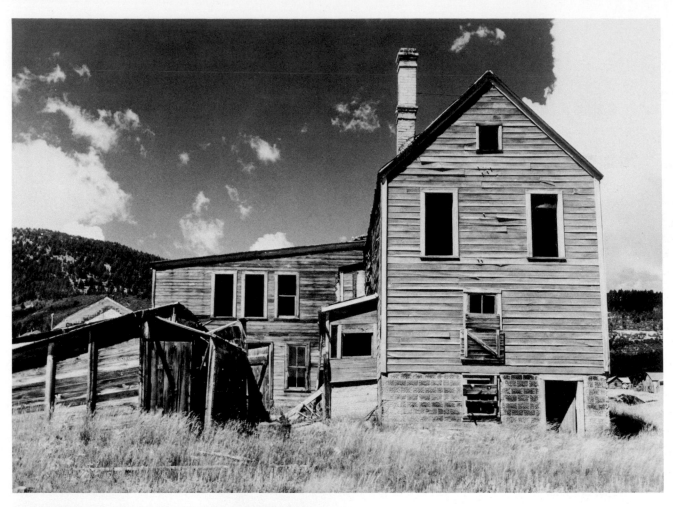

12 ROOMS 1 PATH. *Although Hotel Jaggers in Gilmore, Idaho, offered some "luxuries," patrons had to use outdoor privies. View (above) looks east to them. Walk may have been partially protected. Rear view of hotel (left) looking west – "Men" and "Ladies" at left. Shortly after photo was made area was visited by rousing thunder storm. Deluge of water coming in through roof cascaded down "grand staircase" step-to-step as in fish ladder.*

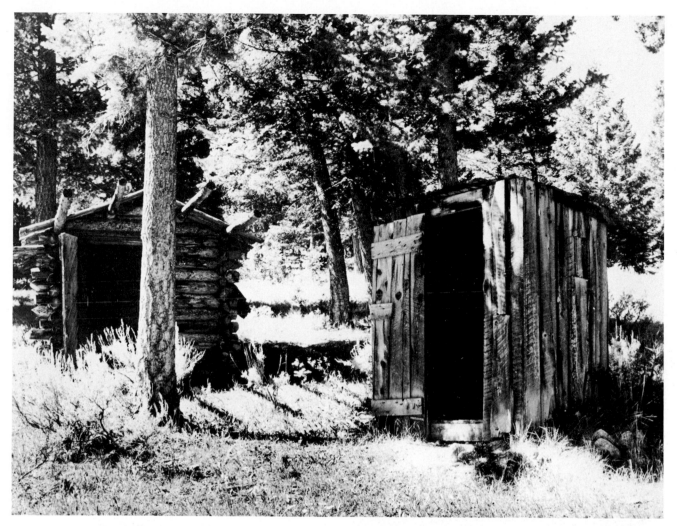

BATHROOMS? Who needs 'em? Houses on upper levels of Gilmore, Idaho, nearer mines, were generally more modest than those below. They had outhouses, still being used by summer campers.

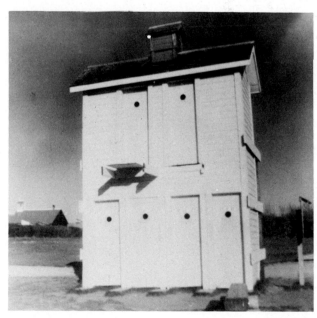

22 ROOMS INSIDE . . . 6 outside. Heritage Park, Calgary, Alberta, Canada, is assembling old buildings and artifacts to recreate semblance of vintage town. Outdoor museum, built around small lake also will display such items as compact railroad, complete with station. This unique privy displayed there was once attached to second floor of large hotel. (Photo from Kodacolor by Mrs. Sam Chadburn, Portland)

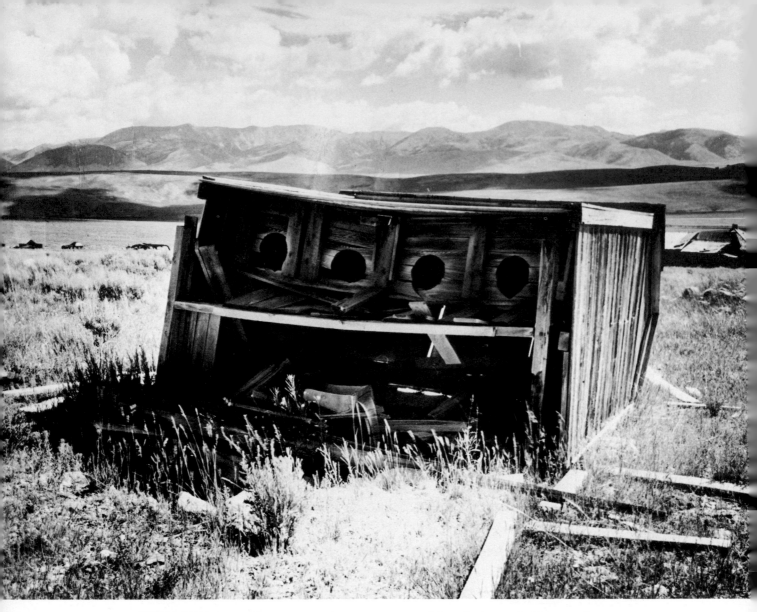

WELL THEN . . . *Where can I go? This overturned four-holer probably served some hotel or school but no trace of either remains. Story is told that outhouse of similar capacity was built at red light house but madame in charge had it torn down and replaced by individual one-holers. She said girls spent too much time gossiping when "out there together."*

FALL OF GLORY. Some outhouses are blown down, some collapse from weariness, some wrecked by irate neighbors. What happened here (opposite top) is anybody's guess. Houses these two belonged to have completely disappeared. In middle background is historic Lemhi Valley, Idaho, site of Sacajawea's birthplace and early Mormon settlement and fort. Not far south is Gilmore Divide separating Lemhi drainage north to Salmon River and Birch Creek flowing south. In distance is Bitterroot Range here forming Continental Divide. Weathered boards of fallen privy (opposite bottom) offer interesting textures.

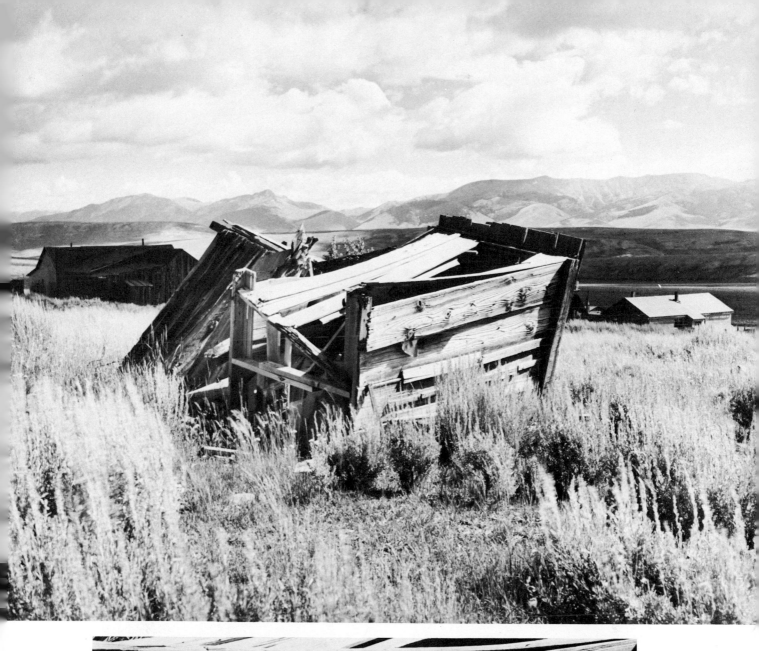

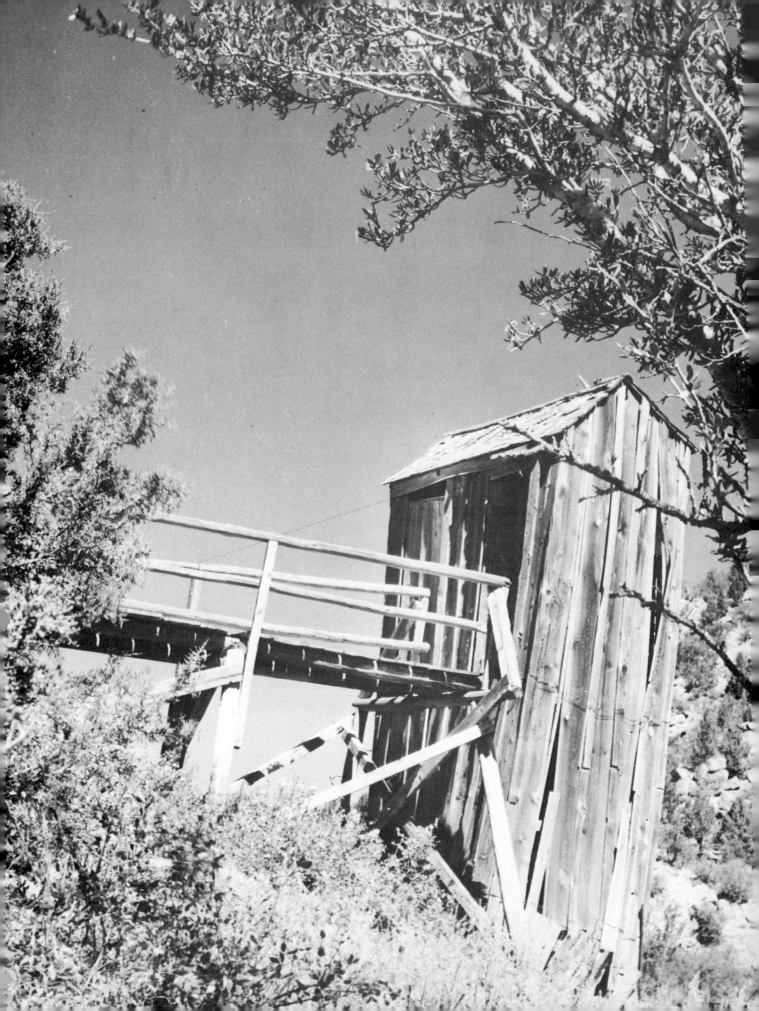

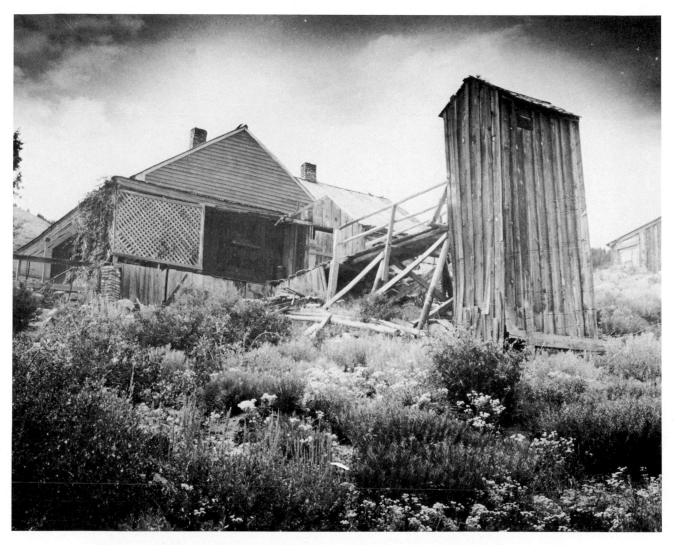

SIGNAL FROM BRIDGE – *"Occupied." Famed "two story" outhouse in Silver City, Idaho demonstrates one way of coping with steeply sloping backyard. This is the same photograph appearing in color on dust jacket. Adjoining building had many uses over years, serving as mine company office and later hospital. Some 15 years elapsed between taking of photo (opposite) and one (above). Novel facility still serves in occasional emergency if showing of pink toilet paper is any indication.*

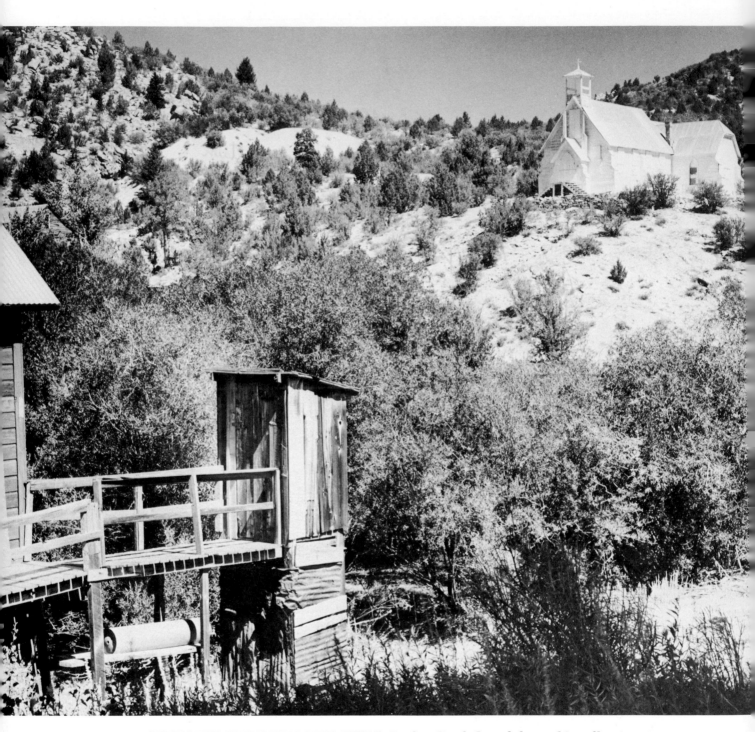

OUTHOUSE BUILT HILLSIDE STYLE. *Jordan Creek flowed down this gulley in Silver City, Idaho, and carried away wastes from this and other privies.*

SILVER CITY BOARDWALK. Fantastic ghost town in Idaho, is still filled with many relics of past silver mining days. Situated near top of War Eagle Mountain, town is buried in deep snow all winter. Easy access to the outhouse was assured by covered walkway.

43

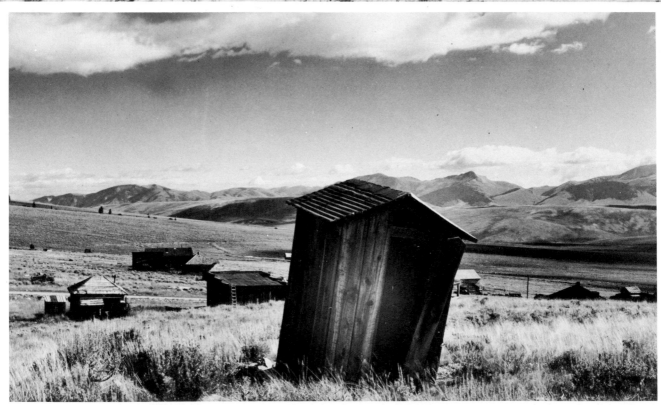

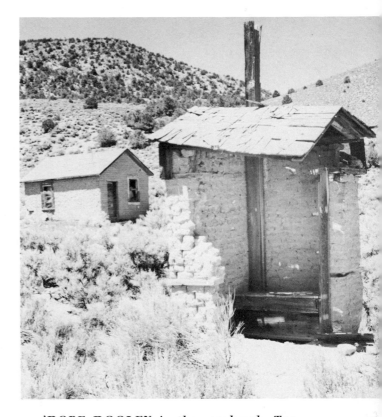

"THE HOPE AND FEAR of yesteryear."
Typical locale of Gilmore, Lemhi Valley,
Idaho (opposite top). Each log house has its
own privy. Here one is isolated, one con-
nected to cabin.

'DOBE DOOLEY in the sagebrush. Tra-
ditionally brick outhouse is symbol of
sturdiness and permanence but those of
adobe or unfired brick are neither. This one
(above), although well constructed with vent
pipe rising directly from pit is crumbling,
offering patron sun bath or shade. Usage,
however, is scant since Grantsville, Nevada,
population has been zero for many years.

BUILDER TURNED HIS BACK on beauty.
Solitary privy (opposite bottom) was not
built to take advantage of grand panoramic
view of Lemhi Valley, Bitterroot Mountains.

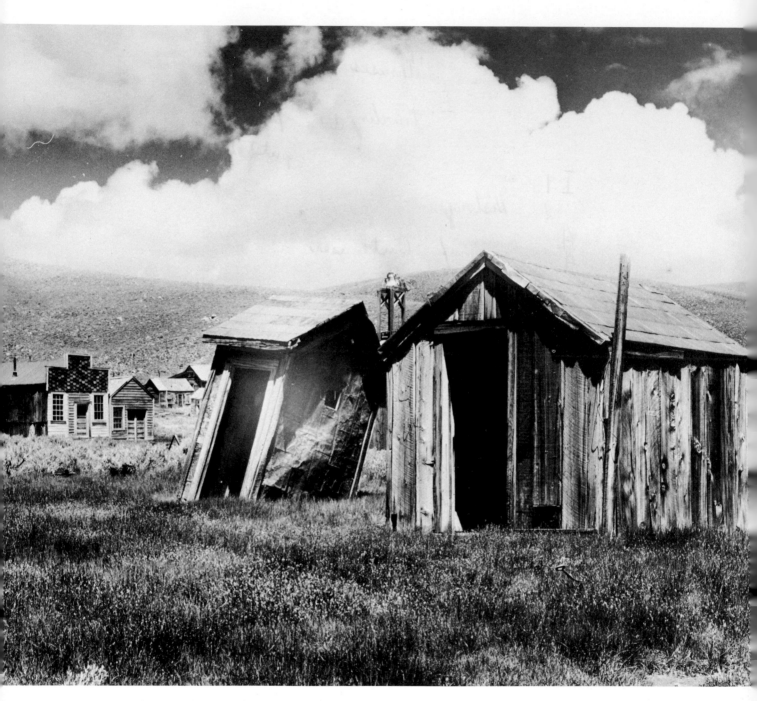

"WHEN SHADOWS FALL AND SPIRITS SAG . . ." Outhouse in Bodie, California,
is on its last lean. Seen in background is fire station at left, old bank vault at right
remaining from disastrous fire.

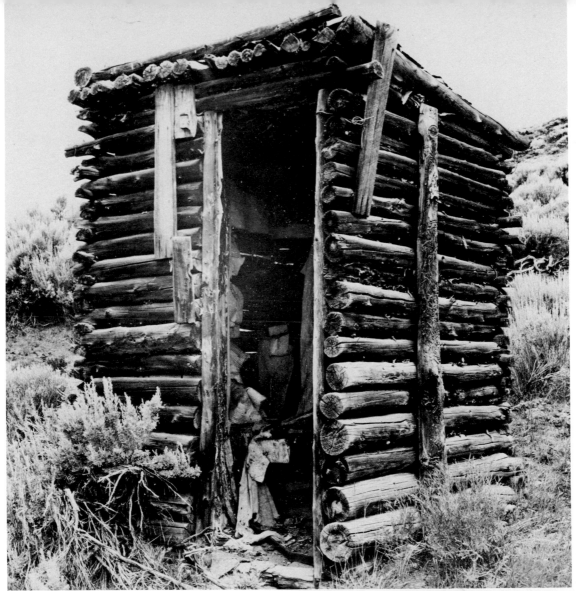

AND SOME HAD GUN PORTS. *Indian-proof was the name of the game in early days of South Pass City, Wyoming, and that meant logs even for outhouses (above) as no sawed lumber was available. Mining camp was long plagued by Indians who resented miners killing game, befouling streams with sluicing. For a time lookouts with rifles stood watch on each of several hills surrounding town. Such buildings as outhouses where escape might be cut off had portholes through which a rifle could be fired. At right detail of construction South Pass City outhouse.*

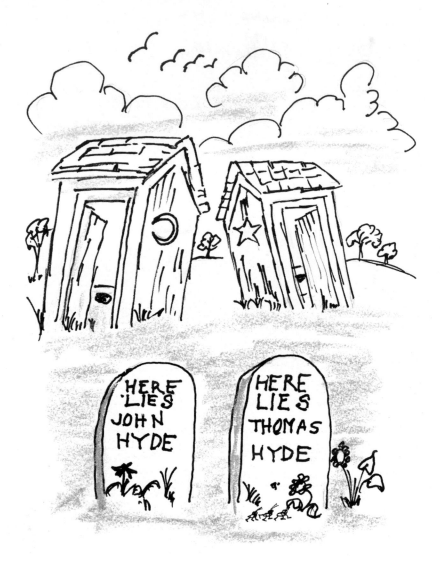

There was a young man named Hyde
Who fell into an outhouse and died.
He had a brother
Who fell into another
And now they're interred side by side.

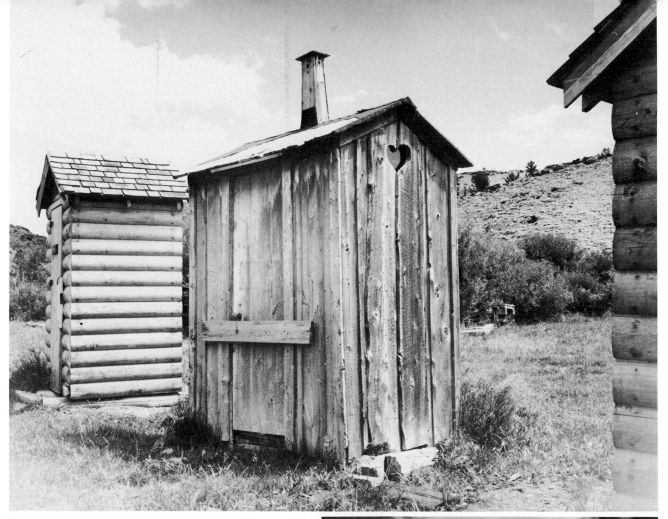

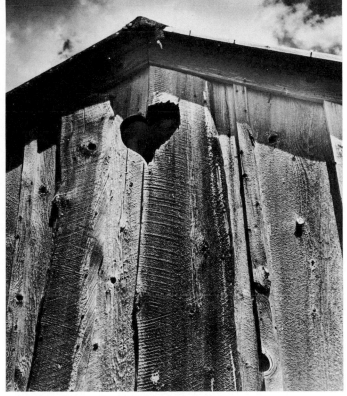

USE THE ONE ON THE LEFT, FOLKS.
State of Wyoming is preserving, restoring what is left of South Pass City. It was here most westbound wagon trains crossed Rocky Mountains. First gold mine was reported in 1842. In 1870 Suffragette Esther Hobart Morris obtained a full voting franchise for women in state, then became Justice of the Peace. Hotel was built here about this time, usable until 1965 when floors became unsafe. Outhouse (above) is an original with more recent one for visitors.

BE MY VALENTINE! *Heart decorates old privy (right) near early day hotel, South Pass City, Wyoming. Rough, wide boards were likely cut by primitive whipsaw although sawmill was established here early.*

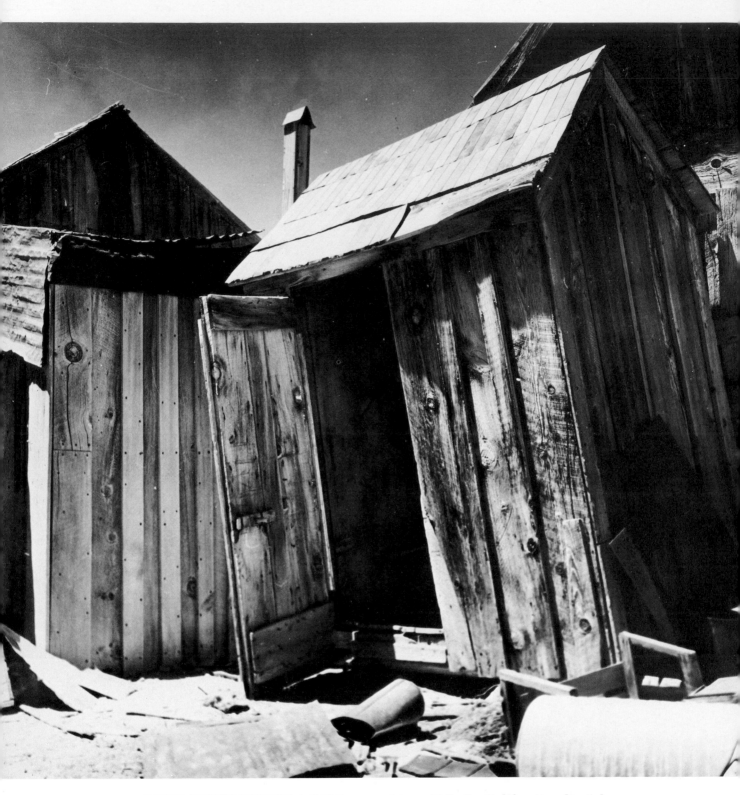

PRIDE GOETH BEFORE A FALL . . . and two old Bodie, California, relics (above and opposite bottom) are nearing end of illustrious careers. Lonely privy at South Pass City, Wyoming (opposite top) must have been elegant when built. Paneled door, ventilator, glass window were unusual amenities in pioneer days.

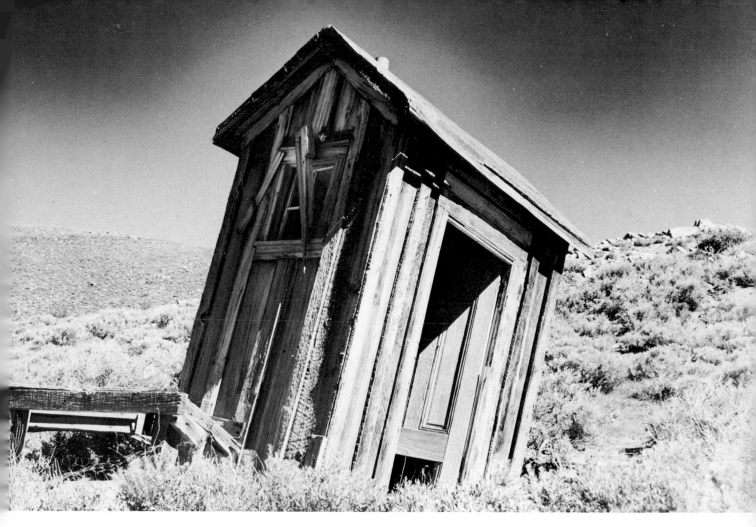

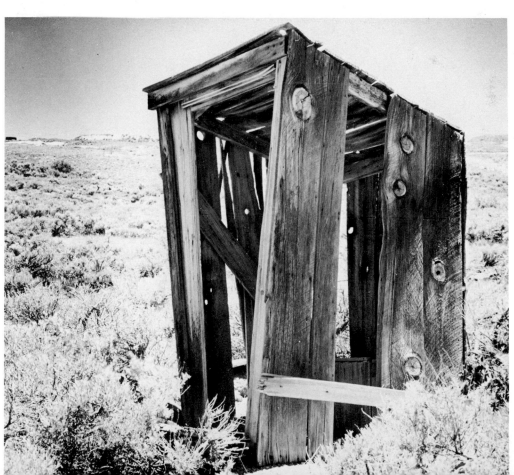

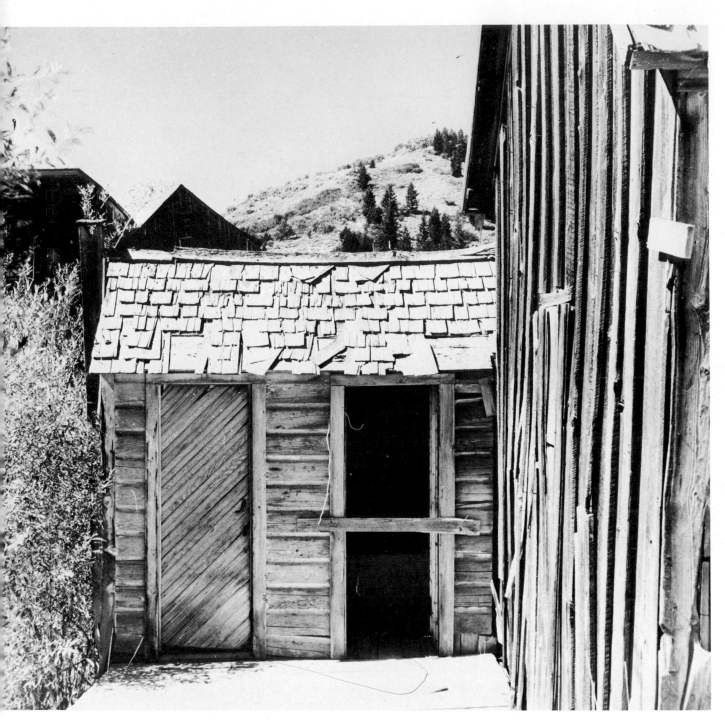

ALL BOYS LEFT . . . all girls right. Boys' and girls' privies were discreetly placed at opposite ends of large school in Silver City, Idaho. Structure like this is at other side. Both overhang Jordan Creek for drainage purposes.

INSIDE STUFF. Outhouse holes were fashioned in many shapes. Squares were easiest to saw out where two boards touched but they lacked something in comfort. Some improvement was made by careful beveling. Much better were round holes with proper beveling, but the oval hole, beveled and smoothed, achieved top billing. One could really relax, beyond the exigencies of the moment, on such a throne. This example in Bodie, California (right), fits somewhere in between, accomplished by angling straight cuts to make circle.

Large mills such as several in Bodie, California, provided facilities to accommodate employees in simplest manner, designed to discourage gold bricking, gossiping or falling asleep. One refinement was shoulder rest (below) which helped to prevent a fall to ignominy. This early American primitive, photographed in 1955, could not be located in later visits, after California Beaches and Parks had taken over.

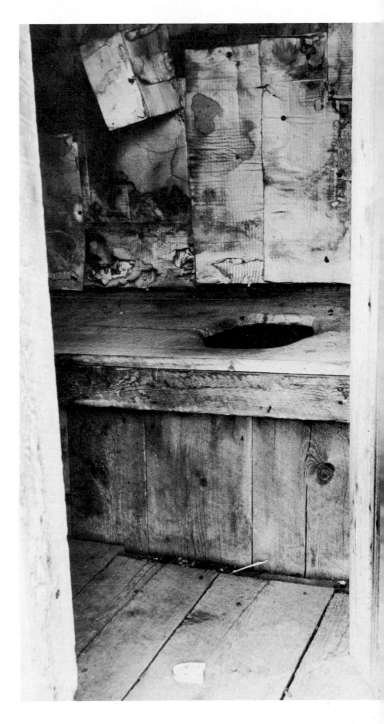

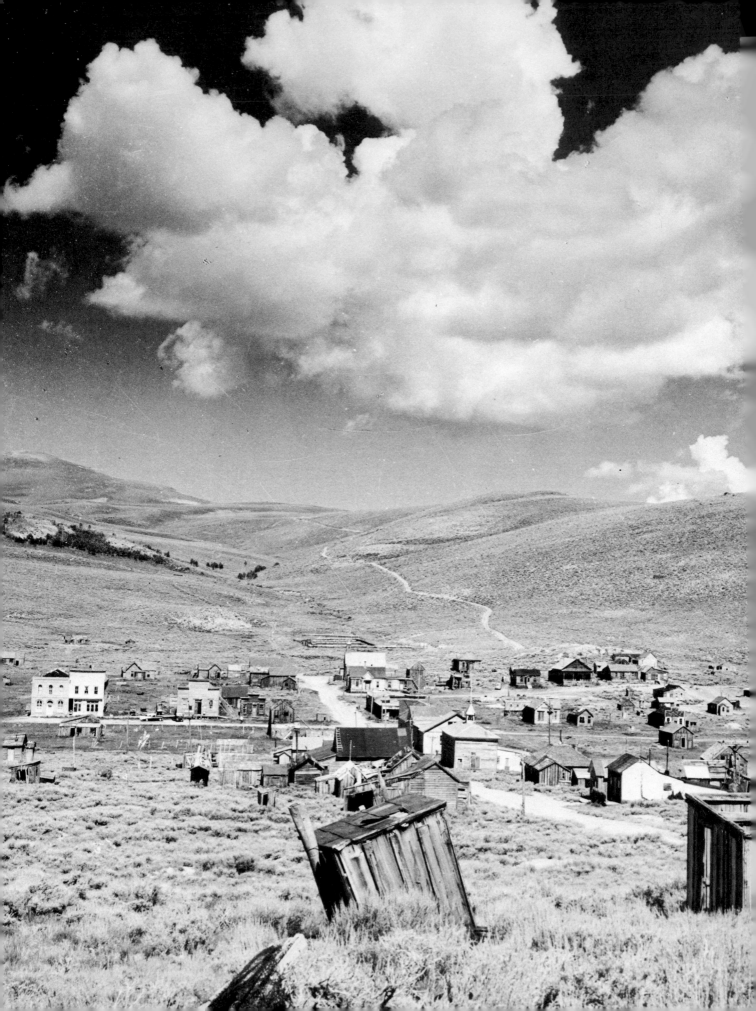

BEYOND "BACKSLIDING" OUTHOUSE, Methodist Church in Bodie, California (below), still stands in good condition. Original shingles on roof, blown off in mountain gale, allowed water to damage interior. Almost too late, building was reroofed with bright green tar paper. Now park bureau has made permanent improvement with shingles similar to original and weathering is giving proper old look. No paint has been used by rangers who aim to "arrest" rather than replace or restore. Siding boards are treated with colorless solution rendering old surfaces almost impregnable. Had these measures been taken before damaging fires, vandalism, natural decay, State of California would have finest example of old mining camp in United States.

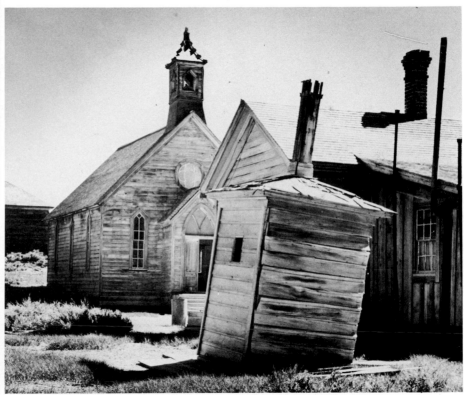

HOW MANY CAN YOU COUNT? Overall view (left) of Bodie, California, with another overleaf, show what author believes is largest assemblage of outhouses in U.S. Middle left are only two remaining substantial buildings from street once solidly lined on both sides to extreme left of photo. Altitude is about 8,000 feet. Deep snows nearly bury buildings every winter.

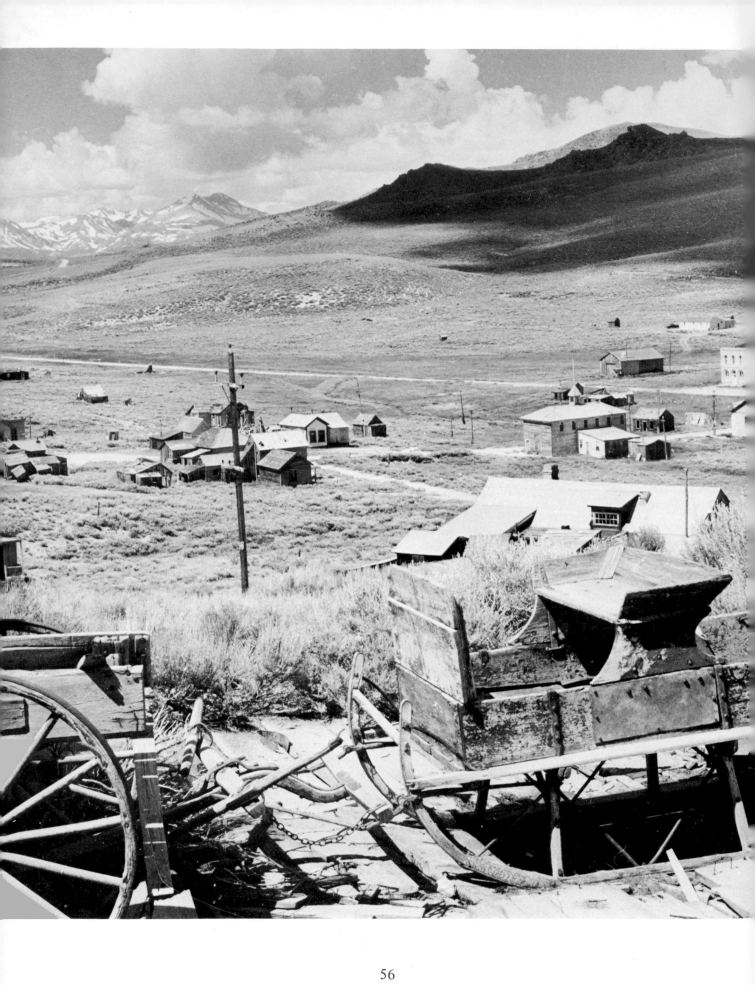

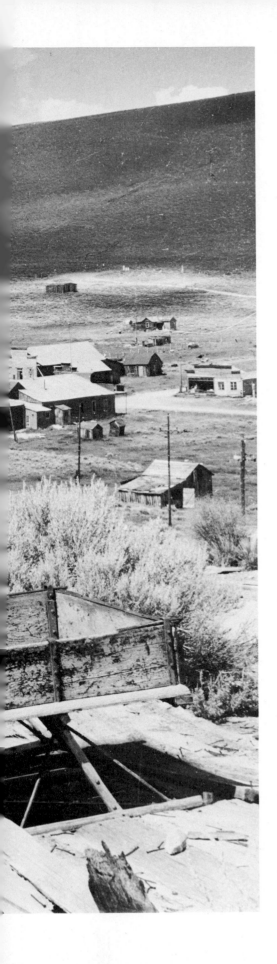

GHOSTLY REMNANTS of Bodie, California (left), swelter under summer heat, no longer counting months until winter snows. In distance is High Sierra, middle at right cemetery with gleaming marble tombstones standing out. Near center is school with bell tower.

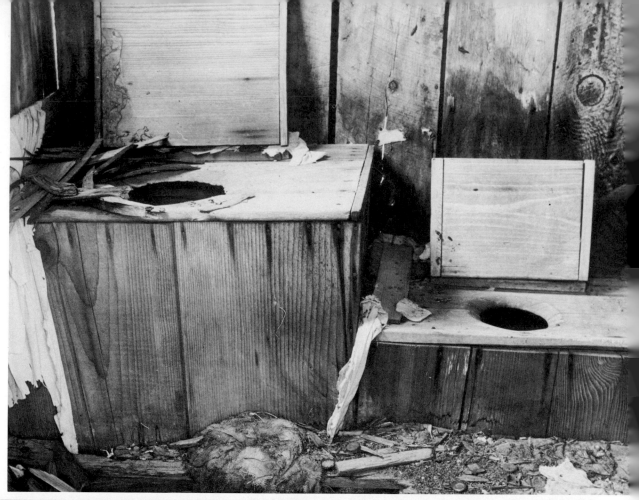

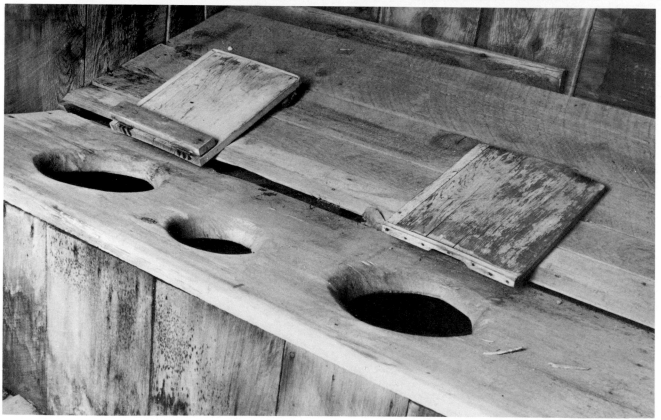

SITTING PRETTY. Papa was thinking of baby's comfort here (opposite top), carefully smoothing edges of hole. Lids are unusual refinement. Stove pipe elbow (right behind lid) serves as ventilator. Nobody expected baby to close lid in this case (opposite bottom) but how did the little rascal get up there? Two somewhat modern additions in this privy — seat cover and padlock on door (below), latter seeming affront to usual hospitality in western scene. All three photos taken in Bodie, California.

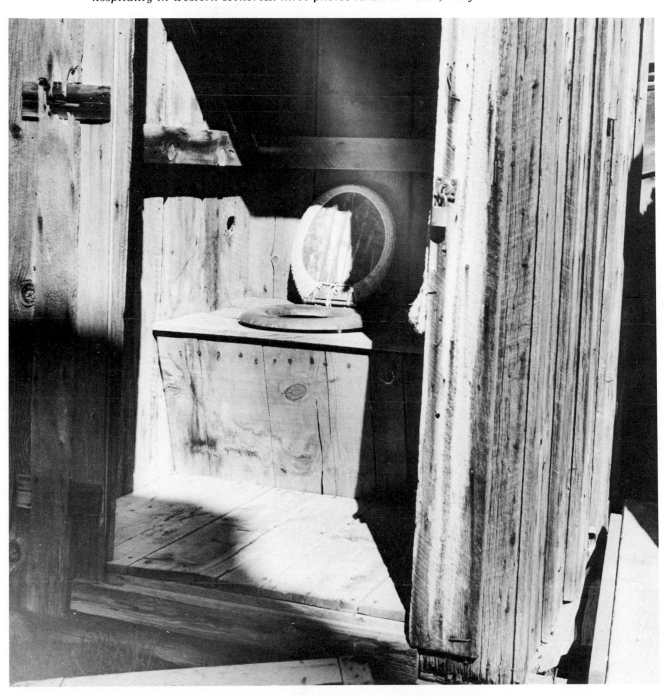

FORMULA FOR FAME? *Maybe you could have become president if you'd lived with an uncle in Newberg, Oregon, and used this magic privy. Herbert Hoover did. Born in Iowa in 1874 he was orphaned when 9 years old and sent to live with his uncle, Dr. H. J. Minthorn in Newberg. He was member of first class to be graduated from (then) Pacific Academy in 1888. The family then moved to Salem and Herbert Hoover's adult career started. Old privy still stands on grounds of Minthorn house on River Street.*

"P HOUSE OF THE AUGUST MOON." *Author's nephew Jack Brosy and family live in large log house at top of long slope above Oregon's Tualatin River, tributary to Willamette. Annual family reunion is staged with sumptuous picnic at edge of river some distance from residence. As a convenience Brosy built this outhouse near picnic grounds, only one in author's collection built of plywood. It is known familiarly as "P House of the August Moon."*

Adapted from True West *magazine cover – "Cowboy Chores" by Fred Harman in* True West Collection.

LAVATORY LUXURY. *Some residences in Gilmore, Idaho, seem almost repairable. Here is peek into bathroom of one, ladder still in place leading to upstairs sleeping room. Jean Amonson, who with husband Peter, often visited in Gilmore during heyday, reports some houses did have bathtubs that were filled by buckets, drained to outside by gravity. Privies were still necessary, one in this house (right) attached at end of hall.*

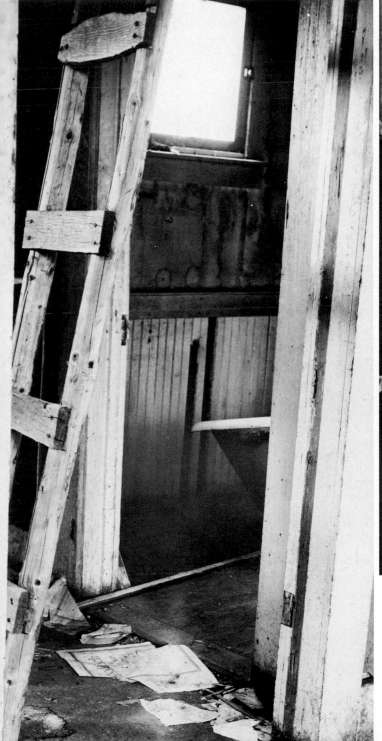

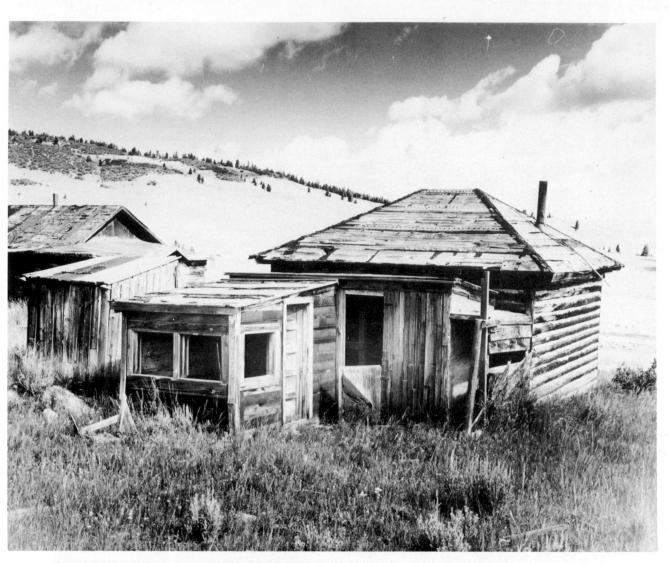

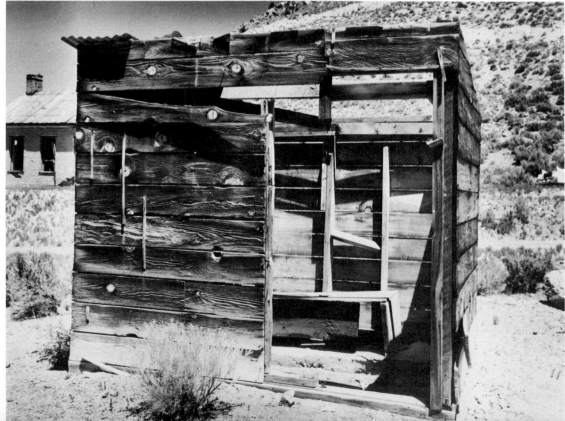

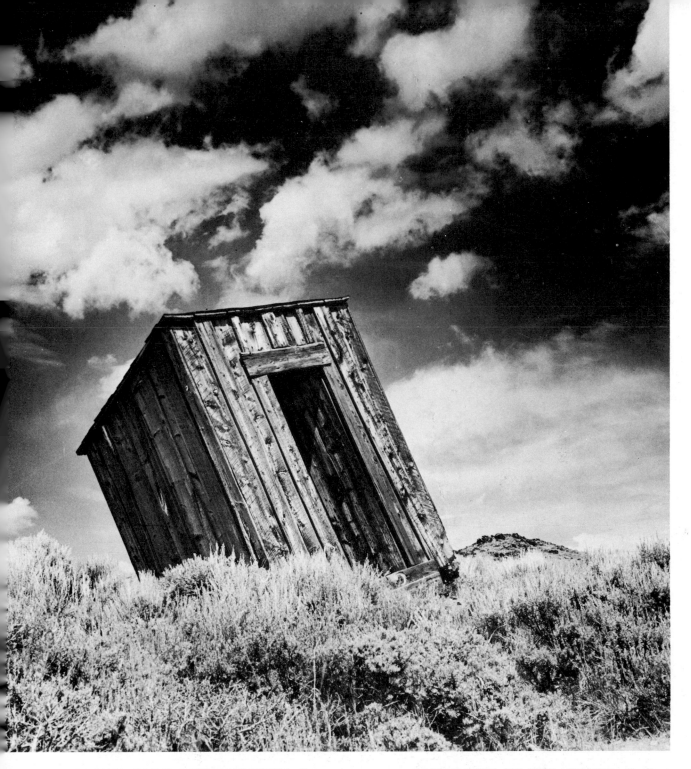

PRIVIES "JEST GROWED" HERE. Complex of small buildings in Gilmore, Idaho (opposite top), includes two privies each deviously connected to cabin. Slopes in background offer pasturage to wandering bands of sheep, their bleatings often only sound breaking silence of utter desertion. Another lonely relic (above) in South Pass City, Wyoming.

BARE BONES ON THE PRAIRIE. Earliest buildings in Grantsville, Nevada, were crude dugouts in rocky banks, roofs covered with dirt. Middle period in long history saw more permanent adobe houses, such as one shown partially in background of photo. Its outhouse (opposite bottom) was of frame construction but over concrete lined pit, a refinement rare in primitive situations.

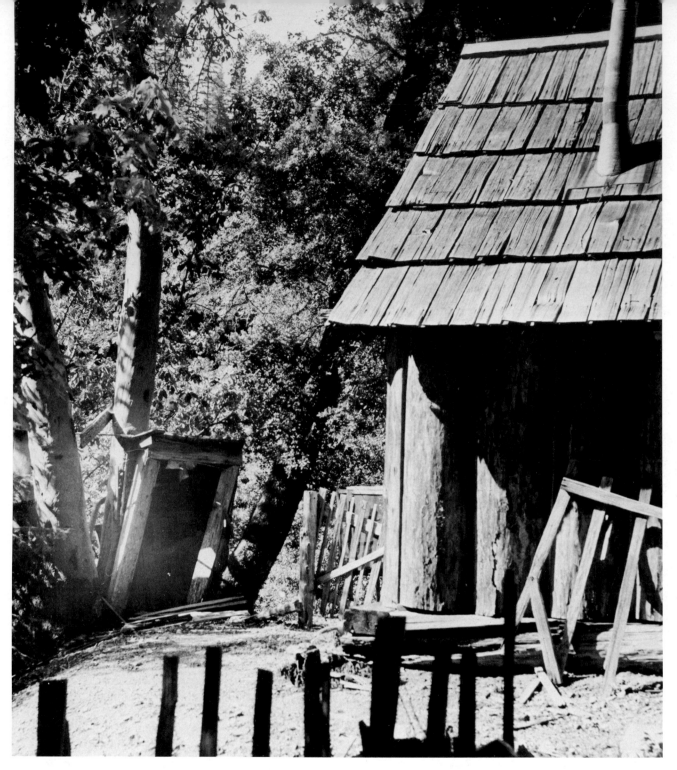

TRAILSIDE REST. Along trail to Denny mining area in Salmon Trinity Alps, Primitive California Area, is this large shelter with all comforts of home. Outhouse leans precariously but is supplied with running water from stream behind. (Photo David Anderson, Ferndale, Calif.)

" . . . WITH SORROW TO THE GRAVE." The old back houses of Bodie, California have fallen upon evil days after pressures of wind, sun, snow and collapse of pits. In photo (opposite top) user of privy would have had to leave a trail of bread crumbs to find his way back through maze of walkways. Location of hidden privy (opposite bottom) in Bodie, California, is betrayed by wooden flue.

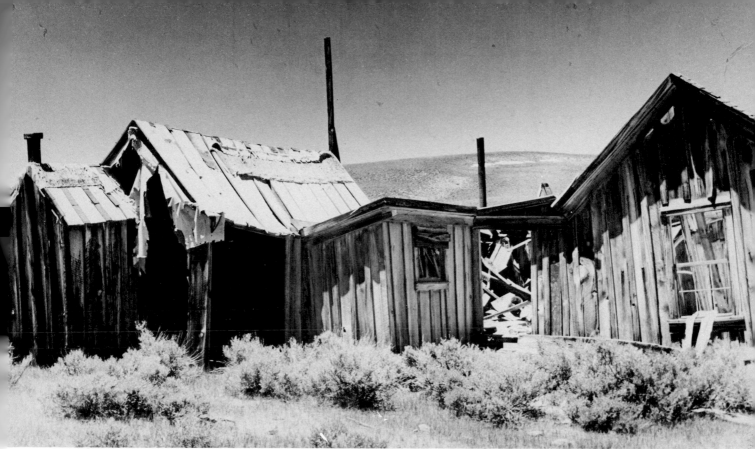

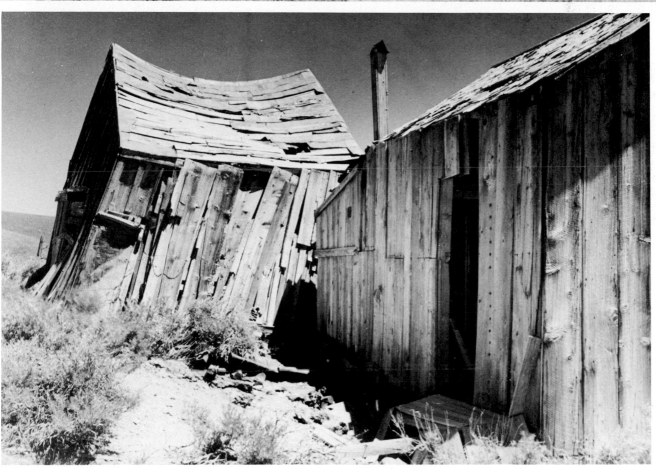

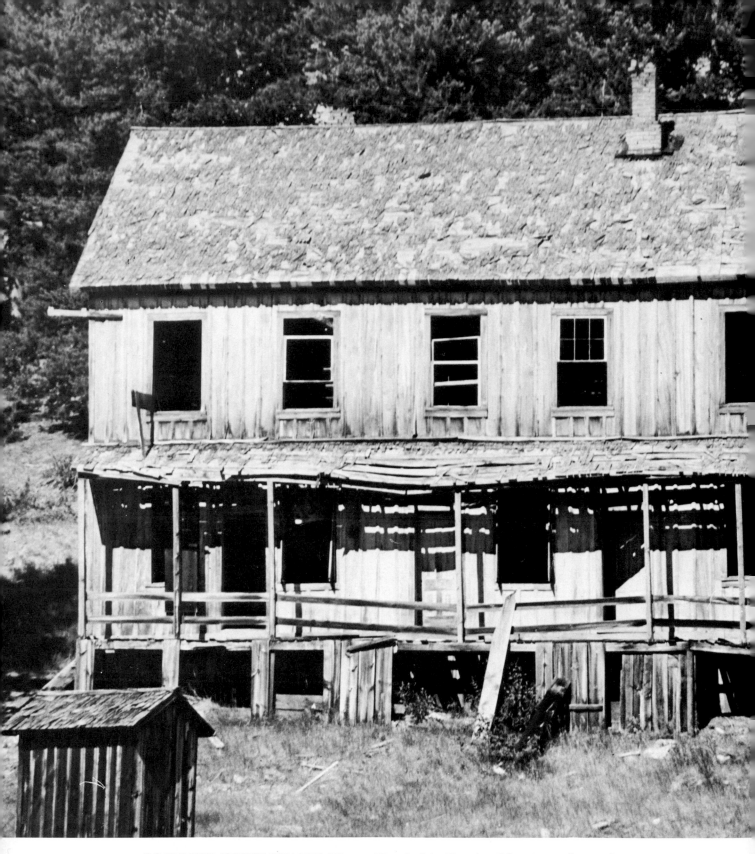

BOARDING HOUSE REACH? *Wrong. Hospital in Granite, Montana, where mine accidents were common, could find no room behind building so placed outhouse in plain view, perhaps rationalizing – "It's what's up front that counts." Bi-metallic mine at Granite yielded fortunes in gold and silver with rich deposits of sapphires nearby.*

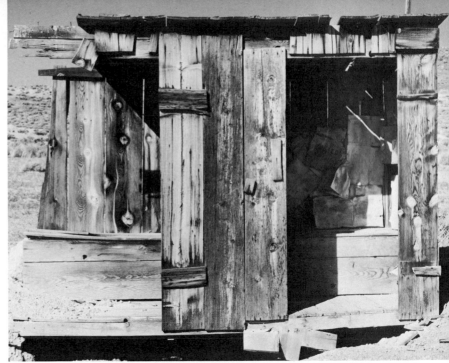

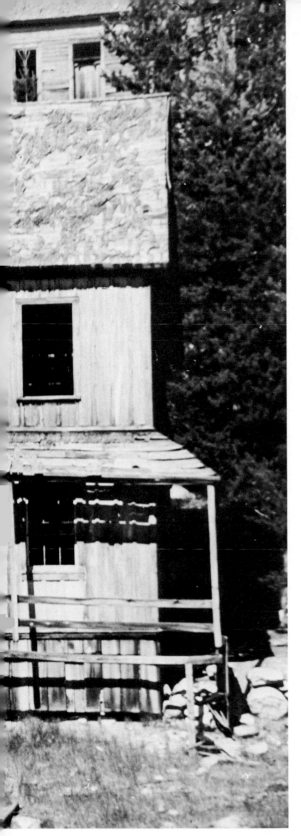

NEVER WASTE A GOOD HOLE. *Hotel owner in Broken Hills, Nevada, covered one with this handsome duplex. 100-foot deep pit would have lasted nigh onto Kingdom Come. Be careful, though. Don't dislodge timbers. Now completely without human life, Broken Hills once roared. Test holes were dug everywhere. This one, sunk in backyard of now vanished hotel, proved barren of precious metals.*

SAD DEMISE. *On last leg of tragic journey of famous "Lost Wagon Train" members camped at cool spring near crest of Tygh Ridge in Oregon, proceeding next morning to destination, The Dalles. Years later when Joseph Sherar built crude road down canyon to his bridge over Deschutes river, way station was established at spring. Buildings still stand precariously, outhouse recently collapsing.*

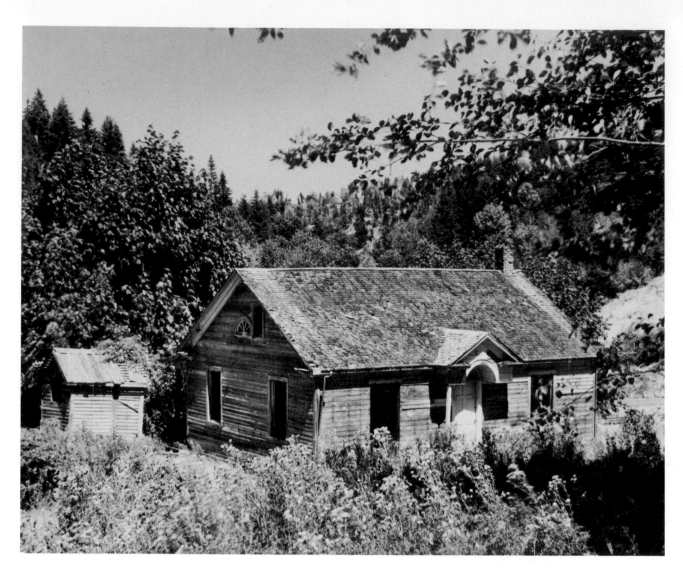

LEFT OVER FROM "BIG WOODS" is this comparatively "fancy" residence for official of McCormick Lumber Co. in McCormick, early day lumber town in western Washington. Even privy was more elaborate than most. Comparatively good state of preservation is due to rather recent date of abandonment by original owners and later use as sanitarium.

The Passing of the Old Backhouse

When memory keeps me company and moves to smiles or tears,
A weather-beaten object looms throughout the mist of years,
Behind the house and barn it stood, a half a mile or more—
And hurrying feet a path had made straight for its swinging door.

Its architecture was a type of simple classic art,
But in the tragedy of life it played a leading part,
And oft' the passing traveler drove slow and heaved a sigh,
To see the modest hired girl slip out with glances shy.

We had our posey garden that the women loved so well.
I loved it too, but better still, I loved the stronger smell,
That filled the evening breezes so full of homely cheer,
And told the night-o'er taken tramp that human life was near.

On lazy August afternoons it made a little bower,
Delightful, where my grandsire sat and whiled away an hour,
For there the summer mornings its very cares entwined,
And berry bushes reddened in the steaming soil behind.

All day fat spiders spun their webs to catch the buzzing flies
That flitted to and from the house where ma was baking pies,
And once a swarm of hornets bold had built a palace there,
And stung my unsuspecting aunt — I must not tell you where.

Then father took a flaming pole — that was a happy day,
He nearly burned the building down, but the hornets left to stay.
When summer bloom began to fade and winter to carouse,
We banked the little building with a heap of hemlock boughs.

And when the crust was on the snow and the sullen skies were gray,
In sooth the building was no place where one should wish to stay,
We did our duties promptly, there one purpose swayed our mind,
We tarried not nor lingered long on what was left behind.

The torture of that icy seat would make a Spartan sob,
For needs must scrape the gooseflesh with a lacerating cob,
That from a frost-encrusted nail was suspended by a string—
My father was a frugal man and wasted not a thing.

When grandpa had to 'go out back' and make his morning call,
We'd bundle up the dear old man with a muffler and a shawl,
I knew the hole on which he sat — 'twas padded all around,
And once I dared to sit there — 'twas all too wide I found.

My loins were all too little, and I jack-knifed there to stay.
They had to come and pry me out or I'd have passed away.
Then father said ambition was a thing that boys should shun,
And I must use the children's hole till childhood days are done.

And still I marvel at the craft that cut those holes so true;
The baby hole and the slender hole that fitted Sister Sue,
The dear old country landmark; I've tramped around a bit,
And in the lap of luxury my lot has been to sit.

But ere I die I'll eat the fruit of trees I've robbed of yore,
Then see the shanty where my name is carved upon the door,
I ween the old familiar smell will soothe my jaded soul,
I'm now a man, but none the less, I'll try the children's hole.

—Generally attributed to James Whitcomb Riley
courtesy Indianapolis Public Library

The Jessie Bingham Selection

Jessie Bingham says, "Outhouses are in because they're out, if that makes any sense. There are not very many in actual use but they're so close to the recent past which is now in current interest. And you see them out there in the lonely reaches of the Western mountains and deserts, so eloquently expressing the simple, rugged life of the '70s and '80s . . . like homeless pooches on their hind legs, pawing at you, begging to belong, to come into your life."

There's Jessie Bingham for you. Out of Texas into Colorado . . . out of education into teaching and social work . . . out of the city into the mountains and all kinds of places—a veritable dynamo of energy with a wide range of activities. A selection of her outhouse photographs follows this sketch of her life.

"I was born in Hopkins County, Texas, and grew up there. My first jobs were in teaching but in 1944 went into social work which I followed as a profession until my retirement in 1972. I obtained my B.A. degree at East Texas State University in 1932, my Master of Social Work in 1953 from the Graduate School of Social Work, University of Denver, after leaving Texas for Colorado in 1945. I retired from Denver Public Public Schools as a School Social Worker following nineteen years in that system. I appeared in the Fifth Edition of *Who's Who of American Women*, 1968-69.

"An avid photographer since 1952, I have acquired an extensive collection of 35mm color slides, 8mm and Super 8 movies, and a large number of B&W photos covering most of our national parks and monuments west of the Mississippi and most of Colorado, the Rockies and Texas. I do slide shows and other types of programs, with and without compensation. Am a charter member of the Ghost Town Club of Colorado, Ghost Town Mavericks and Mile High Jeep Club of Denver, and still active in the Ghost Town Club, Denver Posse of the Westerners and Rocky Mountain Railroad Club. I am a life member of Denver Coin Club and belong to the National Wildlife Federation.

"My interest in outhouse lore probably began when as a teenager I built from the materials at hand on our farm, a two-holer which served our family for some years. As a subject for photography and program talks, outhouses began to grow tall as I covered many miles through Colorado's beautiful mountains on fishing and camping trips, then found the subject enlivened the Ghost Town Club meetings and were of keen interest to others. In all their varieties and locations, my collection of photos and material continues to grow. I am an intrepid collector of all kinds of things, have a large assortment of antiques and Americana such as violins, or fiddles, with a collection of twenty-five to thirty. I belong to the Texas Old Time Fiddlers Association and attend various contests 'fiddlins'. My record and tape collection covers all kinds of music and recorded material, and I have a good variety of Indian kachinas, pottery, jewelry, etc. As 'retirement' time allows, I indulge in a little politics, take care of home and yard, and try to be a good neighbor in a nice group of people who are my good neighbors."

O FRABJOUS DAY – calloo, callay! How dear to the heart are scenes long remembered . . . those crack-o'-dawn mornings in the mountains . . . clear, cold air filling the lungs, lifting the spirits, cleansing the soul! Come on, be reasonable, poet. Consider the weary body, heavy with sleep, eyes half open as it gropes its way through wet grass to the little weathered shack out back . . . to begin another day down the mine shaft or sweeping the grasshoppers down between the floor boards so you could start baking sixteen loaves of bread for the week.

Appealing in its lonesomeness, this Place of the White Door in Tincup, Colorado, was still being used when Jessie Bingham photographed it in 1953 . . . where the first pioneer built his cabin in 1859. Now the summer people bring life to old ghost town, perhaps eyeing white door with something like a dreamy wish that life could be simple once again . . . and on cool, clear mornings they could fill their lungs with the bracing air . . .

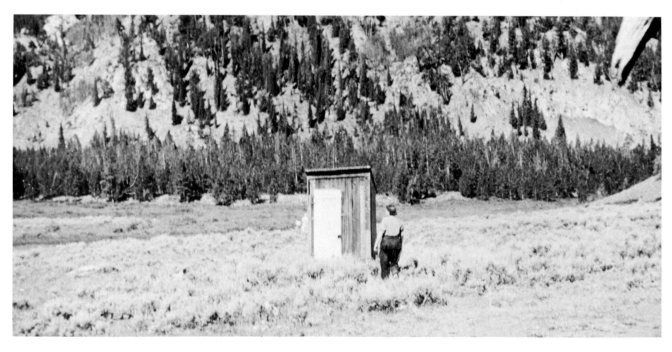

STRICTLY A FAMILY AFFAIR *was this barn-house-privy (above and right), multiple-roofed conglomerate that overlooked a mine but not private comfort in bad weather. A German family lived here, father and sons working in mill and mine, mother and girls making sauerkraut and Wiener Schnitzel in the big kitchen. The living rooms were set next to barn, with its horses and cows, then a narrow hallway led to outhouse, which actually was "in," with its stovepipe ventilator.*

And when you look inside the privy, where is all that Teutonic neatness you hear about? It was there all right, wallpaper and all, split-level seating arrangement for all ages. And behind the door, not shown in photo, stood a 5-gallon oak keg with galvanized pipe drain attached to the bottom . . . exclusive feature for small boys.

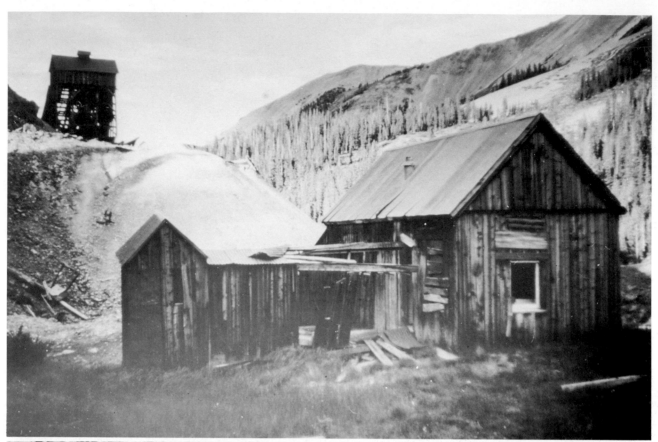

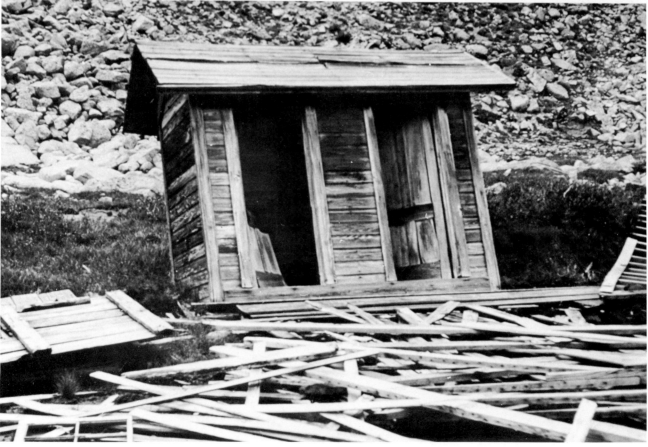

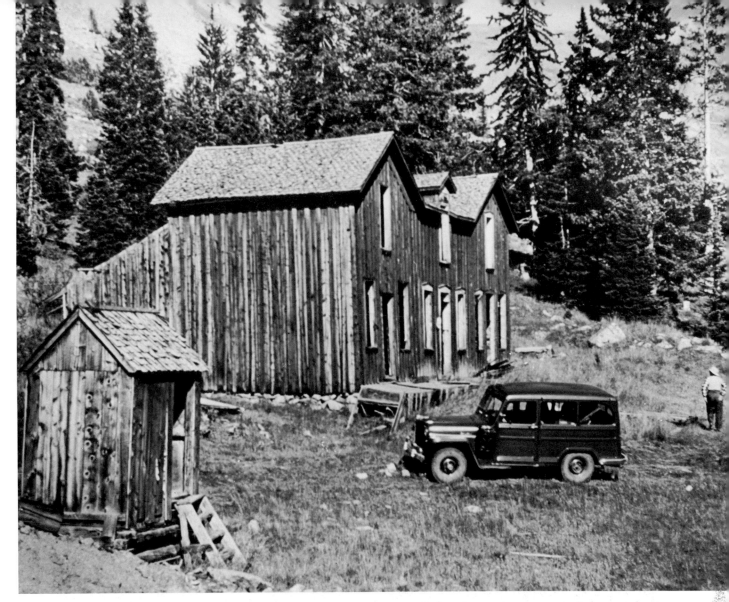

EVEN THE GHOSTS around Red Mountain must go elsewhere for relief. For years residents of this mining camp home could use the covered walkway to the outhouse. Now mine near top of Red Mountain Pass in the San Juans of Colorado is closed down, the shaft house stands guard over flattened remains of human habitation (opposite top).

THE RAILROAD WAS NARROW GAUGE but the seating arrangements were fully standard . . . in both passenger cars and this "Men" and "Women" convenience (opposite bottom). It stood behind depot in little community at west end of Alpine Tunnel through which steamed ore and work trains of Denver, South Park and Pacific Railroad. They stopped running in 1910 but the double two-holer was still standing intact amid wreckage of the station when Jessie Bingham photographed it in 1958.

PRIDE OF PERU CREEK GULCH. Backhouse? No way. This (above) was a front house. As you came bumping down road on your way to Colorado's Argentine Pass you got to Peru Creek in area of mining camp of Chihuahua, above Montezuma, and the first thing you saw was the "travelers rest" station, then boarding house. And what else did you see? Of course . . . the 3-foot elevation to outwit the winter snow, and summer's stepladder. Inside you saw it was a multi-holer, boarding house style.

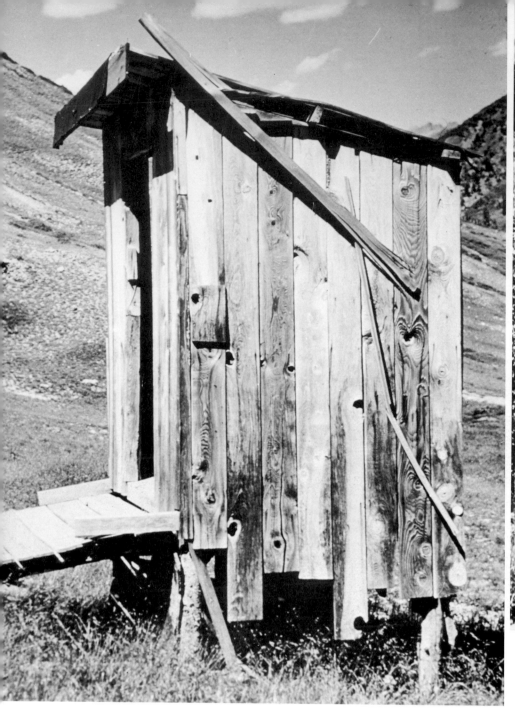
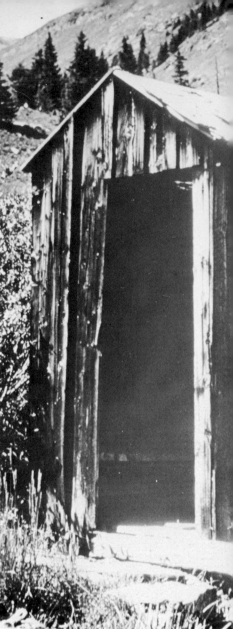

EARLY ROADSIDE REST? What else . . . since there were no other signs of habitation in the area. As photographed in 1963, little dooley (above) sits in all its loneliness on a snake-track jeep road between Elko Park and Pittsburg in Elk Mountains of Gunnison County, Colorado. Surely the pine board one-holer, complete with ramp, was slapped together for the convenience of . . . wandering minstrels? . . . roving reporters? . . . more probably for footloose prospectors and miners.

BRACED AGAINST WINTER this distinctive little number (above right) is still in use when water in house pipes freezes. It has withstood snows of Russell Gulch, Colorado, for many a year, aided in later ones by stout pole. Unaccountable is hen's nest on windward side – not seen here. Also not seen here but caught by keen eye of photographer Jessie Bingham are square nails that hold structure firm.

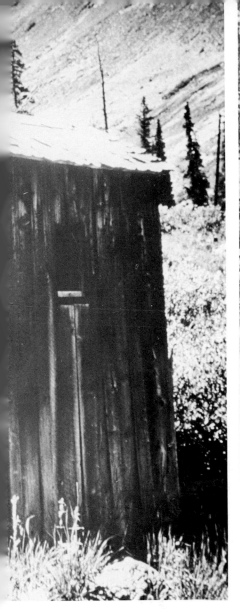
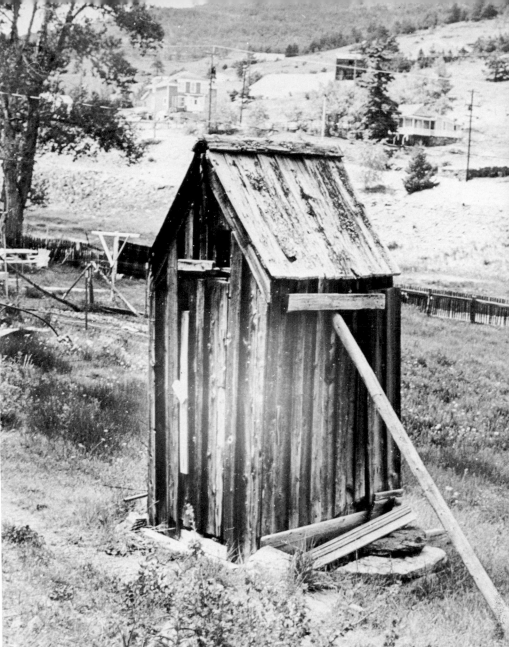

PRIDE OF THE PINEY MOUNTAINS. If anyone can prove this backyard jewel (above center) – Bingham photograph of 1961 – was once used by family of Evelyn Walsh McLean . . . who owned the Hope Diamond and authored the book Father Struck It Rich *. . . let that person step forward and be heard.*

The setting is ghost town of Animas Forks in Colorado's San Juan Mountains where, in 1961, one of few remaining relics was most imposing house close to smaller one. Sketchy legend suggests owner was Walsh family but pointing finger wavers as vicious wind and weather of San Juans leveled evidence. One fact – Animas Forks was high-kicking camp and Walshes or not, this outhouse was vital part of it.

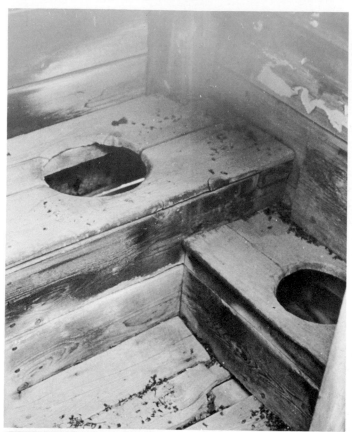

QUESTION BEFORE the (out) house . . .
Why, queries Jessie Bingham, who recorded
these photographs in Russell Gulch, Colo-
rado, in 1971 . . . why are outhouses so often
the only structures standing in Colorado
ghost towns? She has found it to be true as
she prowls the old abandoned sites.

This two-hole relic near the Federal mine
was sturdily built, is still in fair condition
as it leans wearily against the aspens. Inside
we see standard and lower level seat for
children. Now there's something you won't
find in today's bathrooms.

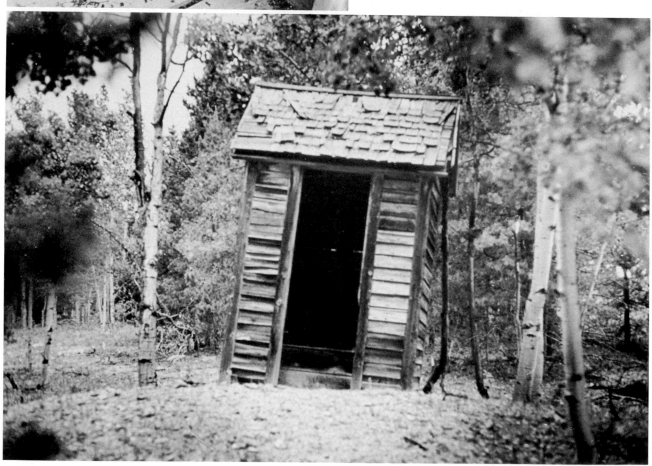

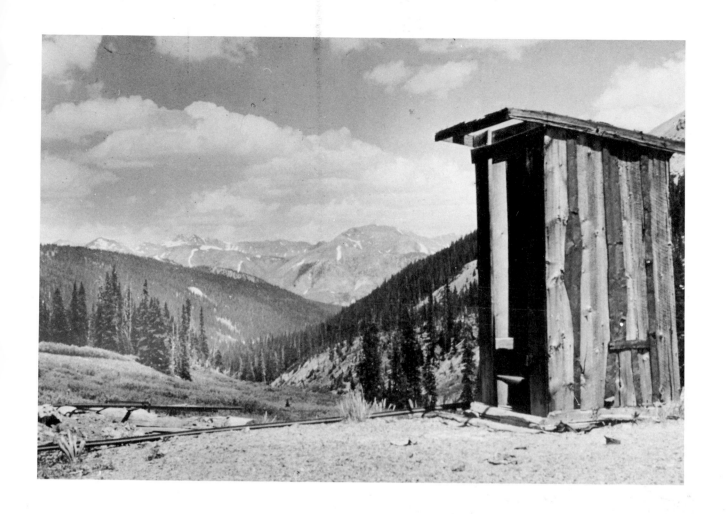

SILENT SENTINEL OF THE HIGH COUN-
TRY. *Standing solid and erect as though
placed there as a monument to memory, is
this stalwart one-holer on a Colorado mine
dump. The scene is the high reaches of
Eire Basin in Taylor Park area, altitude
almost 12,000 feet, the outhouse adjacent to
a sod-roofed log cabin.*

*But pause, stranger, and swing open the
stout door. Look at the thick slab seat, con-
veniently-shaped opening, covered by piece
sawed out of slab to form hole. Sic transit
gloria mundi.*

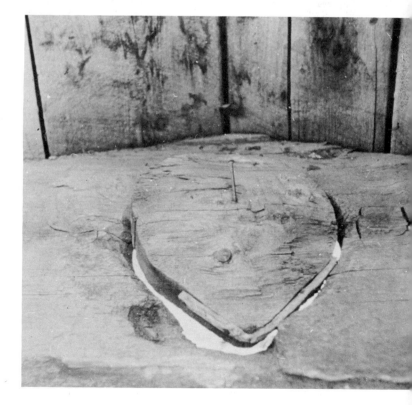

WHO SAYS *the outhouse is a thing of the past? Nonsense. This gleaming white beauty isn't a day over five years old and it was obviously built with as much loving care as a doll's house for a favorite granddaughter. It was discovered in Russell Gulch, Colorado, and photographed by Jessie Bingham in 1971 . . . but when she tried to step inside she got a no-no. The door was securely locked. And why not? Who was she but a nosey camera bug attempting to trespass on private property . . . which had paneled walls and carpeted floor.*

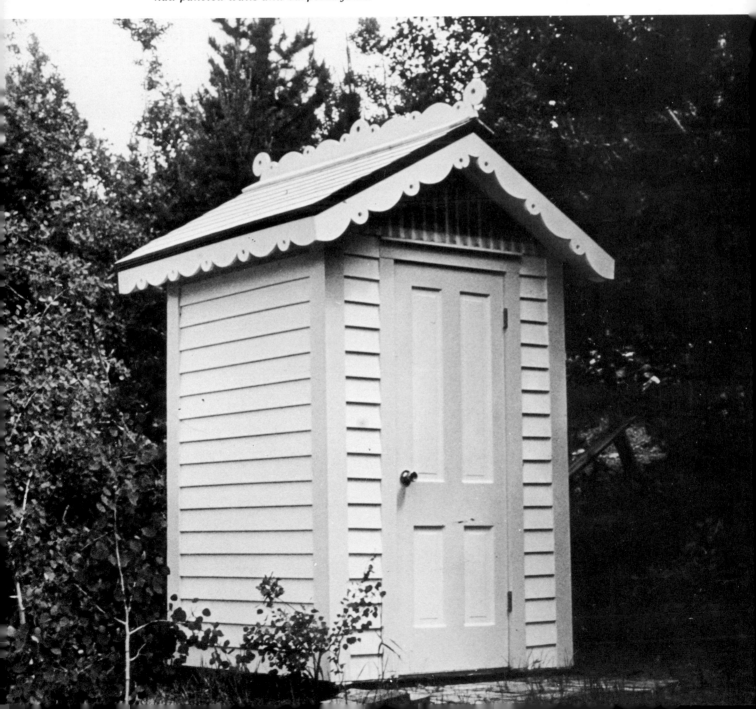

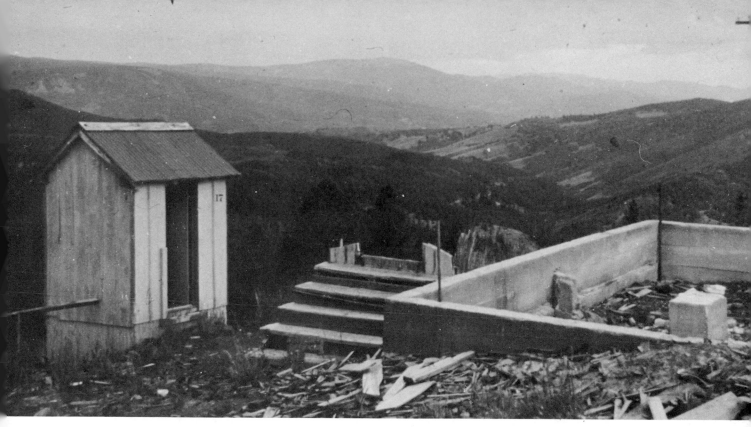

"PASSENGERS WILL PLEASE *refrain from using toilets on the train while standing in the station in full view*" . . . *Engines of narrow-gauge Rio Grande Western, after grinding, grunting up heavy grade to top of Marshall Pass between Salida and Gunnison, Colorado, paused in clear mountain air at 10,846 feet and trainmen opened vestibule doors to let passengers use facilities behind the depot. There were two, modest frame buildings marked 17 for official purposes with drain pipe to ravine below and ventilated brick job with 6" to 8" walls, for private use of depot agent and family. When Jessie Bingham made these photographs in 1960, depot was gone, only rear steps remaining to guide ghosts of high country from wind-swept wilds to earthly shelter of No. 17.*

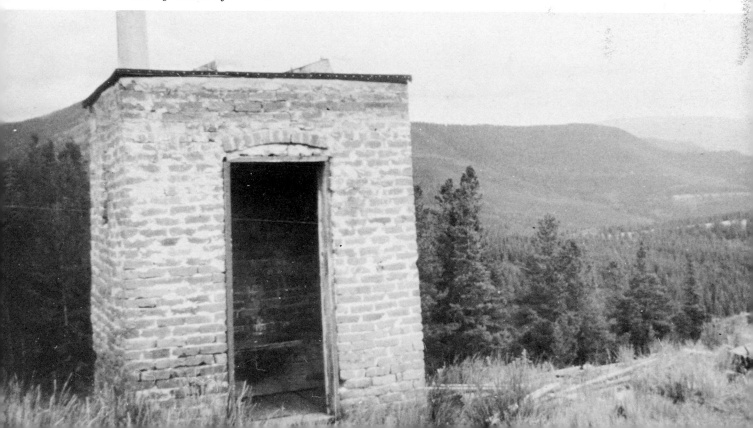

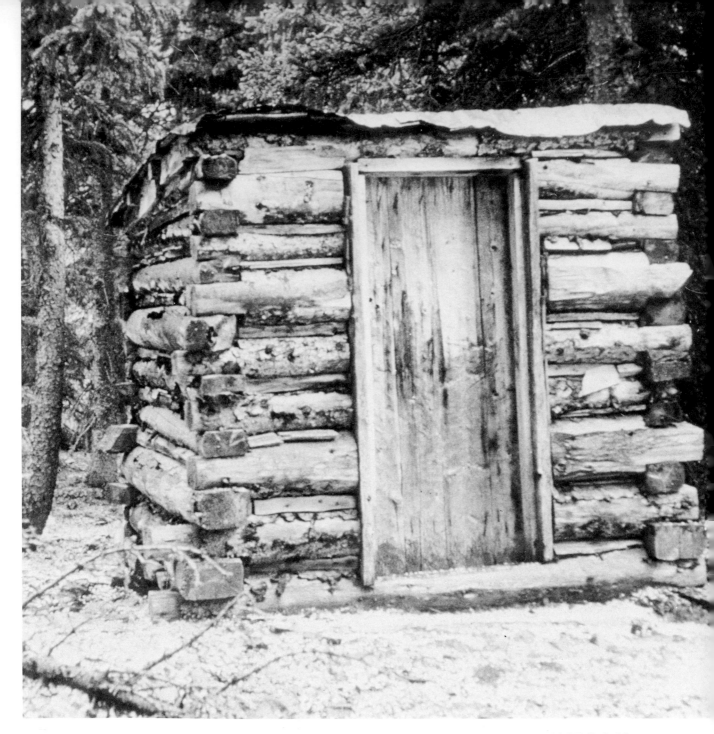

POWDER HOUSE? Hunter's cache? More to the point . . . a shelter in a hail storm? Right. It was to Jessie Bingham who photographed all-but-impregnable log outhouse (above) in 1960 and sought refuge in it until storm passed over. Building could well be standing and usable today although built in the 1880s at the site of Silver Jack mine high in Cimarron River country of Colorado's San Juan Mountains.

"TAKE A NUMBER PLEASE." Seldom, if ever, do outhouses have covered porch areas but this big four-holer did (opposite top). 1962 view here shows sheltered waiting area presumably for patrons who wouldn't, or couldn't, go away.

The building stood on the workings of the Enterprise mine, high above Taylor Park, on west side of Collegiate Range, Gunnison County, Colorado.

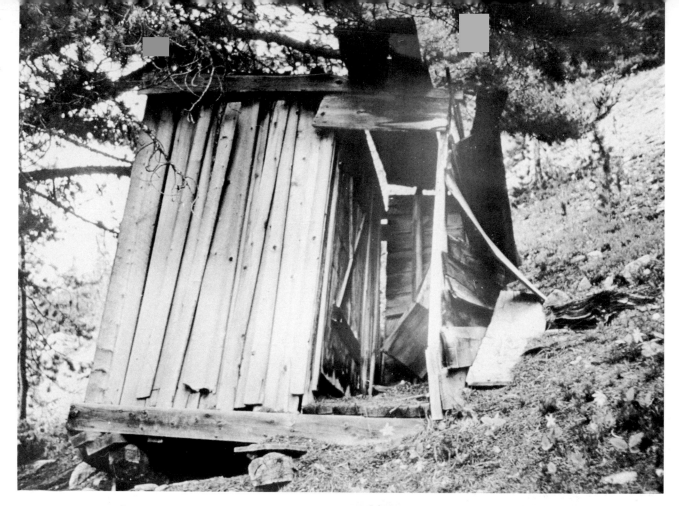

DO WE GET A MESSAGE HERE? The gabled two-holer (right) which Jessie Bingham recorded with her camera in 1964 at the site of the long-vanished community of Guston on Red Mountain Pass in Colorado's San Juans . . . could well be telling ghost town visitors, "There's nothing like having an entrance on both sides for emergency situations" . . . or as others think, "Somebody had to get out of here in an all-fired hurry!" The privy was near station of dead-end narrow gauge railroad that came over pass from Silverton.

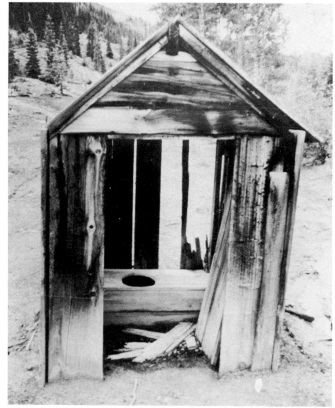

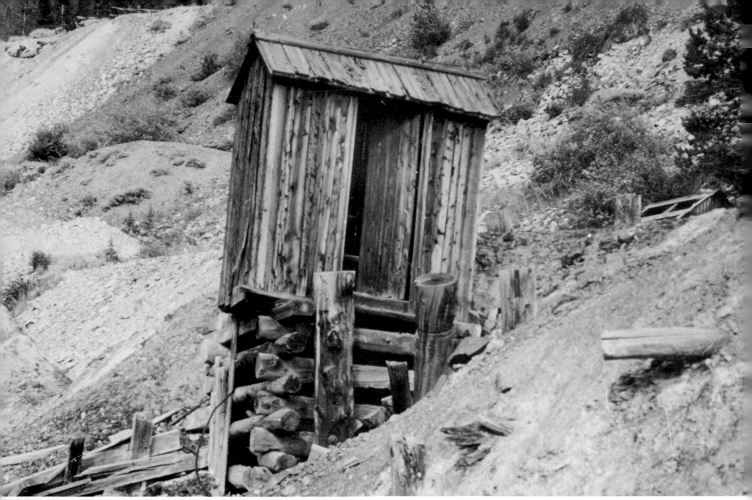

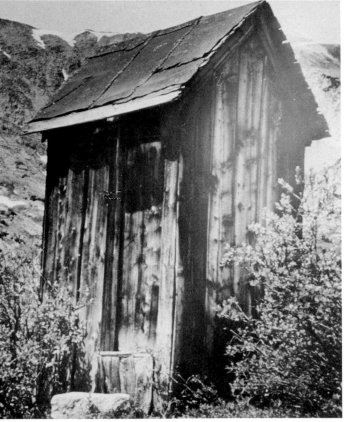

"NOT A LEVEL SPOT in all Christendom!" you can hear builder of this cribbed-up classic (above) cuss at California Gulch out of Leadville, Colorado. Every mountain side is pock-marked with prospect holes, tunnels, mine dumps. This relic, erected by a mining and smelting company, the Resurrection, is one of few wooden landmarks (1964) left in once high-rolling Rockies.

Not far up gulch is site of store operated by H. A. W. Tabor who grew rich and powerful in Colorado's industrial and political days . . . whose widow, Baby Doe, acquired her fame defending her worthless property against law and sanity with shotgun and pungent profanity.

A HOUSE FOR ALL SEASONS including many a windy winter, is this snow-top aerie (left) one of several around Star mine on Italian Mountain overlooking spectacular Taylor Park in Gunnison County, Colorado. Although built in 1870s or 1880s it is still serviceable and mighty welcome in that enchanted but starkly deserted area.

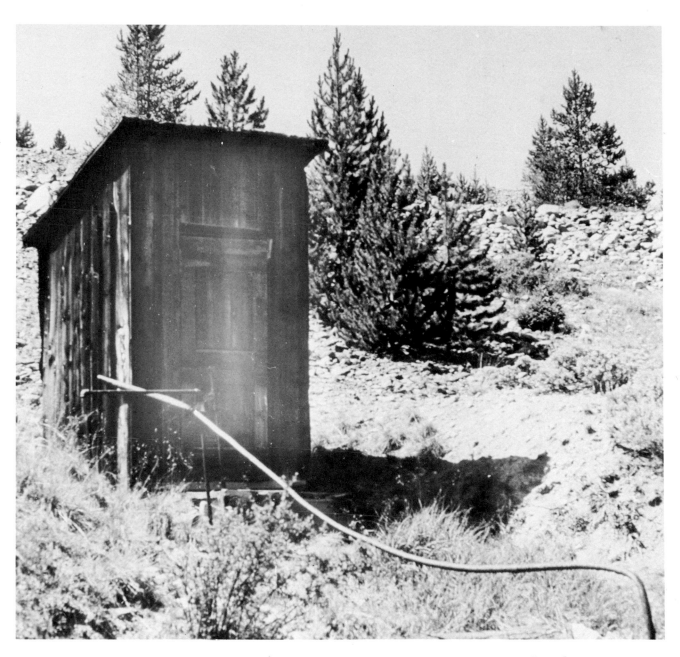

RUNNING WATER? LOOK AGAIN. A fellow needed help to get up the hill to this house of hospitality or guide him upwards in the dark. Thus handrail, contrived of water pipe. Jessie Bingham photographed way station in 1968, one of several in much-worked mining area west of Leadville, Colorado.

This Stamp Needs Help

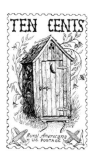

An appealing symbol of rural and pioneer America, it raises the outhouse to a romantic high level. Yet it is a casualty of the bureaucratic wars and lies in quiet desperation, licking its wounds, gathering what strength it can. Don't you like it? Everybody does but the United States Post Office.

The stamp is the creation of Esley C. Weatherall of Portland, Oregon, and these pages present the story of his struggle to have it accepted. His letter to Postmaster Blount is substantially reprinted here.

In a front page article, *The Wall Street Journal* of November 30, 1972, reported the story and said in part: "But Mr. Weatherall isn't getting anywhere. His obstacle is the citizens stamp advisory committee of the U.S. Postal Service. Its 11 members, most of them avid stamp collectors, recommend the 15-or-so commemorative and special stamps issued each year. And they just won't honor the privy.

'The privy isn't newsworthy,' says Connecticut artist Stevan Dohanos, the stamp panel's chairman. Asserts another member, 'We've got more serious ideas to consider.' "

And that is still the situation after two years. The "privy stamp" is just another light that failed. Or is it? Bloody but unbowed, Mr. Weatherall gazes reverently at his stamp and patented outhouse mailbox (overleaf) and hopes public opinion will rally behind his efforts.

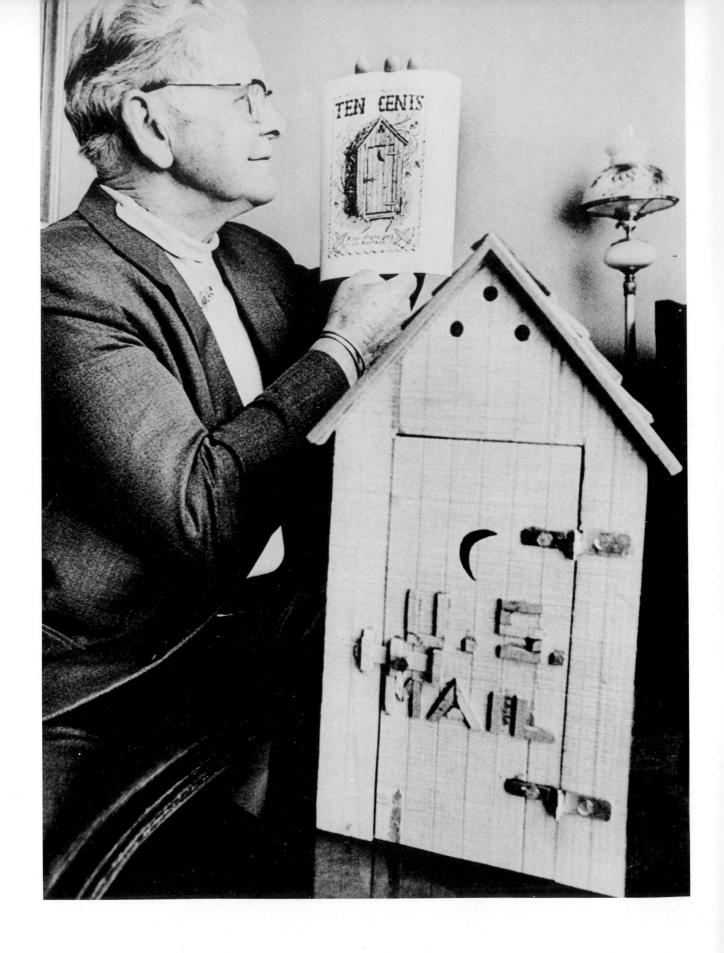

February 15, 1971

The Honorable Winton Blount
The Postmaster General
Washington, D.C. 20260

Dear Mr. Postmaster General:

May I ask, do you believe in:

1. Keeping America beautiful?
2. Keeping our National and International image good?
3. Keeping Progress and Ingenuity ever active?
4. Keeping Conservation in check?
5. Keeping Honesty in merchandising?

Now, before concluding on the above topics, it is only fair to warn you that I am building a case.

Just returned from a visit to my old homestead and birthplace in Arkansas, and what nostalgia! Sure was good to waft the fragrance of the old weather-bleached privy of home.

There she stood, gracefully aging with the years, sagging, but giving the impression of pride to have served well, and belonged to another era.

There in her door was the crescent moon, the wooden latch lock, controlled from the inside, to insure up-per-most privacy.

The cinder path that lead to this sanctum was grown over, and had lost its function. In its heyday the cinders would give off a crunching sound, like walking on spilled sugar at the General Store. This of course would warn the occupant to check the latch door lock for security.

Inside were two wooden boxes and a wooden peg in the wall. The corn cob of this era had two uses: One for making corn cob pipes; and reflecting back to my boyhood, remembering the corn cob pipes on display at the General Store, am not so sure that some of those pipes were not made from reclaimed cobs. The other use was always replaced when company came, and hung from the wooden peg was last year's Montgomery Ward catalogue.

The catalogue had a dual purpose as it also served as good reading material while sitting there wiling away the time.

During the catalogue's absence, your spare time was best spent taking inventory of the cobs—in that the ratio of the reds to the whites were kept around two to one.

Esley C. Weatherall poses (opposite) with artist's conception of stamp he submitted to Post Office to commemorate passing of the privy. Shown also is his patented wooden privy mailbox. Weatherall's letter to Postmaster General appears in full above.

91

The old saying "rough as a cob" is a misnomer. The cob's velvet smoothness is like stroking the fur of a moleskin purse. I mention this to clear up such injustice and to give the cob its just dignity.

Now as to the artistically carved crescent opening in the Old Lady's door, it too had multiple purpose: Was an air conditioner, it emitted light, gave resonance and tonal quality to sounds emitted from the inside, like the "F" holes on a violin, it assisted in hearing foot steps coming down the cinder path, in that all symphonic outbursts were controlled and reserved for the occupant's pleasure only. To share these melodious sounds with one of the outside, would be the greatest of all social faux pas. . . .

I am not so sure that man in the privacy of his privy did not gaze through the crescent opening into the moonlight and in deep meditation dream that some day man would go to the moon. The second part of this statement I am sure of: Man did some of his best thinking in the privacy of his environment.

This was a part of rural America as I knew it at the turn of the century. Quite an image would you not say?

I think there should be a beautiful engraved postage stamp issued, commemorating the passing of the privy, depicting the privy with crossed corn cobs in each corner. This would be artistry with a purpose.

Now for conservation: A few years ago while traveling in Mexico City, had occasion to use a public facility, was greeted by an attendant who handed me two sheets of toilet paper. Guarding against not destroying the image of a good North American citizen I nodded approval. Now with a two sheet handicap it took some doing, your aim and accuracy had to be on target, or you were in big trouble: This could make a conservative out of a most liberal, liberal and that's carrying conservation too far. . . .

I have learned that by careful diplomatic maneuvering I can procure engraved stamps without doing verbal battle.

Please do not treat lightly what I have said. The way I have said it is another story. In summation: I am trying to look through your eyes too and hope you are extending me the same courtesy.

I beg of you to give consideration to modifying those machines to eject engraved stamps, this will be a great contribution in keeping America beautiful, contribute to our National and International image, make for progress and ingenuity, which is good conservation, and eliminate all questions of honest merchandising.

I am also serious about the suggested commemorative stamp.

I rest my case.

Sincerely,

Esley C. Weatherall
2934 N. E. 49th Avenue
Portland, Oregon 97213

cc: Senator Fullbright, Arkansas
 Walter Cronkite, C.B.S.
 American Philatelic Society

Told by the Pioneers

from W. P. A. Sponsored Project no. 5841

STATE OF WASHINGTON

HARRY ROBERTS, Whitman County

I was five years old when my parents came to Colfax, in 1878. My father took up land 8 miles from Colfax. There were no fences, only two houses on the road from Colfax to Farmington. The hills were covered with bunch grass where bands of horses and cattle fed. Tom Kennedy had about the first cattle. Hogs were brought into the country early. They were herded to keep them from roaming too far.

Houses were built of boards, double-boxed, and battened. Cracks were calked on the inside, narrow strips of cloth were pasted over this, then the walls were papered with the Pacific Christian Advocate and Portland Oregonian. One of these houses stands near Colfax, put up in 1878. Before building our house, we lived in the old Perkins house. Mr. and Mrs. Perkins were the first couple to be married in Colfax.

Most of our furniture was homemade. We raised some vegetables, but lived mostly on a meat diet, as meat was plentiful. People went as far as Walla Walla for fruit. Most of the wild fruit in this region was service berries or wild gooseberries, which we canned. Prairie chickens were so numerous my father killed four at a time. We ate only the breasts. Some people killed them only for their feathers.

Candles were used in many homes, however, we had brought kerosene lamps with us from Oregon. As for clothing, the object was to keep warm. We wore red-flannel underwear, and liked it. We were still living in a tent when word came that the Indians were on the warpath. Father didn't allow the excitement to interfere with business.

Detailed accounts of several old camps, railroad stops, early settlements pictured in this section can be found in the author's Ghost Town series of books – Western Ghost Towns, Ghost Town Trails, Ghost Town Shadows, Ghost Town Album, Boot Hill.

AT TIME OF AUTHOR'S VISIT to Gleeson, Arizona, near Tombstone, sole residents were elderly Mexican gentleman and his grandson who were using this old but serviceable system as only water supply. Although copper, gold and other metals were mined near Gleeson, most romantic association is with deposits of turquoise, once mined by Indians, then in limited way by whites.

CORA CLARK, Walla Walla County

I was born in 1863. My father crossed the plains in 1852 and settled in the Willamette Valley. He served in the Rogue River war in 1855-56. Mother crossed the plains in 1859, coming straight to Walla Walla. Father brought his cattle up from Oregon and located on the Walla Walla River two and one-half miles from Touchet in 1859. He was attracted by the fine pasture land and the stream. Our nearest store was at Wallula. Father's timber claim was where the penitentiary now stands. My father was a government surveyor and my husband was the city engineer and engineer for the O. W. R. & N. railroad.

Walla Walla River was a much larger stream when we played along its banks in the 1860's and 1870's. We had a row boat. Our only playmates were two quarter-breed children. Their father was a white man. I was eight years old before I ever saw a white woman excepting my mother. Father's surveying duties kept him away quite a bit of the time, and mother and us children never had a way of traveling, and there were Indians prowling around.

We had a one-room log house with lean-to and a loft, reached by a ladder, where the boys slept. We cooked in the fireplace. Mother made the most delicious scones, dropping the dough in a frying pan which she placed in front of the fire. We hung our kettles on a crane.

One of the best meals my mother ever cooked, we had to run away from. It was in the year 1878. Our first new potatoes and peas made part of that dinner which I shall never forget. Father had brought down two wild ducks that morning and mother dressed them; then made a currant pie. Just as everything was on the table, a man dashed up on his horse, shouting, "Three hundred Indians on the warpath!"

Mother snatched a few trinkets and valuable papers and she and us children joined the procession of settlers on their way to the fort. Father refused to leave his place, but hid the most treasured possessions in the old dugout which had been his first home. It was overgrown with grass and vines, so he felt it to be a safe hiding place. We met the soldiers, but no one turned back. There was no battle, and in a day or so we returned home.

We were near the old camping ground of the Indians. In the fall they came for chokecherries and black and red haws. They dried this fruit and from the farmers they bought or begged pumpkins, and stewed them and dried the pulp.

Frenchtown was not far away, where many of the French Canadians who were with the Hudson's Bay Company, had settled with their Indian wives.

The cattle trail went past our farm and the cowboys always bedded down on some vacant land near us, so they could be near water. They would come to the house and get milk and other provisions. One of the most wonderful sights of my childhood was 10,000 head of cattle being driven to Cheyenne.

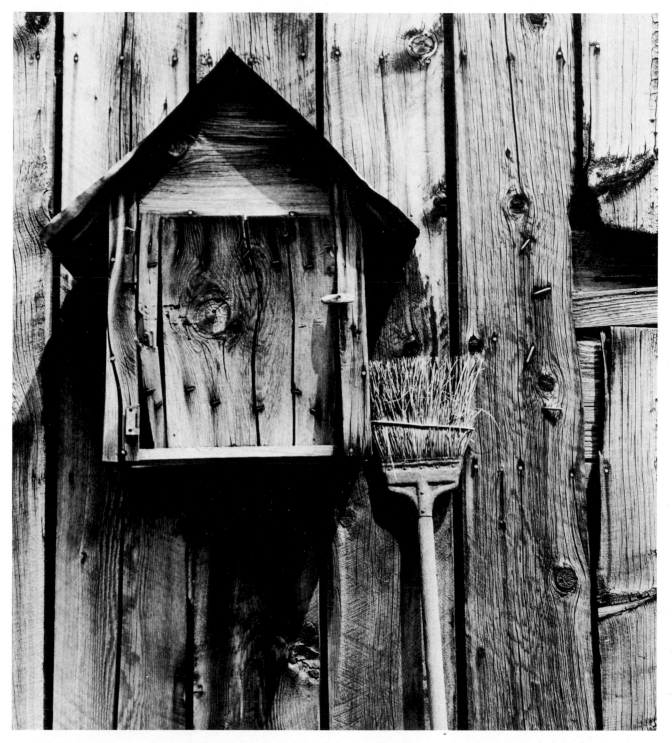

"HOME COMFORT" COAL RANGE (opposite) could be fired up now, coffee pot ready for Arbuckle's Best, in kitchen of old stage station at Stanton, Arizona.

CABINET ON SHED (above) at Gimlet, Idaho, train stop may have housed telephone. Other guesses? Hinges and door snubber still remain.

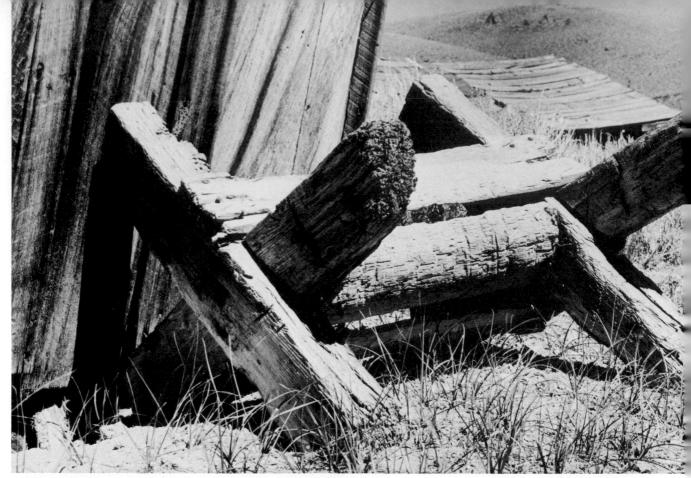

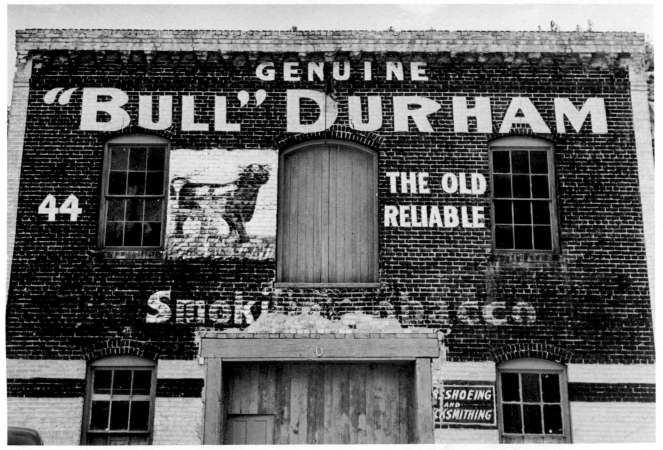

JAMES H. PURDIN, Yakima County

A terrific thunder storm was breaking just as we reached the Platte River. Heavy rains had already swollen the river, so the crossing was delayed while the men removed the wagon beds and caulked them. They lashed them together, end to end, and floated them across, carrying families and goods, the oxen swimming.

By this time we found that our provisions would not hold out, so a trade was struck with a man returning east. He was driving a team of horses and was willing to pay "boot" for the Purdin ox-team. With this money enough food was purchased to enable us to reach Boise.

Reaching Boise in November with less than a dollar in my pocket, I turned our horses out to seek their living on the range. Boise was a mining town. Bacon was $1.00 per pound, flour $4.00 a sack, coffee $1.00 per pound, and everything else in proportion. I must have work, and I found it, mauling rails from bull-pine at 75 cents per day. The small wage could not keep pace with mounting expenses. My employer, a kind-hearted man, befriended us, providing for us through the winter and in the spring when our son, Hugh, was born.

In order to pay the debt incurred, it was agreed that we rent fifteen acres of land of our employer and raise vegetables to supply the demand of the miners. Fortune favored us from the very beginning of our venture. During the winter our thoughts often turned to the faithful team turned out to wander in the hills. One day in May

a band of wild horses passing through the village attracted my wife's attention. She immediately recognized the two horses we had driven all the way from the Platte. Following each was a lively colt. Calling me, we separated our team from the band.

Our garden grew and thrived. Miners' fare that summer included luxuries from our garden. By the first of October, enough gold dust had been weighed out in exchange for vegetables to enable us to settle up with our landlord and leave Boise with $1,500.00 of dust in a little buckskin pouch. In October, 1865, we set out for the land of our dreams. We reached the Willamette and homesteaded, but our plans for an orchard never materialized, as the rainy weather affected my health, undermined as it was by the hardships of war.

Relinquishing our homestead, we drove back up the Columbia River, crossed over and settled at Dixie, twelve miles from Walla Walla.

CAST IRON CAST OFF, rests and rusts outside cabin door in Goodsprings, Nevada. During glory days Goodsprings boomed with mines and mills. Long list of metals, some rare, were dug and processed – gold, silver, platinum and others. Surrounding desert is museum to nature lovers, rare tortoise found here in fair numbers, plants including desert catalpa blooming in spring.

THE BACKYARDS OF BODIE, California, were once cluttered with relics like this heavy sawhorse (opposite top) but thieves and vandals have long since burned or carried them away.

BLACK HAWK, COLORADO, was mining camp where "Baby Doe" Tabor first created small stir, went on to Creede to create bigger ones. This sign (opposite bottom) was painted on front wall of brick blacksmith shop built on flat near Gregory Creek.

ROSA ELLEN FLYNN, Clark County

The first houses I recall were little box houses made of lumber and battened. Most of them were unpainted.

We used boats, horses and ox teams for transportation, and after roads had been built we used horses and buggies.

Most of the people near us, at Mill Plain, cut wood for the steam boats as a means of earning their living. The wood would be stacked on the shore at Fisher's Landing (five miles up river from Vancouver) where it was unloaded from the boats.

VINTAGE HEATING STOVE, together with washboard and bird's nest in National, Nevada, tiny ghost camp just below Oregon border. Entirely deserted, retaining a few traces of turbulent days when National mine alone produced $8 million in gold. Boom days newspaper, National Miner, said in 1909, "Evidence of rich jewelry ore, makes National nothing less than a bonanza." Alas and alack, the bonanza came a cropper.

We didn't cut wood on our place, but really farmed. We raised wheat, oats, clover hay and potatoes after we cleared our land. We lived along La Camas Creek.

We had good neighbors. When we first arrived here, in 1877, we lived close together, for protection against bears and cougars. I remember once when I was picking blackberries. I had put my babies on a log to wait for me. Hearing a funny noise, I turned around and saw a bear at the end of the log. I was terribly frightened, but when he saw me he ran away.

RELICS OF GLEESON, ARIZONA (below) . . . old-fashioned ice box and galvanized wash tub near back door of cabin.

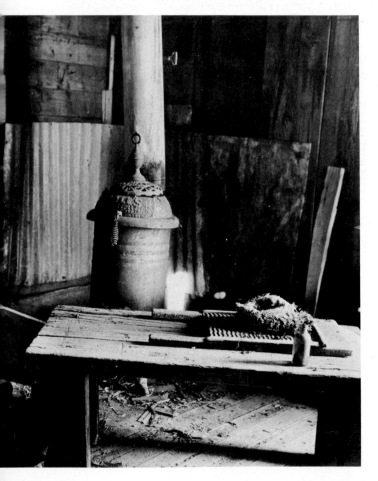

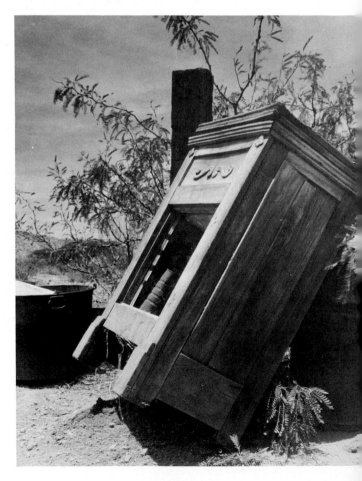

PA KETTLE could well have built this weird and wonderful water system in rear of old Keil house in Aurora, Oregon.

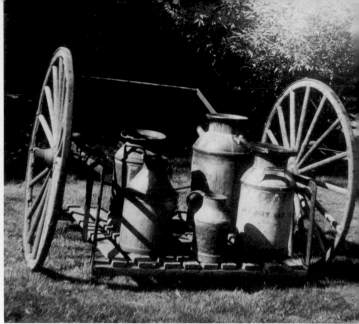

FOUND IN YARD of decaying homestead near Deschutes River, Oregon, once campsite on early wagon trail, was this weather-hardened girl's shoe (above). Animals shown with it are contemporary. Low slung milk cart (above right) originally used on farm of Mrs. Cecil Hockman, Moro, Oregon (photo courtesy Linfred Rickman, Portland); close up of milk can (below) in author's collection. Big blacksmith's bellows (opposite top left) in restored Mormon stage station at Genoa, Nevada; hobby horse (opposite top right) – in Holly Knoll Museum at Beaver Creek, Oregon.

OLD PUMP (below) stands on grounds of small country school in tiny town of Pedee, Oregon. Once thriving community was named by founder, Col. Cornelius Gilliam, who came to Oregon in 1844 and settled here. Although creek running by his home was a mere trickle he nostalgically named it Pedee after the larger stream back home in the Carolinas. Gilliam lived here only 4 years, was killed in 1848. (Photo Byron Larson)

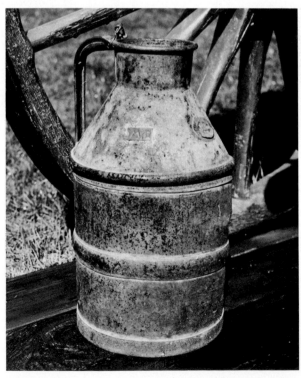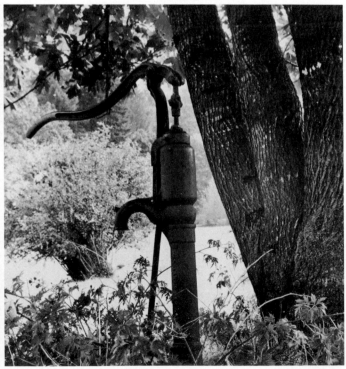

LOUIS F. IMAN, Skamania County

Father came here in 1852 by ox team. There were 37 wagons in their train. They had to get together because they were afraid of the Indians. Mother came West that same year, from De Kalb County, Missouri, but she did not meet father until after they both came to live in the Cascades. Mother was born in Tippicanoe County, Indiana. Her maiden name was Windsor.

When father's wagon train reached the Snake River, they dumped out a lot of their supplies and furnishings and used the wagon boxes for boats to float down the river. But you can't navigate a stream like that in wagon boxes and this they found out.

Father came to this country because there was more opportunity here for work and better pay. Back in Illinois he got paid $8.00 a month and he was a good carpenter and a mechanic, too. Here at the Cascades he could make that much in one day building boats and boathouses.

I remember a few log houses here as a boy, but most of them were box houses of lumber, upright, with battens over the cracks, and were 16 x 24 feet in size.

We got around in boats. All boys had to learn to row. Many a time I've rowed a boat across the river here for medical aid. My oldest sister was the first white woman born in Skamania County. Her name is Flora Addia (Inman) Nix. She was 80 years old on the 24th day of March, so she was born here in 1856.

Also, my brother was the first white boy born in Wasco County, Oregon. For food we had salmon, spuds and plenty of wild game.

When my father came here, there were fifty Indians to one white man. On March 26, 1856, was an Indian massacre. I guess the fight was really between two chiefs, Chief Chinault and Chief Banahah. Each wanted to be supreme here and control the white man. A half breed, a Kanaka Tetoh, son of the old chief Tetoh, married the chief's daughter after Banahah's death. A man named Jones told me this. Tetoh came to town to get a coffin for his father, the chief, who had died. He said he'd take two coffins. Jones said, "Why, is the old woman dead, too?" "No," replied Tetoh, "but she will be!" And sure enough, she did die.

Sure, I can talk Chinook, but I have to have an Indian tell me what I'm saying. An Indian can talk English if you have something he wants and won't give it to him, but if you want something from him, you have to talk Chinook.

101

MRS. AMANDA ERWIN,
Walla Walla County

We raised the first wheat in the Prescott country. We raised wheat and stock and my husband was a stock dealer there. My first stove was a "step-stove." There were three pairs of lids, arranged in steps. My mother's furniture, made in Oregon, was all homemade. I still have a chair made of Oregon maple, with rawhide seat. I also have a chair made by Rev. Spaulding and the first rocking chair brought to Prescott. Joshia Osborn, millwright at the Whitman mission, who escaped with his family during the massacre, was also a cabinet maker. He made a spinning wheel and loom for my mother. These are in the Whitman museum.

I have my mother's brass kettle they used to make apple butter in during the early days, also an immense iron kettle which my mother brought across the plains. It was used to make soap and dye and other pioneer essentials.

My husband's brother entered the country around what is now Prescott in his early days. In 1860 he set out the first orchard on the Touchet. On his timber claim he grew thirty acres of timber from seed and plants, including six acres of black locust and three of soft maple. I have a meat board from the first black locust cut down. The seed came from Iowa. I made my fruit into fruit butter, cooking it in the big brass kettle out-of-doors, sealed it in five gallon cans and packed it to the mines on mule trains.

Just as we entered Indian territory and were camping, an old Indian came up to our wagon and asked for something to eat. We gave him food, he laid it carefully on the wagon tongue, then knelt and returned thanks for the favor bestowed upon him. Taking the food, he left the camp and the next time we saw him was when he suddenly appeared with the warning that Indians were planning an attack. He told us to corral every head of stock and be on guard that night. We were not molested. Several times after that, as long as we were in Indian territory, the grateful red man appeared to save our lives.

The Cayuse war and the Indian troubles following, kept the white people out of the upper country for a number of years. The McCaws settled on the Calapooia River and went through Indian troubles and it was their daughters and their families who have had an important part in the shaping of the destiny of what is now Walla Walla County.

VENERABLE WAGON (opposite) in author's collection of horse drawn vehicles is saturated in clear preservative paint but otherwise little changed from original condition. Canvas cover is modern but fashioned after those used on classic prairie schooners. Old hay rake has hand-whittled teeth.

HEAVY WAGON WHEEL HUB is part of Guy Casey Collection.

OLD TIME WHEELBARROW (above) is still in use on Lovelace farm near Rainier, Oregon. Novel stock feeder (above right) is built on stump behind farmhouse near Apiary, Oregon, in Coast Range above Columbia River. (Photo Byron Larson) Old horse trough (above center) still provides clear water in Northport, Washington. Border town was once important mining center with large mills. (Photo Byron larson)

PERRY W. BAKER, Clark County

There were a few log houses here when I came. They were caulked with mud or moss. Other houses were built of rough lumber.

I can recall a story of the Heisseir and Caples and some other families when they were proving up on their homesteads. One was required to have a glass window in his house. Well, these settlers bought one window between them, and kept it stored under a bed. Whenever it came time for one of the homesteaders to make final proof, each one in turn would borrow the window and use it for inspection.

Meantime they used a wooden shutter with leather hinges, or, if bad weather came, they boarded the opening up entirely or else nailed a sheep hide over it.

We always used grease lamps. Just a dish of grease—bear or hog fat with a wick in it. Not very good light, but one could see to get around. We had puncheon floors. For furniture, we had homemade benches, for the most part. There were very few chairs in the neighborhood, and some homemade rockers.

The story is told of the pioneer, Mr. Heisseir, that he placed his foot in a nail keg while chopping to avoid gashing his leg with the axe.

All the houses had fireplaces in the early days, not only for heating, but were used also for cooking. Dishes were not too plentiful. Our nearest store was 10 miles from here at Stotten. Women often walked that far to sell produce. I've often known my mother to kill chickens and carry them ten miles, to exchange them for sugar, tea, coffee or other supplies at the store, and walk both ways.

GEORGE LAMB, Clallam County

For amusement, there were, as has been told by so many of the pioneers, the ever-enjoyable neighborhood dances, to which gallant husbands and beaus carried the shoes and "party gowns" of their wives and sweethearts, while these ladies accompanied them on foot or horseback, dressed in old kitchen clothes, or even the men's overalls and boots. Many a toilette has been made by these pioneer ladies by the light of smoky lanterns in a barn or other out building on the farm in order that milady might appear fresh and clean and lovely when she entered the "ballroom." Not infrequently, the strong men of those days were compelled to ford creeks and swampy places carrying their ladies in their arms. The dances were worth all the trouble it took to reach them, say those who endured and enjoyed.

Dances, while they never palled upon the populace, did not completely satisfy the pioneer's need for entertainment. Seldom indeed was it possible for even the most intrepid of traveling entertainers to journey into Clallam Bay, Pysht or Neah Bay, although occasionally some third rate company might arrive by boat for a two or three night's stay.

To bridge the long intervals between these appearances, and to satisfy the pioneer's longing for make-believe, local talent plays were given two or three times a year in a church or hall. These, if the memories of pioneers may be trusted, were even better than the shows given by the so-called professionals, and included such farces as "Box and Cox," "The Dutchman's Predicament," etc., and such dramas as "Ten Nights in a Barroom," "Under the Gaslight," "The Mistletoe Bough" (in which a beautiful maiden secreted herself just for a lark in an old chest and was locked in and her poor bones not found for years and years, while the groom-to-be withered away to a shadow), and even some of Shakespeare's comedies.

105

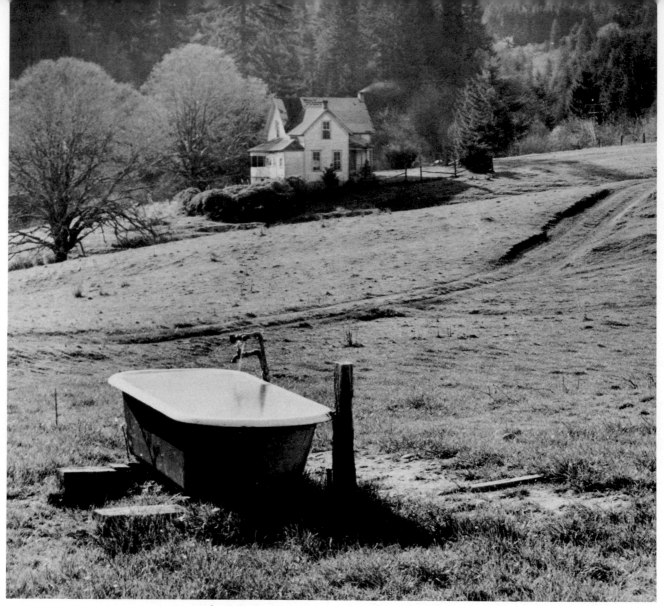

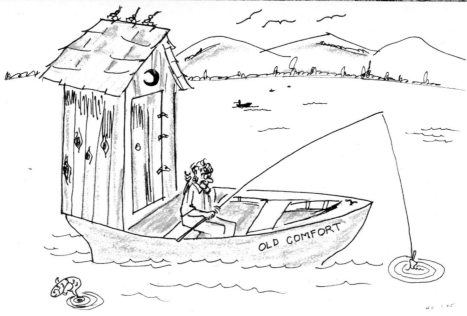

OLD COMFORT

Excerpt from
Pan Bread 'n Jerky
by Pioneer Walter L. Scott

In 1885 we moved on to Harney County where my father filed on a homestead forty miles south of Burns. It was in Happy Valley, seven miles from Diamond and near Barton Lake. We got our mail at Burns, a post office having been established there in 1884. Father built a house with a rock fireplace on which Mother did all her cooking. She baked bread in a Dutch oven buried in hot coals. She made tallow candles for lights in a six-candle mold. Sometimes they used a grease light—a twisted or braided piece of cloth immersed in a shallow pan or saucer of grease. And father dug a well from which he drew up water in a bucket let down into the well on a rope.

In those days my folks bought green coffee beans and mother roasted them in a pan set on hot coals raked from the fireplace onto the hearth. I can remember seeing her stirring the green coffee in the pan to keep it from scorching. She had a coffee grinder, and ground only enough coffee beans to make the coffee needed for each meal.

The women and children of the community gathered duck eggs from the tules during nesting season but we did not like them very well, and did not often join these egg hunts. Settlers were a long way apart but there was a schoolhouse which stood at the foot of a lone table-topped butte half a mile from our house. This was my first school. Mother could watch me going across the meadow all the way to school. My sister Jessie (Mrs. J. S. Dyke, of Baker) was born on this homestead on December 25, 1886.

Father cut juniper wood for fuel, and had to haul it several miles around the lake in summertime. The lake was shallow, and froze over in the winter so he could haul his wood across the lake on the ice. He cut fence posts for Pete French, and he had a little money coming in regularly from the sale of his home in Missouri. The homesteaders went in a group to Fish Lake, Steens Mountain, to camp while catching their winter's fish. They took barrels and salt with them, and salted the fish down there at the lake. The men waded out into the shallow water and built a rock-walled pen, leaving an opening at one end. Then they waded farther out into the lake and "herded" the fish into the pen, after which they rocked up the opening. They caught the fish with their hands and tossed them out onto the ground where the women folk killed them with sticks—big nice fish they were, too. The thing I remember best about this was a man by the name of Durham catching a fish which slipped out of his hands and fell headfirst into the top of his rubber boot. Its tail flapped against his leg until he caught hold of it again and threw it out onto the ground.

I can remember eating the salted fish in the wintertime, too. While eating fish,

FEW YEARS BEFORE CIVIL WAR, Fort Hoskins was established near King's Valley, Oregon, to protect settlers from Indians. Most buildings have long since rotted away, hospital alone remaining in good condition. This home (opposite), contemporary with period, still stands at edge of parade ground. Water for "horse trough" is probably piped from some still functioning spring supplying fort.

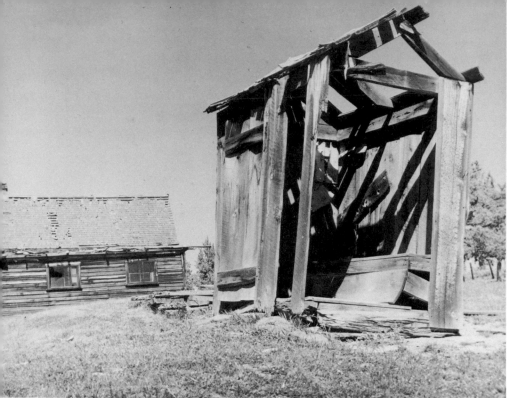

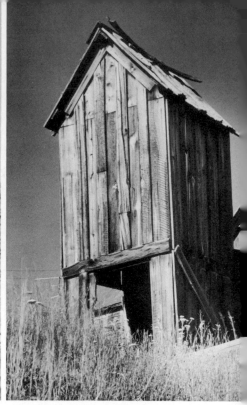

OLD HOMESTEAD (above) is now part of Lloyd Woodside ranch which lays no claim to modernity. Wapinitia, Oregon, is part of area more or less parallel with eastern edge of Cascade Mountains. Range obstructs rain-laden clouds long enough to deposit most ocean moisture on western slopes. In ignorance of this condition eager land-hungry homesteaders settled and built from Columbia to California border. After years of drought and starvation almost everyone departed, leaving few traces. (Photo Byron Larson)

GROUP OF RUINED BUILDINGS (above center) at Placerville, Idaho, which is almost ghost town. Narrow structure at left was probably smokehouse. In it meat would be hung on racks over slow hardwood fire until cure was complete. (Photo Byron Larson)

I accidentally swallowed a bone which lodged crosswise in my throat. It was so far down, father could not get hold of it to remove it. It was a sizeable bone, and by placing his fingers on my neck he could feel where the bone was lodged. Whether or not there was a doctor in Burns, I do not know. At any rate, Burns was two days away, and the situation was critical. Father did not panic. He brought in a neighbor woman to hold me, which mother could not have done. He sterilized his razor blade, cut into my neck and removed the barbed fishbone. It was something that had to be done, and he did it, which was typical of my father. He treated the incident so matter of factly that it was years later before it dawned upon me what courage and what an iron nerve such a procedure

had taken. He had no such thing as an anesthetic and in looking back on it now, I don't know how the neighbor woman held me still enough for father to take that fishbone out of my throat.

Father was a crack rifle shot, and he used to stand in the cabin doorway and shoot geese out in the meadow. One of his favorite hunting spots was on Kiger Creek. He kept us supplied with venison, and always he had sacks of jerky hanging in the attic. In the fall when the settlers went to Steens Mountain to get their winter's meat, an old man by the name of Bybee went along. He did not hunt but worked around the camp gathering wood for the campfires. The hunters saved all the deer tongues for him, and he salted them down in a barrel. Late in the fall, father killed deer which he hauled to Union where he traded them for flour, sugar, hams, fruit,

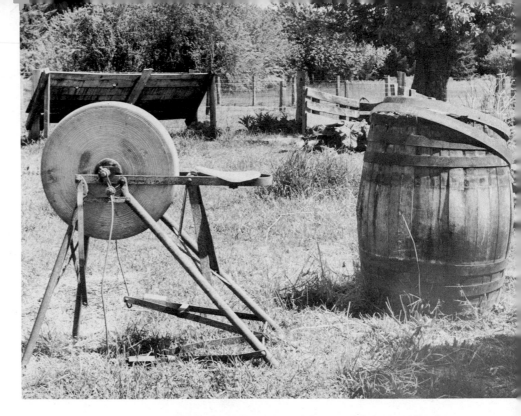

and other foodstuffs. There were no game laws in those days.

It was a several days' trip to Union, and he took the family with him, camping along the way. One day, while we were stopped for noon on Dixie Mountain, mother saw three deer coming down the hillside, single file, toward the road. She said, "Oh, see the deer!" Father had leaned his rifle against the wagon wheel right beside him. He picked up the gun, and as the deer stepped down into the road, he felled them one by one. He dressed them, and took them on into Union with those he had brought from home.

It was a two-day trip to Burns, and the halfway camp was at Government Well which was down on the floor of the valley a short way from the bluffs or rimrock. It was a dug well, approximately forty feet deep. One time when we stopped for the night the wind was blowing a gale, and we made our camp under an overhanging ledge of the rimrock. Father unhitched the horses and led them to the well for water. Finding that someone had taken the bucket rope, he took the lines from the harness and some rope he had to let the bucket down into the well to bring up water for our camp and for the horses.

OLD HANSEN FARM (above right) near banks of Nehalem River (Oregon) retains many relics of days when Charles O. Hansen cultivated many acres. Now widow Hansen and married son concentrate on hay, cattle. Durable grindstone once sharpened axes used to whet scythes and sickle bars, binding knives and other tools. Stone is large, heavy, requiring double treadle peddled by operator perched on wobbly seat. Barrel was once in constant use to hold rain water and cure meats. (Photo Byron Larson)

OLD KEROSENE LANTERNS had some advantage over modern types. They operated silently, giving soft light, were windproof, dependable and used on every farm in the country. Horseshoes were found in brush at now ghostly Ferry, Washington, near Canadian border. Ferry endured long, bitter cold winters with ice for many months. Heavy studs helped horses keep footing. Shoes from Joe Stalheim Collection.

109

Excerpt from
Days of My Years
by Pioneer Earl R. Smith

Shortly after my birth in Platteville, Colorado, in 1882 my parents moved to Sidney, Nebraska, which was on the stage line extending from Cheyenne, Wyoming to Deadwood, South Dakota. Sidney was the jumping off place for the open range country of southern Nebraska, South Dakota and eastern Wyoming, and to say it was tough is putting it midly. When I was a little chap, I was with my father in the saloon where the plot was perfected to have Jack McCall kill Wild Bill Hickok, and the town was the habitat of such characters as Wyatt Earp, Bat Masterson, Buffalo Bill Cody and others of the same brecd. . . .

Shortly after this we moved out on a claim on the North Platte River sixty miles from Sidney. Father had filed on 160 acres of bottom land not far from the river, and there he put up a sod house, dug a well and built a corral for his horses. He had two, Bill and Charley, and neither could be ridden.

WASHING MACHINE (opposite top) was tremendous improvement over earlier model in which agitators were simple wooden prongs much like cows' teats. Gear ratios concentrated hand power to raise and lower suction cups shown here.

ADVERTISING SIGN (opposite bottom) depicting famous Gold Dust Twins was painted on side of small building which stood for years at edge of old farm on now busy Sandy Boulevard in Portland, Oregon. After years of exposure to weather sign was covered by building erected close to it. In spring of 1974 entire corner was razed, newer building first, exposing this long-forgotten message which soon disappeared as this building came down. (Photo Byron Larson)

Those sod houses were something to reckon with, but were warm in winter and cool in summer. To build one about the only tools required are a good team of horses, a plow and square-pointed spade. The prairie sod in those days was tough and interwoven with grass roots and packed by centuries of buffalo herds. A furrow was plowed and this could be a half mile in length without a break in the turf. After turning over a few furrows, the sod was cut into lengths of maybe a foot and a half or two feet. Thus a block a foot wide, six inches thick and two feet long was made, the spade being used to do the cutting. These blocks were then hauled to the building site and the house built as one using brick.

As I remember father telling me, our house was 16 x 24. The walls were two feet thick and seven feet high. A ridge log was put atop the gable ends and smaller poles laid, transversing across, and these in turn covered with grass and then a foot of dirt spread over the whole and there was the house. Back in the breaks along the river grew scrub cedar and out of this was hewed lumber for window and door frames and also the door itself. We had leather for hinges and muslin dipped in lard for windows. The lard made the cloth semitransparent and also waterproof. The floor was of dirt and mother used to sprinkle it to keep the dust down, and in time it became most as hard as cement. There was a support, a big post, set in the center of the room under the ridge log to help carry the weight of the roof. The inside

of ours was a little extra, for dad plastered it with mud. There never was a dull moment for the housekeeper in one of those houses, for out of the walls came bedbugs, nits, centipedes, thousand-legged worms and sometimes young snakes and mice.

We were located in what was known as Code Valley, but I don't know where they got the valley part, for the whole country was a level floor from the river back to the bluffs, which as I remember were several miles. Our post office was Gering, quite a town, for it sported a bank.

We had one neighbor, a bachelor, Dan Calahan, who lived about a mile from us and had the same general setup as we did. Between us and the river ran the old Mormon Trail, and I remember watching the old prairie schooners slowly and laboriously wending their way along the river.

Our house faced the east just a few miles above Chimney Rock, a landmark even today. I well remember watching the sun sink below Laramie Peak in the evening and the shadows lengthen and the land gradually grow purple and then dark. How I loved to watch the shadows of the clouds as they chased each other across the great open spaces. It was a big land for a little boy. One of the first songs I learned to sing had this verse:

O the hinges made of leather,
The windows have no glass,
Thru the roof comes in the blizzard
 and the rain!
We can hear the howling coyote
As he's sneaking thru the grass
In that little old sod shanty on the
 plain.

It was a hard life at best and hardest on the wives and mothers. Many, many women went stark crazy and no wonder. The menfolk were gone a great deal of the time as in my father's case. The land

PLOW AND WAGON WHEEL (below) on farm of Bob Law near Hamilton, Montana. Several substantial log buildings remain at Adams Camp, Idaho, which was way station on primitive road running south from Grangeville to now ghostly Florence, Idaho.

MAN'S LOVE FOR HIS DOG is evident here in this miniature log house (below center) as substantial as main house. 4-wheel cycle (below right) carried rider deep into mine tunnels of War Eagle Mountain, Silver City, Idaho. Flanged wheels fitted narrow gauge tracks used primarily for ore cars. (Photos Byron Larson)

was raw, he had no money to fence and without it a crop was impossible, for range stock would destroy every vestige. So to live he had to work away from home, and as the only industry in those early days was cattle raising he joined up with a cow outfit. Sometimes we would not see him for two weeks and then only for a night when he would bring home something to eat. . . .

One evening just before dusk as we sat there a big rattlesnake came slithering through the door and just inside he paused as if making a survey of the land. He was in no hurry nor was he scared, but took his time. He was between us and the door, so mother whispered to me and told me to jump over him and get the ax on the woodpile and toss it in to her. I took a deep breath and a couple of steps and jumped. I think it was the highest jump over the lowest object I ever made, but I did as told and Mr. Rattler lost his head to a woman.

Our well was some twenty feet deep or more, dug in hard sandstone a good part of the way; and at the top was a tight cover and a curb built up about waist high. Water was brought up in a bucket with a rope. I used to love to look down and watch my shadow in the water; if I spit there would be little wavelets roll away from the impact. One day the thought occurred to me that it would be fun to watch my hat sail down and land in the water. It was an old straw and would float. The more I thought on the matter the more I was convinced that that was the thing to do—and so of course as all who yield to temptation do, I threw my hat down the well. Of course there was a reaction, for mother asked where my hat was. One thing I never did was lie to my mother, and so I told her. She fished it out and told me if I ever did it again I would have to go down after it. That did not sink in very deeply, for it was not long ere the temptation overcame me and down the well went the hat. It was such fun to watch it float from side to side and then settle on the water. This time mother did not ask where my hat was, she told me—and also told me I was going down after it.

That was a rugged experience, for she took the rope off the bucket and tied it under my arms and amid much squirming and kicking and a great deal of howling,

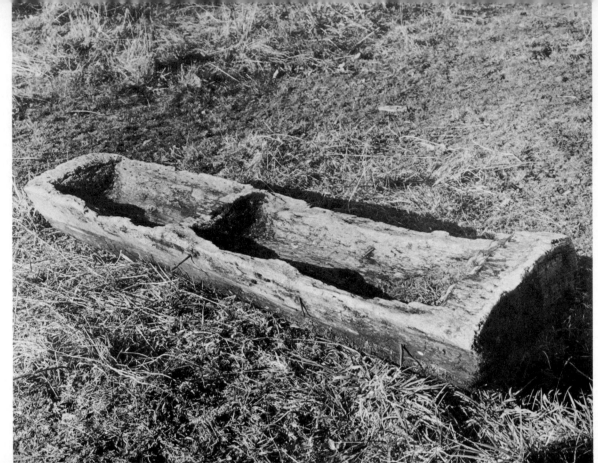

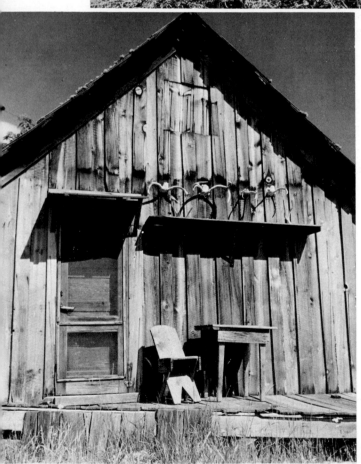

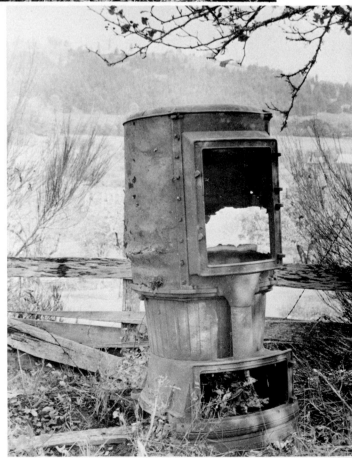

over the curb and down the well I went. I have gone down many wells since and have worked in deep mines, but that was the longest, darkest and most awesome trip I ever took. I howeled and cried, but kept dropping deeper into the dark, wet ground. Finally I was in reach of my hat and the descent ceased, and after taking a firm grip on said hat I started for the top. Mother consoled me and told me what a brave boy I was and I promised never to do it again—and I have never broken that word you may be sure. . . .

It was while living on the claim that we became acquainted with some hard characters, for the Rustler's War, or as others called it, the Johnson County War was building and it erupted just a couple of years after we moved away. One of our neighbors was Tom Waggoner who was hung and I have always thought my father was a party to the hanging. Then there was the Bill Kingon family who lived on

the river above us. My father helped put him in jail in Cheyenne for cattle stealing. He broke jail and froze to death in a blizzard trying to get back home. Nate Champion and Nick Ray, two cowboys who located a claim across the river from us, worked for the same cattle outfit as my father. They were ambushed in their cabin in 1892 and both killed by hired gunmen of the big cow outfits. These boys were great friends of ours and did many little acts of kindness for my mother.

Ella Watson (Cattle Kate), was a neighbor and she was hung along with her boyfriend, Jim Averill. Kinch McKinney, a cowboy on the ranch, got eight years in the pen for cattle stealing. Billy Gray received the same sentence, but died in the Cheyenne jail before he could be sent to the pen. We lived in Cheyenne at the time and I remember his funeral. We had known him on the ranch and so father arranged the funeral.

REMINISCENT OF INDIAN DUGOUT CANOE is this ancient trough (photos opposite). With two compartments it offered food and water to livestock. It was discovered in Portland's West Hills in backyard of log cabin reduced to little more than rubble. Simple shack, now abandoned, was once someone's home in area of mountains, pine trees and lakes, near old mining town of Conconully, Washington. Little country school near Pedee, Oregon, on present Burbank farm, has vanished except for well pump and this woodburning heater. Area here is steeped in early Oregon history. Small Pedee Creek flows into Luckiamute River, bordering old Fort Hoskins, defense against Indian attacks which never came. Also nearby is Kings Valley, named for founder Nahum King, member of tragic "Lost Wagon Train" of 1845. (Photos Byron Larson)

TIME WAS WHEN every farm of any affluence was visible for miles because of prominent water tower and windmill. This tower (right) at Warren, Oregon, on the lower Columbia River, is rather more ornate than some. Iron work filigree is the envy of every passing collector, some making substantial offers for it. Windmill is also "hot" item now with much talk of non-polluting power. (Photo Byron Larson)

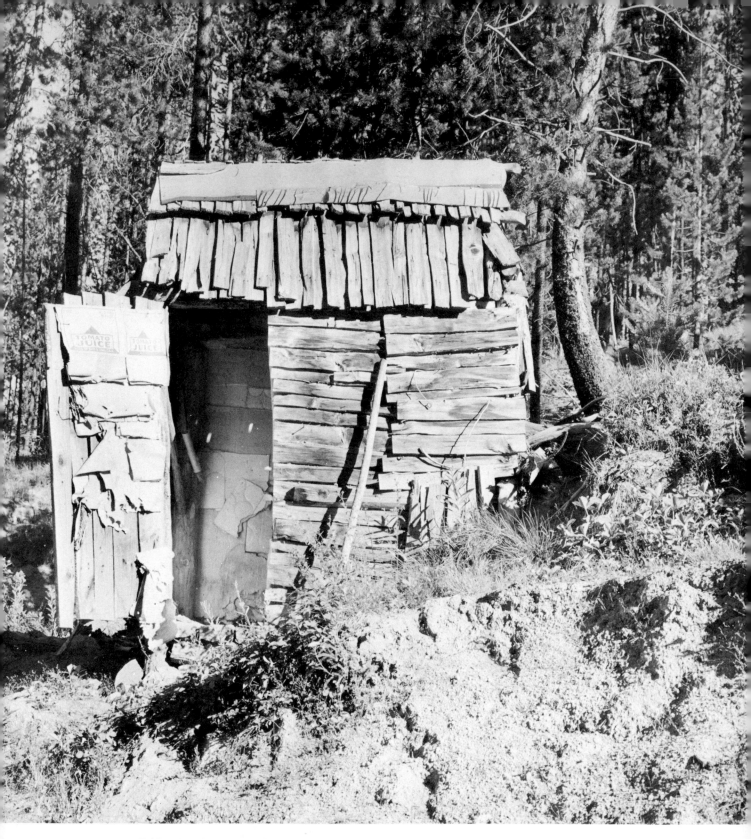

LAIR OF THE FOREST ELVES? Bewitching hideout in Idaho's fastness near Dixie. Framing and roof poles are covered with shakes . . . cracks covered with cloth and paper bags. Area saw good mining boom in 1890s, is now wild, untrammeled wilderness.

The Byron Larson

Selection

The talent of Byron Leon Larson as a camera craftsman is becoming more widely appreciated every year. Still employed as a master repairman of amusement devices, he spices up his life with sallies into bush and back country for photographs of the off-trail and unusual. Those in this section are typical.

Born in Omaha, transplanted to Fresno, California, Byron Larson took to the open road at an early age, then attended public schools in Portland. Again the greener pastures but these were on the water, on the Columbia River sternwheeler *Undine*, plying between Portland and Astoria. Then the big sea called and he went into the Merchant Marine, on voyages to the East Coast and the Orient. Married and with a growing family, he settled in his home port ten years working with boys as Cubmaster and Scoutmaster.

Cameras? From a box "Brownie" Byron moved on to 35mm slides, then took to a 2¼ x 2¼ Rolleiflex, becoming very proficient in its use. His views in this book were made with this model, all on tripod and most with an A filter. He has made excellent color photographs with a 4 x 5 Speed Graphic, such as the one used for the dust jacket of Lambert Florin's *Western Wagon Wheels*.

McKEE FARMHOUSE (above) where general atmosphere of tidiness is characteristic, extending to barns and other outbuildings. When farm was active, hands washed up in wooden trough before supper.

SEGREGATION PROBLEM SOLVED HERE (opposite top) when door to "Women" side was removed and outhouse became open territory? This is merely idle conjecture. "Men" door remains and women either use that building or fling privacy to winds. Scene was photographed in Ferry, Washington, once teeming mining camp near Canadian border, producing antimony, used for hardening other metals.

"MY OUTHOUSES STAY PUT!" says farmer McKee. He is 91, coming to place near Amity, Oregon, as infant. And while there is now some plumbing in house, he states emphatically, "I wouldn't tear my outhouses down for anything!"

The privy shown (opposite bottom) under gnarled old apple tree and graced by a white porcelain door knob, was for residence use but there are others around farm for hands in days when whole acreage was in cultivation. "Besides," says the venerable McKee, "I could never tell where I might be when I needed one, and maybe in a hurry."

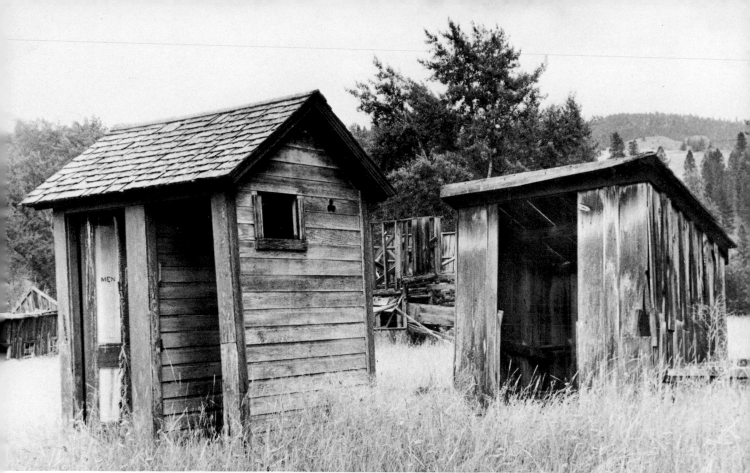

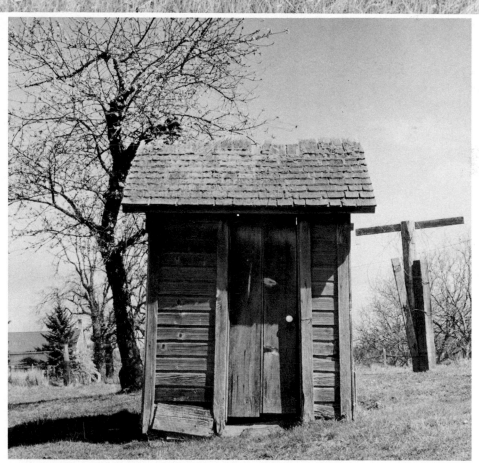

119

"TELL HER TO CALL BACK, BY." One of several outhouses of old McKee farm near Amity, Oregon. Young Guy Casey, avid bottle collector, could not resist temptation to "get into the act" by stepping into line of already set up camera.

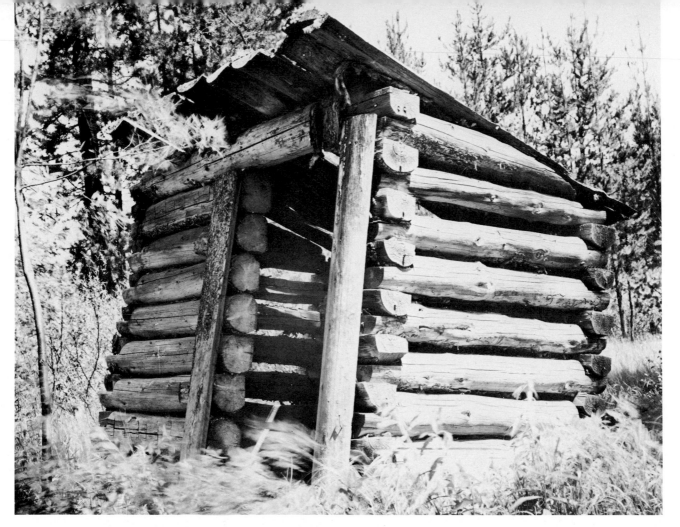

BUILT TO withstand Indian attacks, log outhouse has weathered many years as haven against attacks of more anatomical nature. Building adjoins hotel and livery stable at top of long, arduous climb into Warren, Idaho, mining camp . . . two days journey in early days. Half-logs of roof were likely whipsawed lengthwise. Corners seem to be notched by sawing, rather than with broadaxe. Spaces between were probably chinked with moss and clay as winters here were bitter cold. Warren history is told more fully in Lambert Florin's Ghost Town Treasures.

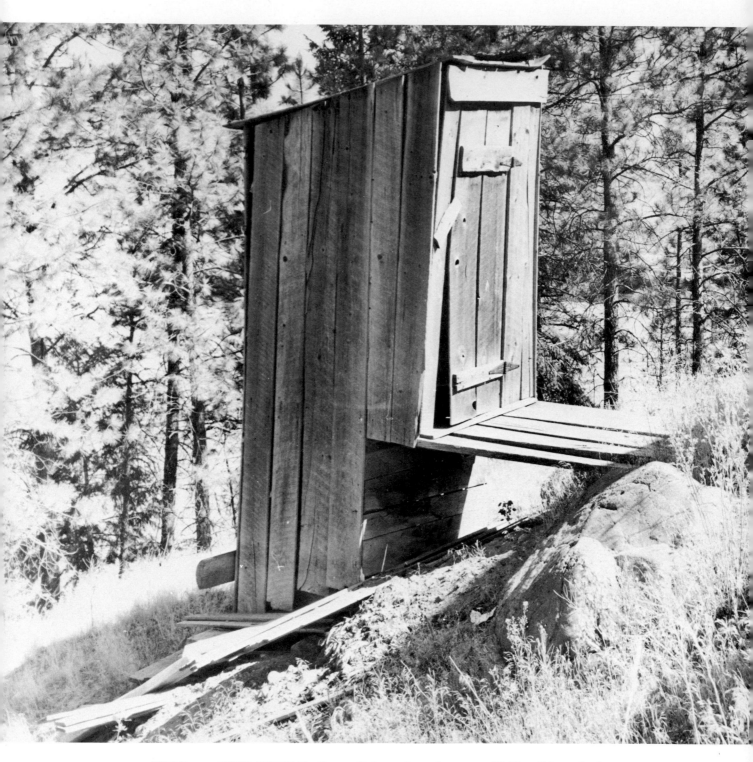

WELL . . . WHO WOULD dig a pit in such rocky ground? Not this early farmer in northeastern Washington. He took advantage of ground sloping down to lodgepole pines to build practical split-level outhouse. Photographer Byron Larson found it sitting solidly on Novatney farm near Curlew.

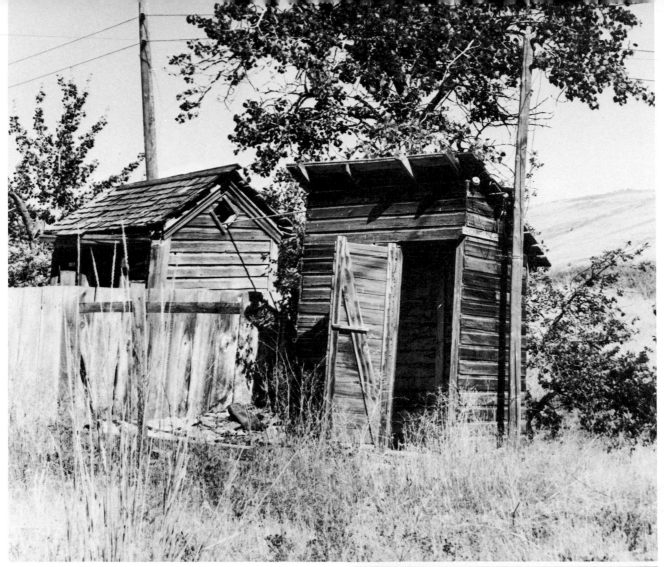

CONCESSION TO PROPRIETIES? *Byron Larson, Portland photographer, raises question since both outhouses are on same property. What's good enough for father not good enough for mother? . . . visiting firemen? . . . itinerant photographers?*

LEANING RELIC OF CHESAW. *While this north central Washington settlement has struggled back to life after gold excitement of 1890, now boasting store, tavern, gas pump, post office, rodeo grounds, this privy and few old houses are only remaining evidences of early boom. Perhaps it leans to belief that . . . "Self-preservation is first law of (outhouses as well as of) man."*

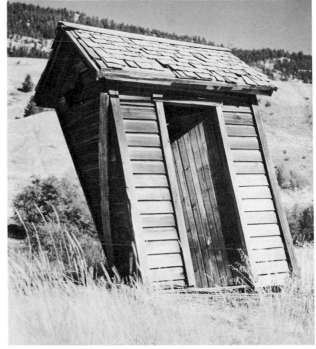

BI-PARTISAN PRIVY *of old school (below) on Upper 8-Mile Creek in north central Oregon, south of The Dalles. Photographer Byron Larson comments, "Small rural schools were close to settlements in early days but now children may travel 30 miles or more by bus."*

BACKHOUSE FOR A FACT. *This privy (opposite left) was built against still substantial log cabin near Conconully, Washington, on Salmon Creek. Since rear wall of it is set only part way back, question arises. Was there another section of it reached from rear of cabin?*

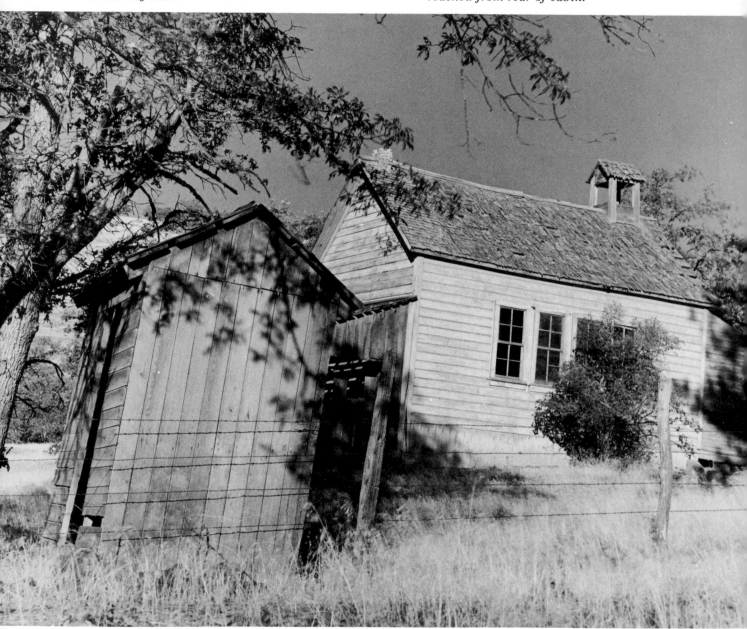

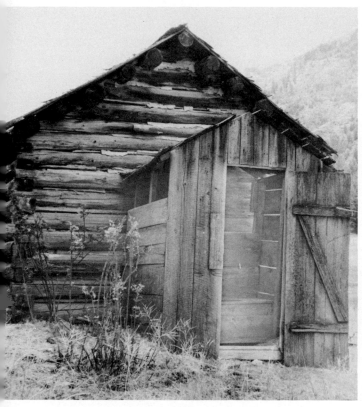

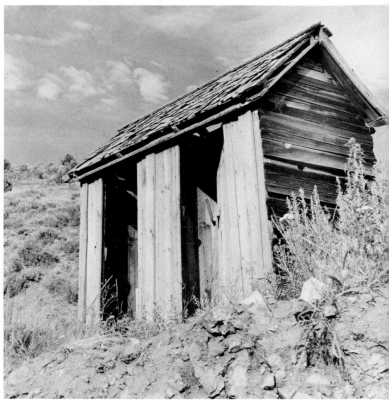

DEWEY'S GIFT TO DEWEY. *Imposing, 4-hole, double-headed dooley (above right) was adjunct to first hotel Col. William H. Dewey built in town he founded . . . is now, with ruins of mill, only remains of it. Out of rubble comes this story.*

Col. Dewey was broke and doing menial jobs in Virginia City, Nevada, when he heard of rich silver strikes at Silver City, Idaho. Shouldering pick and shovel he walked all the way to saddle on top of War Eagle Mountain. Lucky in Silver City, Dewey moved down valley of Jordan Creek to found new town, modestly naming it for himself. As fortune continued to smile on once destitute laborer, he built fine 3-story hotel with electric lights and plumbing system – wonder of the countryside – which outmoded outhouse. Successive fires destroyed both hotels.

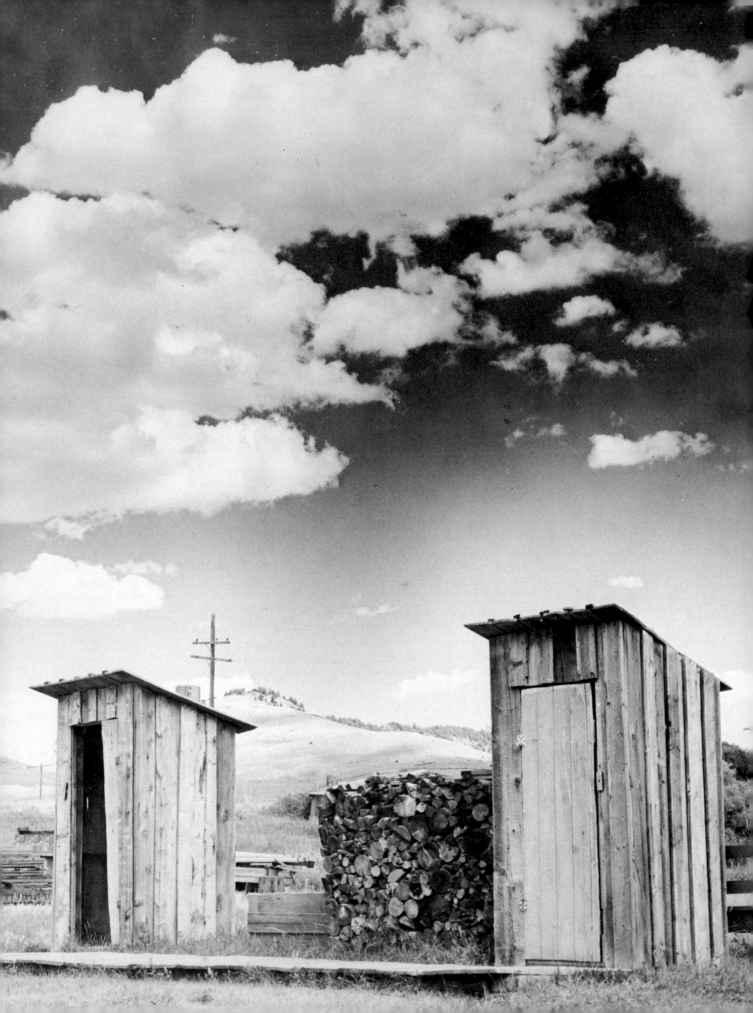

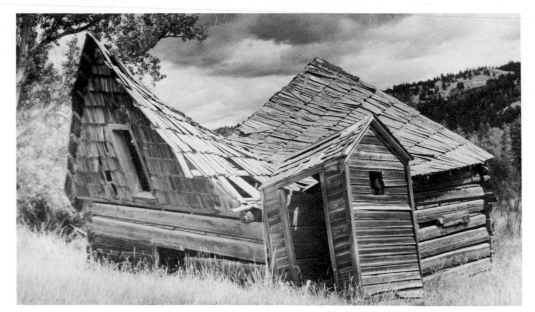

HOPE NOBODY WAS HURT "*when the cyclone struck.*" *Venerable building near Conconully, Washington, was stoutly constructed, logs hand-trimmed, roof of shakes hand-split with froe. Weakness of roof beam caused collapse.*

MONTANA'S FAMED BIG SKY *arches over pair of outhouses (opposite) in back of old school house in Nevada City.*

"BUILT LIKE A BRICK YOU-KNOW-WHAT." *Earliest construction in Denver was almost all of flimsy material. After numerous fires, and incomes of tycoons mounting, brick came into popular use. View (below) shows Todd residence, Denver, dating from 1860s, outhouse of similar style. (Photo Denver Public Library, Western History Dept.)*

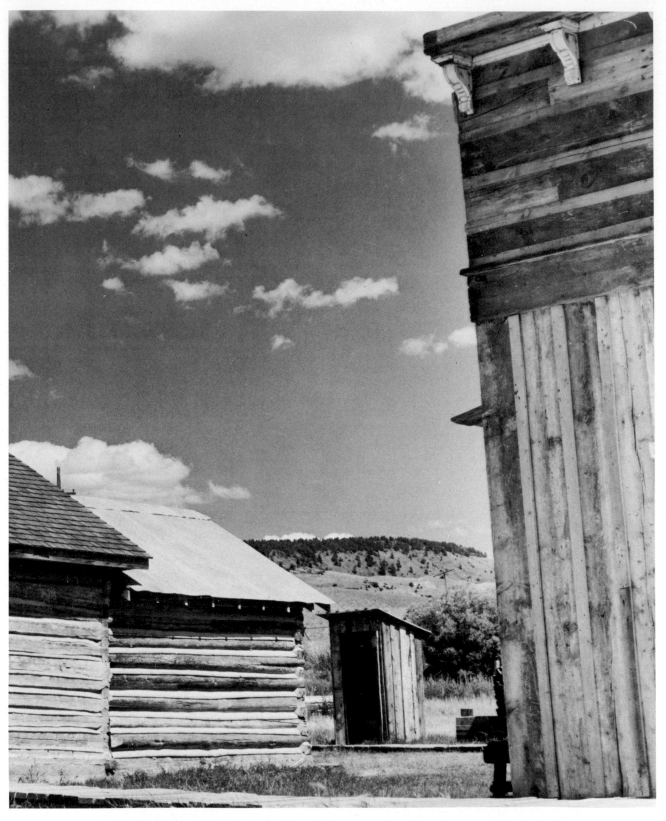

RANCHER'S PRIVATE QUARTERS SEEM to bid for attention as lamb's tails float
tranquilly overhead. Scene is near Nevada City, Montana.

SPRING, APPLE BLOSSOMS AND LAMBS all come together at old McKee farm near Amity, Oregon.

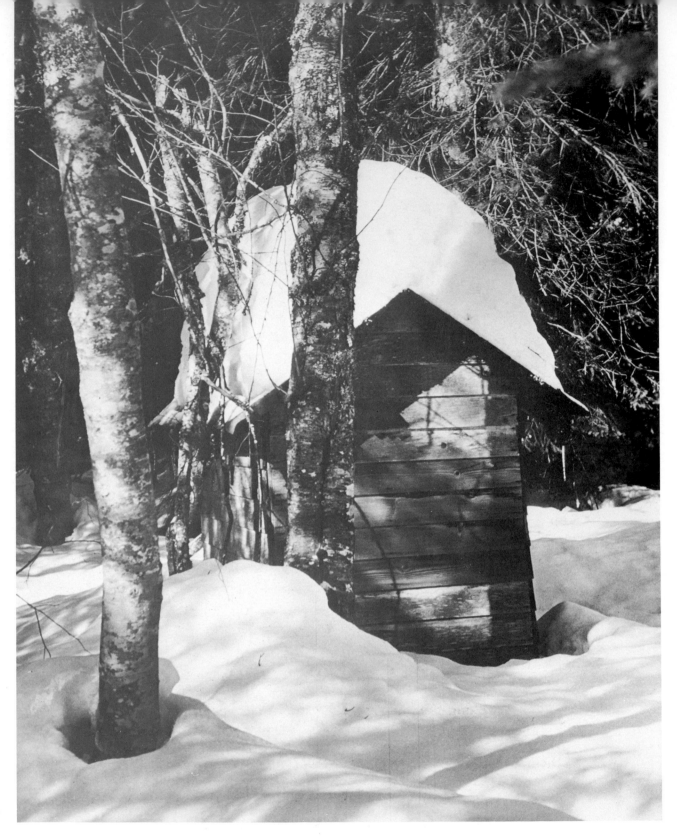

SNOW, SNOW, BEAUTIFUL, ABOMINABLE SNOW. Members of Mazama (Portland climbing club) arrange frequent snowshoe treks near lodge on slopes of Mount Hood, Oregon. Privy is for climbers' convenience and sometimes winter snows completely bury it.

The Myron Levy
Selection

Mountain climber Myron Levy, native of Portland, Oregon, is a photographer with flair. In commenting on the view of him shown here with a member of the Kaya Kaya tribe, notorious head hunters of New Guinea (where he served for three years in World War II) he said, "I am the one on the left and look fairly amiable. So does the man on my left. I guess he was on vacation."

Levy is a specialist in handling surety bonds and fiduciary matters, is on the staff of the *Portland Daily Journal of Commerce*. His avocations are the outdoors and photography, both pursuits sharpened by his active membership in the Mazamas, Northwest high-country climbing group. As to his outhouse pictures included here, he explains, "After a major climb or trip many of us gather at the clubhouse to see slides taken by members. Peaks and flowers dominate almost to repletion and I discovered my photos of innovations such as outhouses encountered along the way got more than the usual attention. This put me on the trail to what might be called a collection."

A selection of these photos has been converted from 35mm slides by the author to black and white prints for this book. The method used was by enlargement on paper negatives, then printing by contact.

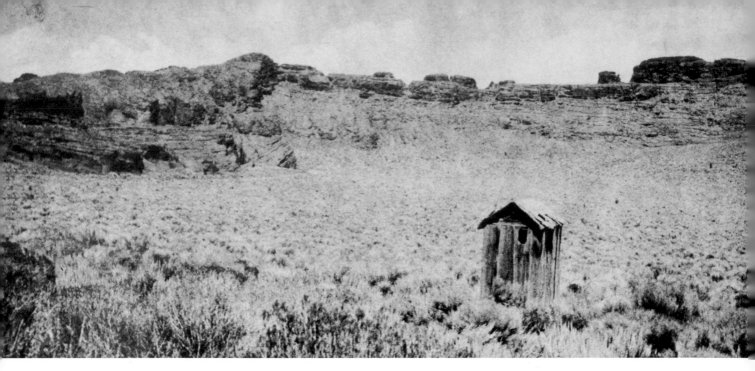

CONSOLATION MIDST DESOLATION.
*Fort Rock in arid south central Oregon is
rough, near crescent-shaped island of rock
suddenly jutting from low mound on dry
ancient lake bed. Honeycombed by caves,
rocky bastion offered home to primitives
in prehistoric times. In 1938 anthropologist
Luther Cressman discovered here pair of
sagebrush sandals dated as 9,000 years old.
Standing in center of circle of cliffs is this
appropriately "primitive" privy (above).*

*"You didn't close the door when you came
 in, Harry"*
"Al – have you forgotten we're ghosts?"
 *Simple conveniences (below) for "Blue Sky
Hotel" near Hart Mountain National Antelope
Refuge in south eastern Oregon. National
encampment of Order of Antelope is held
here. Privacy? Who needs it?*

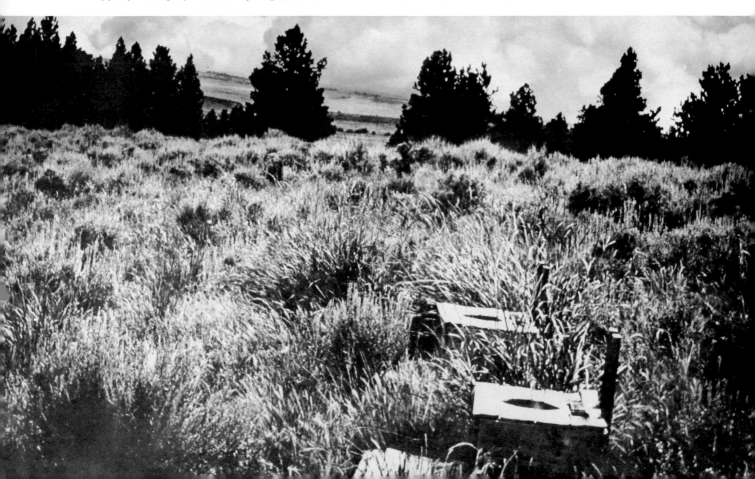

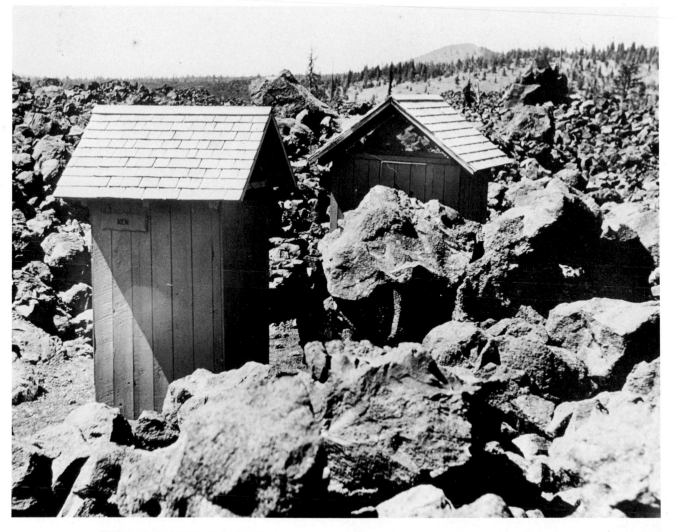

TWIN BEACONS OF HOPE *in stark lava flow area on eastern slope of Oregon's Cascade Mountains.*

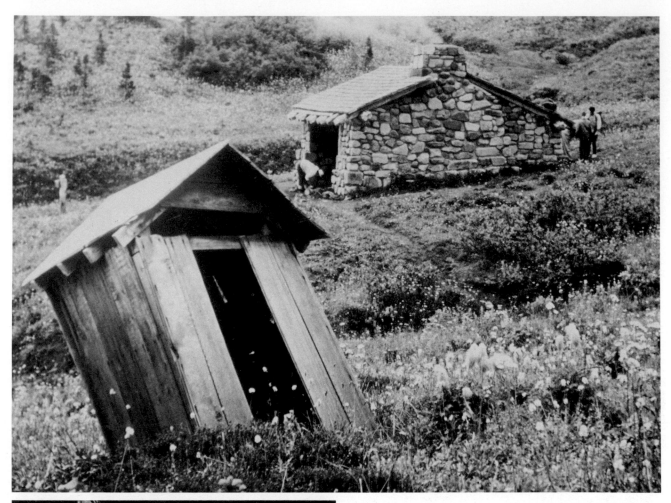

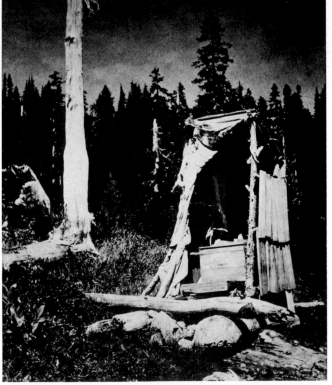

TRAGEDY AT ALPINE MEADOWS. *Overnight rest stop, 7,000 feet (above), on Wonderland Trail, Mount Rainier, Washington. Floral displays here are unequaled at this altitude. Old, outcast outhouse seems dejected, forlorn.*

Sticks and stones,
Some shakes, a sack
Make a little house
For use out back.

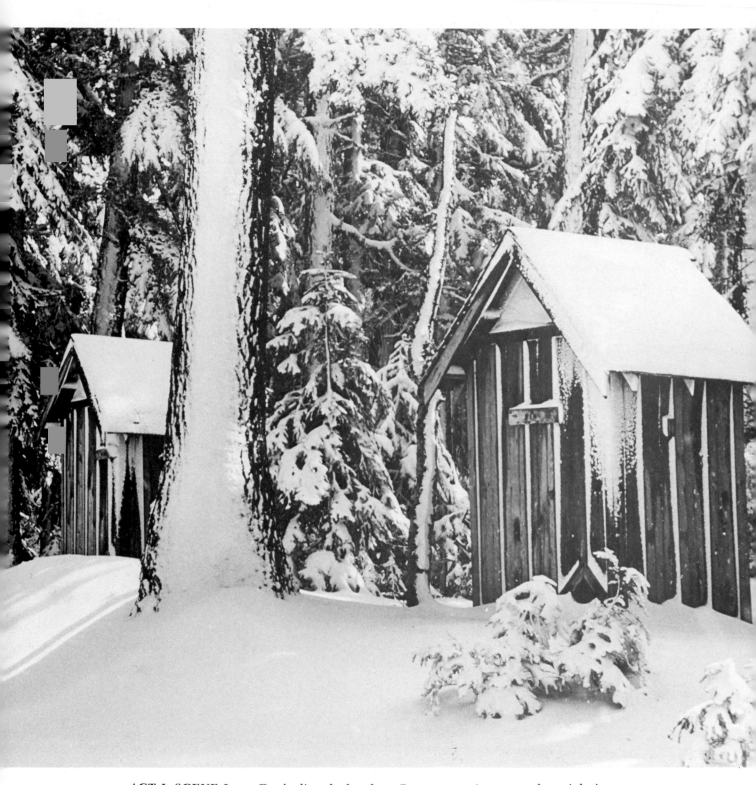

**ACT I, SCENE I . . . Don't disturb the elves. Pretty as a picture . . . but violating
principles of segregation is this Oregon mountain scene.**

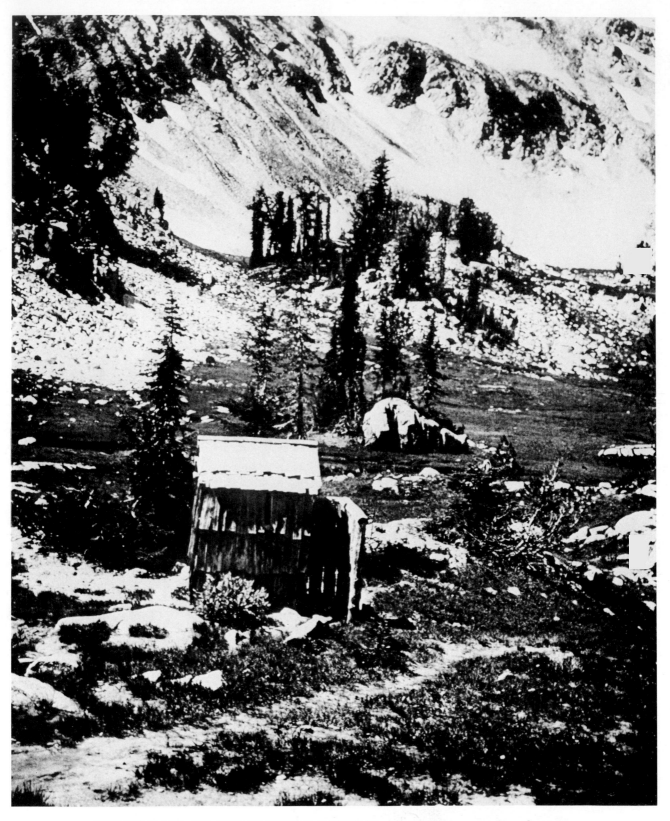

WHERE HAVE ALL THE FLOWERS GONE? *They went thataway when the snows came down the mountain. But they'll be back again and hikers will come to admire them and use this cedar shake outhouse.*

MAGICIAN'S STAGE PROPS? Name it and you can have it (right) . . . but don't take it away from slopes of Mount Hood, Oregon. It's needed there, this portable plastic and metal "conjuror's cabinet" used for sanitary purposes at special social gatherings.

SEX DISCRIMINATION REACHES RANCH. "Ponderosa-minded" host offers travelers choice of accommodations (below). Significance of auto license plates on doors remains a question.

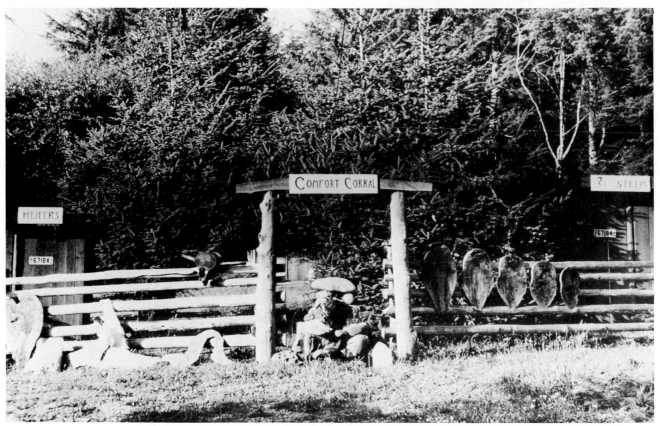

DO NOT TARRY LONG, STRANGER here at Frenchglen, Oregon — population 21. The relief this convenience offers does not extend to hordes of man-eating mosquitos, each one carrying spear gun.

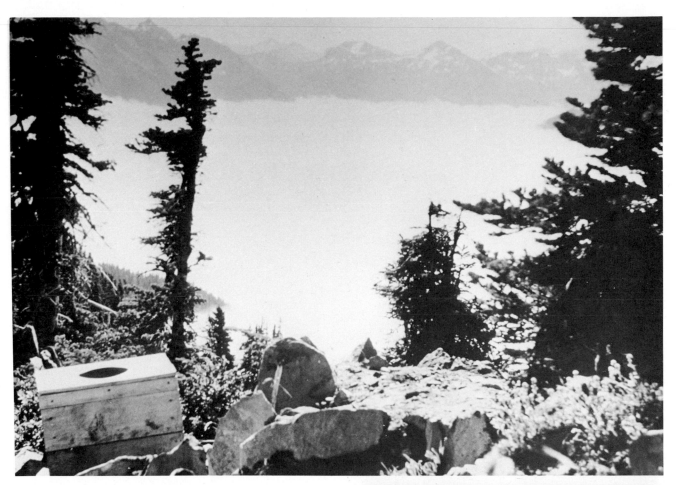

SEAT OF THE HIGH AND MIGHTY high on Bogachiel Peak in Olympic Mountains of Washington (above) and mighty handy. Climbers get spectacular view of range from here on clear days and must thank Forest Service for back-packing wooden boxes and supplies to such inaccessible spots . . . rare enough on high mountain trails.

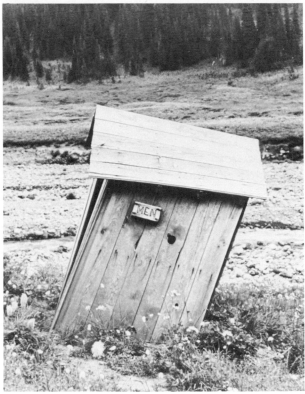

WOMEN CAN PICK FLOWERS instead if this sign (right) means what it says. But up here on this glacier stream under heavy cloud cap, what they or anybody does won't make headlines.

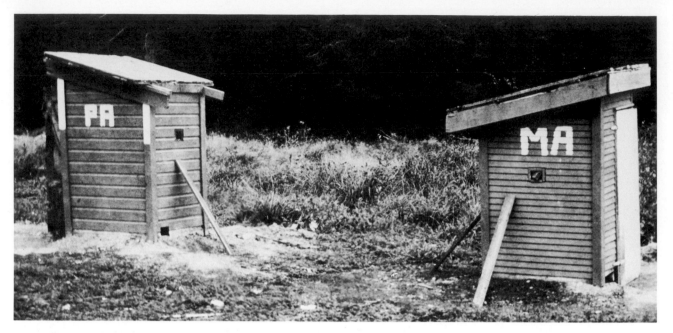

FAMILY RELATIONS DETERIORATING? Maybe and maybe family eyesight also as these designations (above) could be seen at night from next county. "Gun ports" or peep holes in the walls arouse further suspicions. And do props indicate possible attacks from Indians or from "Pa" or "Ma"? Life can be baffling.

RAIN FOREST ATTRITION seen here in this weather-battered dooley (below) in Olympic Strip of western Washington, highest rainfall area in continental United States

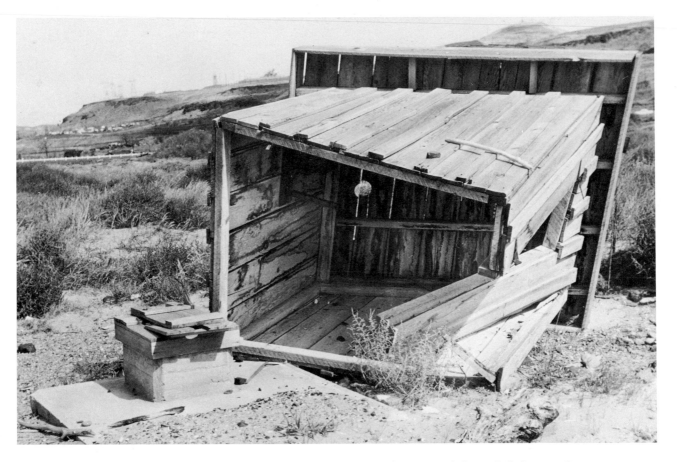

OUTHOUSE OUT . . . but not (quite) down. High desert winds have failed to render this privy inoperable . . . at some loss of privacy.

PERCH PERILOUS. *"Echo Canyon," reproduction of painting by Lloyd Mitchell,*
used on greeting card published by Leanin' Tree, Boulder, Colorado.

BUS STOP SHELTER? Magazine *Organic Gardening* says it's a privy beside busy roadway (above) in Chekang Province, China. It seems travelers along road are encouraged to stop briefly (and show no self-consciousness over public defecation).

In this privy container is placed beneath seat, emptied periodically in vegetable gardens. Most U.S. authorities state practice poses some health hazards – using raw sewage as fertilizer. Others say proper composting greatly reduces or eliminates danger of infection. (Photo courtesy Rodale Press, Emmaus, Pa.)

LAST STAND for "Secessionist" outhouse. Nevadaville, Colorado, flourished as suburb of Central City. One group of miners broke away from larger city, hoping to establish "new" government. Authorities stopped movement by arresting splinter group as "secessionists." Although Central City is kept in good condition as historic relic, Nevadaville is almost ruined ghost town. Photo (below) shows barn and outhouse of W. C. Russell house, built in 1860s. (Photo Denver Public Library, Western History Dept.)

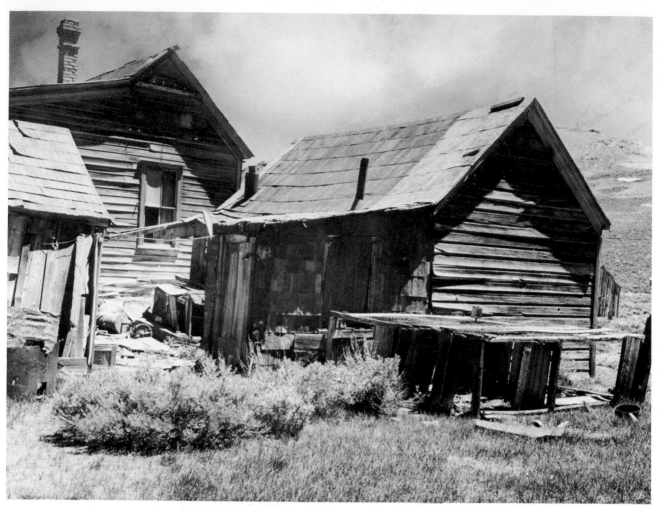

SHELTERED FROM DUST AND HEAT *and snows and wind and idle eyes of old Bodie, California. Outhouse (or inhouse) could still be in use.*

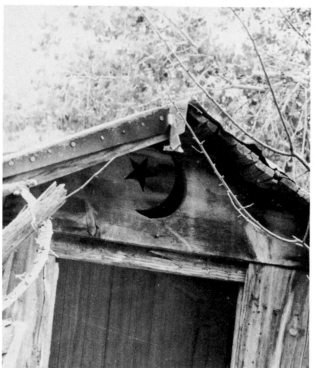

WAS PIONEER A TURK? *You'll find this emblem on the Turkish flag. Well, at least the builder of this privy had an artistic sense and did a neat job with a keyhole saw.*

ALAS, POOR JAKE . . . Many people knew it well but now it lies all of a heap in eastern Oregon's used-to-be wilderness. (Photos Lambert Florin)

The "Old Wish Book"

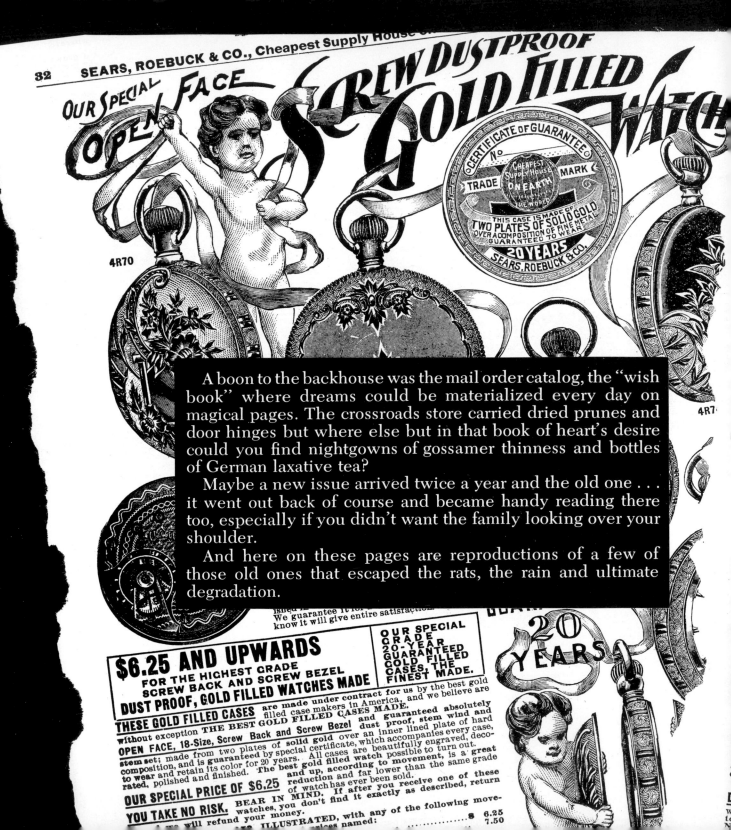

A boon to the backhouse was the mail order catalog, the "wish book" where dreams could be materialized every day on magical pages. The crossroads store carried dried prunes and door hinges but where else but in that book of heart's desire could you find nightgowns of gossamer thinness and bottles of German laxative tea?

Maybe a new issue arrived twice a year and the old one . . . it went out back of course and became handy reading there too, especially if you didn't want the family looking over your shoulder.

And here on these pages are reproductions of a few of those old ones that escaped the rats, the rain and ultimate degradation.

BOOT AND SHOE DEPARTMENT.

OUR FACTORY was taxed to its fullest capacity last season, and to meet the increased demand for home made shoes we have added more new machinery, thus placing us in a position to make the very best at the lowest prices. **ONE ORDER OF 35,000 PAIRS** is now being made for the United States Government, thus demonstrating the high quality of the goods produced. If you appreciate value, the latest styles, foot fitting and shape retaining shoes, send us your order. Tell your friends about us.

HOW TO ORDER. Be sure to state size and width you want.

IT IS CHEAPER to send ladies' shoes, slippers, etc., by mail than by express. The postage rate is 1 cent for each ounce. When you wish goods sent by mail, always send cash in full and include enough extra to pay postage, and we will ship by mail, postpaid. Be sure to enclose enough extra to pay postage. If you send too much, we will promptly return what is over. Weight is given under each description that you may know the amount necessary to send. THE WIDTHS RUN: AA, extremely narrow; A, extra narrow; B...

OUR NEW 20th CENTURY SHOE PLANT. Devoted exclusively to the man...

LADIES' KID DRESS BOOT, HAND TURNED, $2.75.

One of the ... wear that we ... one herewith ... **MADE WIT** **IMPORTE** ... The style of las ... medium wide to ... and medium high ... abling it to carry ... The vi... tannage ... best, and ... hand, ar... found on ... having e... required... not know... ting or a... any pric... dress sho...

CLOTH TOP

Weight averages 17 ounces.

For postage rate see page 4.

LADIES' DOUBLE S' WELT, $

A handsomer patte... with illustrated we... one of the very lates... time is to be found... custom shops of the la... We aim to be first i... clusive effects in shoe... pleasure in showing th... the unheard of price... from the very finest ... toe last, with pater... 12-8 Cuban heel, ... eye calf top... hand welt... double all th... not only a ... practically i... NOTHIN... BE BOU... WEAR A... Those who h... w... as... so... al... p...

688 SEA

KEN**W**

A Wo**r**

the name "Acme," and finding that they were goods which could not be excelled and which adopted the name "KENWOOD," issued the most complete Windmill Catalogue ever published nently before the consumer. We felt perfectly safe in doing this, as our previous experience h...

THE RESULTS HAVE BEEN MARVELOUS.

From a few orders a week, our sales have increased until we now contract for the entire and exclusive sale of the output of the factory, which is next to the largest windmill factory in the United States, the home of the steel windmill.

KENWOOD

STEEL WINDMILLS AND TOWERS

ARE NOW KNOWN throughout the entire United States, and are everywhere recognized and acknowledged to be the standard of excellence in windmill and tower design and construction, and

THE VERY BEST GOODS THAT MONEY CAN BUY.

OUR PRICES A... tory, and giving th... ing their capacity... purchase material... goods at the very... towers at a very... sary to produce... facturing the goo...

Our No. 3... or Our No. 3... Prices w... quality to t... material an... offered. Pr... Windmill A...

NONE BETTER MADE AN

SHIPMENTS OF ALL WINDMILLS, Towers and Windmill Attachments, except... Wisconsin, from which place you must pay the freight. In ordering be careful t... mill is to go on wood or steel tower or wood mast, and if for wood mast, give... mills are to go on wood tower or wood mast, proper fittings are furnished without ex... steel tower, unless the tower is ordered with the mill, no tower cap is furnished except at...

OUR BINDING GUARANTEE. TO SATISFY OUR CUSTOMERS that... towers are as good as we represent the... statements are made in absolute goo...

OUR BINDING GUARANTEE with every windmill and tower, of which exact copy:

Certificate No.

CERTIFICATE OF

$18.00 Giant Power Heidelberg Electric Belt

OUR

FOR ONLY $18.00 WE OFFER THE GENUINE 80-GAUGE CURRENT HEIDELBERG ALTERNATING, SELF-REGULATING and ADJUSTING ELECTRIC BELT AS THE HIGHEST GRADE, VERY FINEST ELECTRIC BELT EVER MADE, AS THE ONLY SUCCESSFUL ELECTRIC BELT TREATMENT, as the most wonderful relief and cure of all chronic and nervous diseases, all diseases, disorders and weaknesses peculiar to men, NO MATTER FROM WHAT CAUSE OR HOW LONG STANDING.

$18.00 IS OUR LOW PRICE, based on the actual cost to manufacture, for this highest grade electric belt, a superior belt to those usually sold at $30.00 to $50.00. Our $18.00 Giant Power Belt is the result of years of scientific study and experiment, it is the very highest grade, a belt that has all the best features of other electric belts without their drawbacks, defects and discomforts, with exclusive and distinctive advantages not found in other makes. Positively wonderful in its quick cure of all nervous and organic disorders arising from any cause, whether natural weakness, excesses, indiscretions, etc. The nerve building, health giving, vigor restoring current penetrates and permeates the affected parts; every nerve, tissue and fiber responds at once to its healing, vitalizing power; health, strength, superb manliness, youthful vigor is the result.

OUR GIANT POWER 80-gauge Current Genuine Heidelberg Alternating Electric Belt at $18.00 will do you more good in one week than six months of doctoring. The Heidelberg Electric Belt for disorders of the nerves, stomach, liver and kidneys, for weakness, diseased or debilitated condition of the sexual organs from any cause whatever, is worth all the drugs and chemicals, pills, tablets, washes, injections and other remedies put together. Its strengthening, healing and vitalizing power is magical—never before equaled.

HAVE YOU DOCTORED? Have you perhaps written to some quack, so called institute or self styled men's physician, have you tried various so called remedies for your peculiar trouble without success, without getting any help, perhaps not even temporary relief. Perhaps you are discouraged; maybe hopeless. Don't give up. Don't despair. You may yet be cured. The Giant Power Heidelberg Electric Belt is just what you need. Just what you should wear. Send for our Giant Power 80-gauge Current Heidelberg Electric Belt at once, wear it according to directions. In a day you will feel a difference, in two days there will be a marked change for the better, in three days you will experience relief, in a week or two weeks your system will be filled with the grand health giving current, in a month you will be a new man.

OUR GIANT POWER 80-GAUGE HEIDELBERG ELECTRIC BELT AT $18.00 comes complete with the finest stomach attachment and most perfect, comfortable electric sack suspensory ever produced. The lower illustration shows the style of these attachments, but you must see and examine, wear them, to appreciate the comfort and convenience. The suspensory encircles the organ, carries the vitalizing, soothing current direct to these delicate nerves and fibers, strengthens and enlarges this part in a most wonderful manner. The sack suspensory forms part of the circuit. The electric current must traverse every one of the innumerable nerves and fibers. Every wearing means the electric current in contact with the organ; every wearing brings the current through and through with the strengthening, healing current; means a liveliness imparted, a vigor induced, a tone returned, a joy restored that thousands of dollars' worth of medicine and doctors' prescriptions would never give.

DON'T SUFFER IN SILENCE, don't endure in secret. $18.00 will buy our Giant Power 80-Gauge Current Genuine Heidelberg Electric Belt. $18.00 will enable you to face the world anew. $18.00 will bring to you health and strength, vigor, manliness and happiness, a bigger bargain than you could ever possibly secure in any other purchase.

ARE YOU IN DOUBT? Have you tried so called remedies without avail and hesitate because some unreliable firm or doctor took advantage of this great offer? Do you fear to take advantage of you? With us you run no possible risk. Let us send you one of our Genuine Giant Power 80-gauge Heidelberg Electric Belts under the liberal condition of our offer. We will send you the belt, then after ten days' fair trial if you have any reason to be dissatisfied, if you are not greatly benefited, return the belt to us and we will refund your money.

HOW THE 80-GAUGE HEIDELBERG ELECTRIC BELT IS MADE. Every $18.00 80-Gauge Electric Belt of the Heidelberg make is the very finest belt that can be put together by scientific, skilled mechanics, hand made and finished in every part. The woven non-conducting duck, forming the very best and perfect insulating case possible.

...ve of the highest grade materials money will buy, put together by scientific... ry of cells is made of an extra quality very fine selected satin, a grade prepared particularly for this purpose, absolutely non-conducting, lined ...ghton insulating flannel, and then a layer of close ...

In our $18.00 Giant Power Heidelberg Electric Belt we furnish the new and genuine Heidelberg battery, ...e cells, producing an 80-gauge Heidelberg battery, ...ighly excitable, metal alloy and composition. The battery is ...nation producing the quickest, most powerful and last-...battery in any other make can compare in any respect ...One cell of a Heidelberg battery, with its distinctive ...and special composition, has more strength, produces ...two cells of the ordinary electric belts usually advertised. ...Four large and one extra large (five in all) electrodes ...secure a fine equal distribution of the current to the ...affected parts. The electrodes are large size, splendid ...extra full and finely silver plated. The four electrodes ...across, the front and largest electrode is 5 inches across. ...tment of diseases of the stomach, liver and kidneys, ...electric fluid straight to the affected parts. The ...trodes can be adjusted for any position, any part, ...in the direct route of the current. For a weak or ...em the electric treatment has splendid results. ...te, gives tone to every tissue and muscle. The ...effect. No words can describe the change in ...even character, from the result of wearing a ...Power Electric Belt.

PUT UNDER OUR BINDING GUARANTEE ...wer, more and quicker relief than any belt ...ice. Simple, comfortable, efficient. Nothing ...comfortable. No one can tell if you wear it. ...sent with every belt. Complete

...yn special and perfect current regulator ...ectric belt maker in the country. By means of this regulator ...ted to any strength desired without removing the belt from ...edium or strong, just as you like, just as your case requires. No ...pleasant shock, no chance to get a current too strong and irritate ...ths, different degrees of current are possible. A simple movement ...get just the strength, just the gauge of current required. ...rvelous, really magical in its power. Will cure any case, no ...how obstinate, how long standing. Tones up the system, ...st cold, against sick attacks of any kind. Perfect in its relief ...uge Belt affords relief when everything else has failed ...a vigorous circulation of blood into the ...uickly respond to this infusion of ...produced, youth...

FOR QUICK RELIEF for an ultimate speedy cure of all weaknesses, no matter from what cause, nothing can equal... drugs, whether...

No. 38R1566 This is our most elegant design and the best number we have. Poke bonnet, made in faille, Normandy style, with two rows of ½-inch...

Instan-

Sanitary House Commodes.

The Sanitary House Closet is a complete and satisfactory substitute for the porcelain water closet used in cities where sewer connections can be had.

The advantages of our House Closet over the stationary porcelain closet are that it can be moved into any room or up to the side of the bed for the sick, and with the noiseless, odorless receptacle cover, no germs can possibly affect the air. The price at which it is sold brings it within the reach of every family. You will consider it an indispensable necessity in your household in less than a month. It has been carefully designed with reference to its use, and is manufactured from...mate-

This illustration shows the upholstered commode open.

This illustration shows the upholstered commode closed.

...home. $3.65
 4.00

vily nickel soline, arti-eaters, and satisfaction. eet 8 inches, d strongest ur summn amount...

steel, s eled in etal rs, ena etal heat

het ub

No. 38R1618 This Pretty College Shape Tam O'Shanter is made of fine quality black velvette; around the curved band are three rows of silk soutache trimming, and over top of crown it is finished with a fancy braided design, and silk tassel; lined throughout; very stylish and one of the prettiest tams made.
Price, each........48c
If by mail, postage extra, 15c

Cir-
han-
with
rcules
d silk
e row
id on
e of
lined
ery
able.
e or
25c
tage
s.

No. 38R1626 This stylish Circular Tam O'Shanter is made of fine quality black velvette with a row of 1-inch faille silk ribbon around brim, completed with a little bow of same material. For a rich and dressy tam for either a boy or girl, this is an excellent number; lined throughout. Sizes, 6¾ to 6⅞. Price...47c
If by mail, postage extra, 12 cents.

Circular ...ter. New, ...aking a ...ppearance. ...s trimmed ...soutache ...shed in ...shown in ...ows of gold ...im; made ...flannel. ...nal or

...cular ...r. It is ...made of ...nel; the ...of crown ...trakhan ...covered ...nter; the ...e same ...n cloth. ...lown over ...roughout. ...mbination ...Red flan-...akhan, or ...Price..52c ...ts.

...cular ...r. It is ...made of ...nel; the

Price.
If by mail, postage extra, 4c
No. 38R1642 Child's Cap, made of good quality pressed flannel, white fancy band around peak of cap, and fancy design on top of crown of soutache braid; the cap is lined and well made. Colors, cardinal or navy blue. Price........24c
If by mail, postage extra, 10 cents.

No. 38R1638 A very pretty Misses' Lawn Hat. The crown is beautifully trimmed with two rows of narrow ribbon, lace and ruffle tucking; has two ruffles all around hat, of which one is trimmed with two rows of narrow ribbon, the other is edged with Valenciennes lace; one row of ribbon under the brim, ruching around front; wide lawn strings; lined with cambric. Colors, blue or red.
Price, each........82c
If by mail, postage extra, 11c

No. 38R1640 A beautifully trimmed Misses' Lawn Hat. High crown, large bow in front edged with fine Valenciennes lace; brim trimmed with fine straw braid, also edged with straw braid; a very pretty ruffle all around hat edged with Valenciennes lace to match; wide lawn strings. For a stylish and high grade hat we would recommend this number. Colors, pink or light blue. Price, each........98c
If by mail, postage extra, 11c

BOYS' AND CHILDREN'S CAPS AND TOQUES.

No. 38R1641 Child's Cap, suitable for little boy or girl, made of white cotton pique, with heavy blue polka dot band and shield. A very popular spring and summer cap.

No. 38R1643 This is a very neat little cap, made of all wool flannel, fancy ornamental design on crown of silk braid, as shown in illustration. Black velvet rim and peak, black velvet covered button on top of crown, satin lined. A very neat and dressy little cap. Colors, cardinal or navy blue. Price, 41c
If by mail, postage extra, 12c

No. 38R1644 This is a very stylish and dressy little cap for boys. Made of good quality velvette; the rim is made of a fancy mixture of cloth, with a double row of silk cord around front; satin lined. Colors, black only.
Price........49c
If by mail, postage extra, 12 cents.

No. 38R1645 Child's Toque. Turkish design. Made of nice quality flannel, very ornamental in design; are two bands of fancy braid, and over the flowing end of the crown seven rows of band trimming as shown in illustration. Silk tassel on end of cap; cap is lined, and a very excellent value. Colors, cardinal or navy.
Price, each (If by mail, postage extra, 8 cents) 23c

tiro closet weighs only fifty po... for shipment. **For the sick room it** ... even with a bathroom with closet on ... floor it is for the invalid a long distance to go e... if only in the next room. For country residences, where lack of water connections prevent the use of regular closets, this portable closet is especially desired.
No. 24R7560 Price, each........$7.60

Open Plumbing Lavatories.

Italian marble slab, 20x24 inches, 1¼-inch thick, 8-inch back, 14-inch round patent overflow basin, nickel plated metal plug with rubber stopper, nickel plated S trap; No. 1 Fuller basin cocks, chain and stays, and nickel plated brackets.
No. 24R7565 Price, as described$10.50
Open Plumbing Lavatory, furnished complete, as shown in cut. Back and bottom slabs are made of Italian and Tennessee see pink marble, highly polished. Back slab is 8 inch...

8R1634 Misses' ...Hat, top made of all-...mbroidery and ...d with lace, wide ...uffle all around hat ...s trimmed with Val-...nes lace, lawn bow in ...ide lawn strings. Very ...tyle. Colors, cream ...blue. Price.......42c ...ail, postage extra, 9c

No. 38R1646 Child's Toque. Oriental design, combination design, made of good quality black velvette and all wool cardinal flannel; with two rows of gold silk soutache braid around brim...

........$0.85
........ .95
........ 1.20
........ 1.40
........ 1.75

a Heavy Tin e Bath Tubs, le seamed, roll at top, wood bottom, pipe at end Nothing bet-de in a tin tub.
........$5.00
........ 5.50
........ 6.50

Bath Tub.

Combination de of 3X tin, , nicely ja-ed. Nothing n tin tub. Size,
........$3.85

OUR TALKING MACHINE DEPARTMENT.

THE GRAPHOPHONE, OR TALKING MACHINE, has proved itself in the past, and we believe always will be a most successful and popular entertainer. The novelty and wonder of the natural reproduction of the human voice as well as band and instrumental music insures preliminary interest, and the performance itself is so wonderfully realistic and the actual reproduction of speech and music of such a quality as could not otherwise be heard.

IT REPRODUCES with startling accuracy the productions of the most noted bands, orchestras, vocalists and public speakers and the songs, music or conversation of self or friends. The capabilities of the Graphophone are not confined to the reproduction of regular factory made records, but, when provided with a recording diaphragm, they will record and reproduce any words spoken to it, or song sung to it, and such records may be preserved and reproduced at any time.

AS A MONEY MAKER or as a home entertainer it has no equal. It is one of the most wonderful of all inventions, and yet its construction is so extremely simple that it causes the observer to wonder that its basic principle did not lead to its discovery long ago.

RECENT IMPROVEMENTS, simplicity of construction, replacing the expensive electric motors with the simple but practical spring motor, automatic machinery for their manufacture, making them in very large quantities, etc., has enabled us to make arrangements with the manufacturers whereby we can now offer this most wonderful little machine, complete with all the necessary accessories, at a price which not only brings them within the easy reach of those of small means, who wish to give public entertainments, but they can be owned by almost any family as a source of home amusement.

The Perfect Musical and Talking Machine. Tried, Tested and Guaranteed. A Public Entertainer of Unrivaled Merit and a Mint of Money for the Exhibitor.

AS A MONEY MAKER THE GRAPHOPHONE HAS NO EQUAL.

OUR LEADER, THE NEW GEM GRAPHOPHONE TALKING MAC

YOU CAN MAKE $5.00 TO $25.00 every evening by giving public exhibitions in halls, churches, school houses, etc., at 15 to 25 cents admission, or by using with hearing tubes and charging 5 cents for each individual.

No. 21R1 Gem Graphophone, with two hearing tubes and concert horn, but without oak base and carrying case...... **$10.00**

No. 21R2 Gem Graphophone, with two hearing tubes, concert horn and handsome oak carrying case with handle, as illustrated...... **$12.00**

Above price does not include records. Price of our best musical and talking records is $5.00 per dozen or 50 cents each when ordered in less than dozen quantities.

FROM THE ILLUSTRATION, engraved by our artist direct from a photograph of the outfit, you can form a good idea of the appearance of this, OUR SPECIAL OFFER $23.75 PROFESSIONAL TALKING MACHINE EXHIBITION OUTFIT, but you must see and compare it with other graphophone outfits to appreciate the real value we are offering.

COMPLETE OUTFIT $23.75

GET OUT OF THE RUT which, perhaps, you are in If you are making less the $200.00 a month, you can afford to lose this opportunity. Start in a business v the way has been p and everything prepar those whose wide bu experience enables th place in hands an perfect complete respect ready go at work.

talking machine outfit ever gotten together. Every detail of the outfit has been carefully prepared and considere satisfaction, and we feel safe in guaranteeing absolute success. Remember, $23.75 is a special offer price; $23.75 is a p on a concert exhibition graphophone and complete outfit such as we are now offering; $23.75 is a price that is intend a price based on the actual cost of material and labor, with only our one small percentage of profit added; a price that on a complete high grade outfit; a price that means a saving to you on such an outfit of fully one-half.

NEW IMPROVED GEM TALKING MACHINE EXHIBITION OUTFIT.

For those who wisl Gem Talking Mach made up an exhibition outfit. We furnish the following complete outfit which includes everything needed as follows: plete Talking Machine Exhibition Outfit, including our new large Concert Exhibition Graphophone with the new 26- and more complete Talking Machine Outfit than has ever been offered before at a great deal more money. No. 21R5 (

No. 21R2 Gem Graphophone, the popular and perfectly finished Gem Graphophone described above.

1 Automatic extra loud Aluminum Reproducer.

Talking Records, your own selection.

No. 21R5 OUTFIT

ALL FOR

1 Large Japanned Tin Amplifying Ho supporting stand.

1 Instruction Book, complete, with information a the outfit, making engagements ahead, etc.

The carrying case in which records are shown in is not included with the outfit, but it can be pur

WAVES, BANGS AND WIGS.

All Wigs, Toupees, Waves, etc., being made to order, we ask three to four days' time in filling your order, and we require cash in full with order as on all other merchandise, guaranteeing satisfaction or refund of money.
BE SURE AND SEND A GOOD SIZED SAMPLE OF HAIR.

No. 18R4378 Melba Bang. Made of the best quality naturally curly hair, with vegetable lace parting, most suitable for youthful faces and a very popular style of hair dressing. Each **\$1.50**
Gray and blonde hair, each............ 2.50
If by mail, postage extra, each, 5 cents.

Parisian Bang.

No. 18R4382 Parisian Bang. Ladies who do not require large, heavy front, will find this a little gem; light and fluffy, ventilated foundation.
Price, each.....**\$1.35**
Gray and blonde hair, each**\$2.00**
If by mail, postage extra, each, 5 cents.

Alice Wave.

No. 18R4386 Alice Wave, invisible hair lace; foundation natural, curly hair; 3-inch part, 12 inches
...... Price, each.....**\$3.25**
............ Price, each...... 4.50
....... 6 cents.

Ladies' Wigs—Long Hair.

Can be arranged in many different ways.
No. 18R4410 Made of the best selected hair on silk foundation, 18-inch hair.
Price, each**\$15.00**
If by mail, postage extra, each, 10 cents.
No. 18R4414 Made same as above on silk foundation, 24-inch hair.
Price, each............**\$18.00**
If by mail, postage extra, each, 10 cents.
The above prices are for ordinary shades hair. Red, Blonde and Gray Hair cost 50 per cent more, which please add when you send order. Be sure and send sample of hair. Send measurement of head.

Men's Toupees

To measure for a Toupee or top piece, cut a piece of paper the exact size and shape of the bald spot, ... and parting, enclose a lock of hair, ... straight or curly.
... upee, weft foundation.
postage extra, 8c)..**\$5.50**
... ventilated founda-
\$10.00

Theatrical Wigs and Beards of E... Description.

No. 18R444...
tache on wire ... common. Each...
No. 18R4450 ... tache, ventilated.
Price, each.........
No. 18R4454 Go... Price, each.........
No. 18R4458 W... ers, side. Each...
The above come i... and medium shades
If by mail, postag... tra, each, 3 cen...

Full Beards.

No. 18R4462 Full Beard on wire. Each...
No. 18R4466 Full Beard, ventilated.
Price, each..........
If by mail, postage extra, each, 3 cents...

Minstrel and Character Wigs.

No. 18R4470 Minstrel or Plain Black Negro Wigs.
Price, each..........49c

Court Wigs, Hair Nets, Imperial Hair Regenerator, Grease Paints, Etc.

No. 18R4474 Imperial Hair Regenerator, restores gray hair to the color of youth, regenerates bleach... hair, gives it new life and vigor, and makes it a... color desired; makes it beautiful, natural a... healthy. Comes in seven shades: Black, dark or m... dium brown, chestnut, light chestnut, gold blond... ash blonde. Absolutely harmless.
Price, per bottle..........**\$1.**
Liquids cannot be mailed.
No. 18R4478 Court Wigs. Made ... s style. Price, each, **\$3.2**... postage extra, each, 6c...
...482 Fright Wigs.
...l, postage extra, each, 6c...**\$3.5**
18R4486 Invisible Hair Net... of the best quality of best si... by mail, postage extra, each, 2c...
...o. 18R4490 Silk Hair Nets, me... um size netting, all colors. Each...
If by mail, postage extra, each, 2c...
No. 18R4494 Pencils for the Eye... brows, brown or black. Each......20
If by mail, postage extra, each, 3c...
3 Blue Pencil for the veins.
...l, postage extra, each, 3 cents......20
502 Theater Rouge, in cakes on porce... in paper boxes. Price, per box......20c
... postage extra, each, 3 cents.
06 Fard Indien, a preparation ... the eyelashes artistically ... eyes appear larger. Colors... dark brown and black.
box50c
...postage extra, each, 5 cents.
0 Rusma Depilatory Powder ... al of superfluous hair from ... chin, arm, etc. Price..95c
...tage extra, each, 5 cents.
...Toupee Paste, which is ... upee in place; heat and ... r stick42c
...l, postage extra, each, 5 cents.
3 Grease Paint, for make up purposes... in a box. Price, per box......70c
...tage extra, each, 5 cents.
522 Burnt Cork, in glass jars.
... mail, postage extra, each, 5 cents...

The Braided Wire Hair Rolls.
... of the finest tempered wire, cove... lace to match any shade of hair.

... to produce fullness in any part of the ... become musty or damp from perspiration ... the hair as do the ... in vogue. ... sanitary.

...ING PLOWS.

...ONGLY PUT TOGETHER and firmly braced in the most ap... s are well braced, secured by iron straps at th... bottom and set wide apar... at the bottom, thus pro... venting clods from fill... in between the hand... Wood beams are so... ern oak, well arched ... made extra heavy dir... over and forward ... standard. Steel b... are double flanged, ... making them light ... very strong; ... highly arched so a... give ample cleara... Each plow is

...stubble plow with ...having a short, ...turf and stubble ...ally adapted for

FURNISHED WITH A BR... ADJUSTABLE CLEVIS,
so that plow can be set t... the required depth an... used with any number of ... horses. Any style coulter, ... wheel or jointer can be ... used, but are furnished ... only at extra price. Made ... in right hand only, either ... wood or steel beam, and ... either stubble shape or ... turf and stubble shape ... Guaranteed to be made ... first class materials a... well painted and nicely ... finished, and perfectly ... ted for the work they ... intended to do.

...IPPED DIRECT FROM FACTORY IN NORTHERN ILLINOIS.

...SHAPE PLOWS.
...D BEAM.		
...93 pounds.	Price..........	
...8 pounds.	Price..........	
...5 pounds.	Price..........	\$ 0.50
		9.75
		11.10
... BEAM.		
...pounds.	Price..........	\$ 8.55
...pounds.	Price..........	9.80
...pounds.	Price..........	11.15
...for Above Plows.		
...pounds.	Price..........	\$ 1.90
...pounds.	Price..........	2.25
...pounds.	Price..........	2.55

TURF AND STUBBLE SHAPE OR GENERAL PURPOSE PLOWS
WOOD BEAM.
No. 73R85	Size, 12-inch.	Weight, 97 pounds.	Price.........
No. 73R86	Size, 14-inch.	Weight, 103 pounds.	Price.........
No. 73R87	Size, 16-inch.	Weight, 109 pounds.	Price.........

STEEL BEAM.
No. 73R89	Size, 12-inch.	Weight, 99 pounds.	Price.........
No. 73R90	Size, 14-inch.	Weight, 105 pounds.	Price.........
No. 73R91	Size, 16-inch.	Weight, 111 pounds.	Price.........

Eqtra Steel Shares for Above Plows.
No. 32R93	Size, 12-inch.	Weight, 14 pounds.	Price.........
No. 32R94	Size, 14-inch.	Weight, 16 pounds.	Price.........
No. 32R95	Size, 16-inch.	Weight, 18 pounds.	Price.........

...AS FOR STUBBLE, AND TURF AND STUBBLE PLOWS.
...ds.	Price..........		
...d beam. Weight, 6¼ pounds.			\$0.65
...d beam. Weight, 6¼ pounds.			.81
...am. Weight, 15 pounds.			1.01
			1.63
No. 32R129	Rolling Coulter, for steel beam. Weight, 15 pounds......		
No. 32R132	Gauge Wheel, for wood beam. Weight, 13 pounds...		
No. 32R133	Gauge Wheel, for steel beam. Weight, 12 pounds...		
	NOTE—You must specify for which...		

FOR T...
LATE...
STYL...
HAIF...
DRES...

Thes... most ... for the ... pompa... fects now ...

...mounted on silk ...
Gray or blonde hair, each...
If by mail...

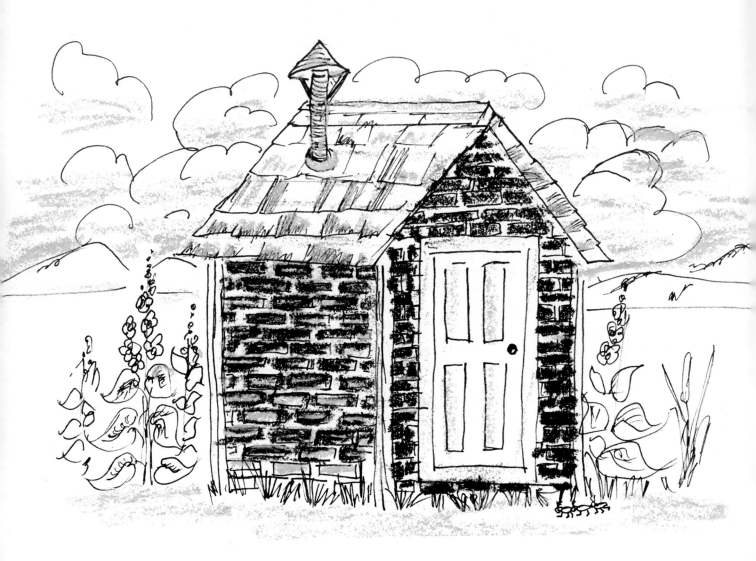

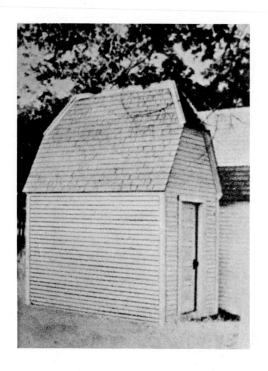

Early American
Works of Art

by W. R. Greer

On this and the following few pages are reproductions of a whimsical promotion of outhouses prepared some years ago by the Perkins Glue Company of Pennsylvania, a firm no longer in existence. The name "L.A. Vitorie Company" is of course explainable when pronounced as one word.

When the American people were faced with the problem of safely occupying an additional amount of leisure time, the L.A. Vitorie Company offered a solution.

By developing and promoting a greatly neglected and almost forgotten American institution, we placed ourselves among the pioneers in this social movement.

Our products are peers in their line, and were popular even before we improved them. Now that we have made them more attractive and added variety to a line which was dying out for want of new material, we find that people love to spend hours using them.

We are proud to say that not one of our many thousand customers between Plentywood, Montana, and Skowhegan, Maine, has ever expressed dissatisfaction with our products.

Many people scoffed at the idea that these products would relieve a situation which confronted the citizenry of this country. Despite the ridicule of his friends, Mr. Vitorie started this movement which has done more for farmer relief and the pleasant use of spare time than any other in America. None other has been so great or universal.

We offer this line in the hope that it will furnish you complete relief and satisfaction.

THE L.A. VITORIE COMPANY

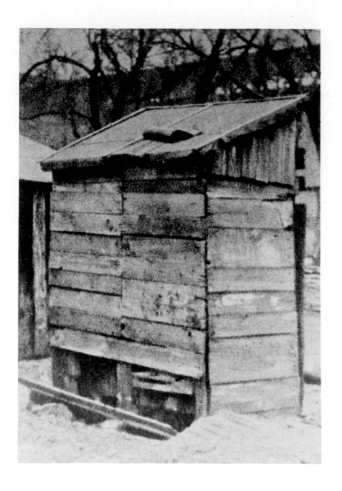

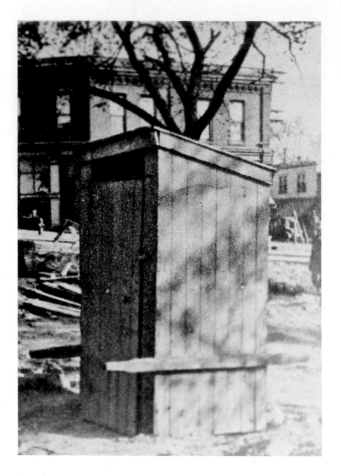

THE EUREKA
66P5000 **$41.50**

The Eureka is the last word in unique toilet construction and is a time saver for those who place privies on hills.

The special open back permits the owner to find out if the facility is in use. By merely looking through the opening he gains the desired information by counting the number of feet or legs he sees, thus saving tiresome walks up and down the hill.

The viewfinder in this model is so sensitive that even a glass eye can detect a wooden leg.

THE TOURIST
66P9991 **$27.39**

The Tourist is the only portable privy made in this country. Reinforced to permit rough usage without damage, this palace of comfort will delight any person away from home.

In use, the cabinet is placed over any sewer manhole after removing the cover. With each Tourist we furnish charts of manhole markings in all cities of more than 10,000 in the United States. This prevents painful involvements with steam tunnels.

Charts of manhole locations in other countries may be obtained from us at nominal charge, permitting the Tourists's use on world tours.

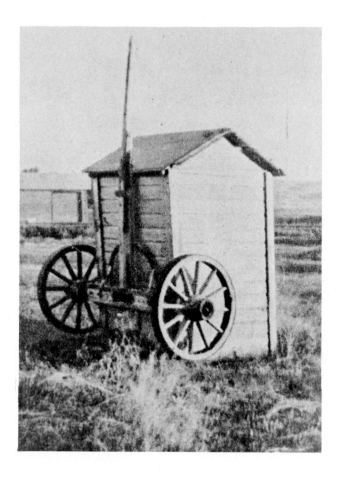

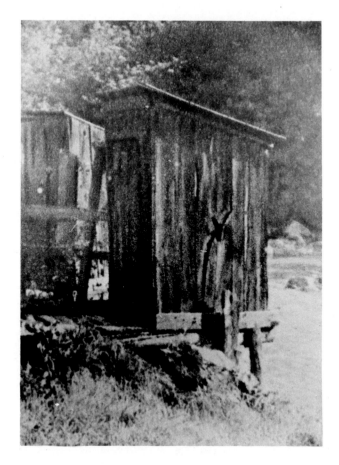

THE PRAIRIE SKIPPER
66P2757 **$13.15**

The Prairie Skipper is an elegant example of maximum utility and mobility at the lowest possible price.

Standing on the prairie by itself, this outhouse will be a thing of beauty and a beacon of hope to any traveler.

Anchored by two heavy fence posts, set four feet deep, the building is a solid bulwark in time of storm. Sided, inside and out, with a good grade of heavy tar paper securely fixed with packing box strips, the building is adequate against weather, yet should the owner be forced to leave his property in a hurry, heavy wheels and hitching tongue are already at hand.

THE VENETIAN
66P9342 **$51.23**
66P9343 with splash-proof
attachments **$55.63**

One cannot view this chaste, classical model without thinking of sparkling sunbeams playing upon tiny ripples on the placid canals of old Venice.

Designed by an Italian artist, our Venetian outhouses fairly exude the atmosphere of the city of canals. Sold either with stilts or guy wires, they make suitable gifts for friends living on river deltas or factory waste runoffs. (Running water as shown in photo is not shipped with unit.)

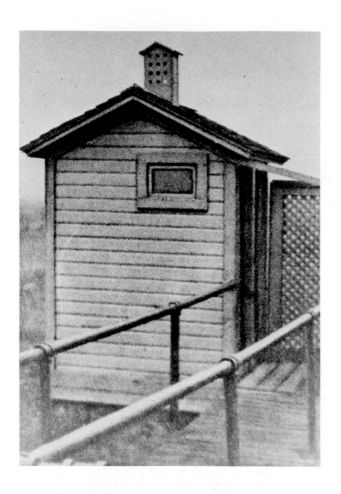

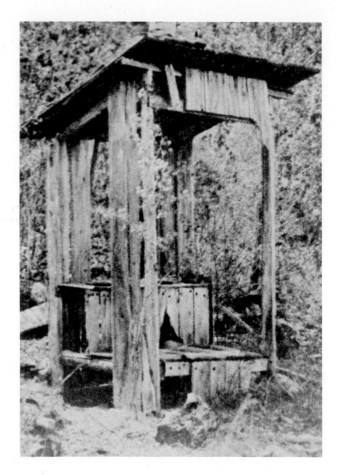

THE SODBUSTER
66P4300 **$39.78**

The Sodbuster was made expressly for hardy plainsmen who demanded security with their luxuries. Constructed from weather-tight materials, assembled by craftsmen of long standing, it assures every possible comfort.

It is furnished with hand-high iron rails running from the back door of the owner's house, defying its users to get lost in any kind of storm. This privy will be found useful in areas of exceptionally dark nights and those plagued by inebriates.

THE TROPICAL
66P2356 **$53.36**

The need of an outhouse with maximum ventilation inspired The Tropical. Requests from lake resorters for something cool and refreshing have resulted in this engineering masterpiece.

Unique construction allows cross ventilation sought for years by manufacturers and users of similar products.

Revolutionary new principles allow a quantity and quality of light, never before hoped for in privy fabrication, to be admitted freely.

The study of literature and art are cultural attainments which have been long recognized. Enjoy them to their utmost in the Tropical.

THE BILLIKEN TWINS

66P5714 **$65.49**

The Billiken Twins are unique in design due to a patented non-tippable feature. Braced so the center of gravity falls in the space between the units, it is almost impossible to upset either one.

This improvement was created by our staff engineer, I. F. Oolthebois, after an unfortunate experience in his own outhouse one Hallowe'en night. Strapped together with heavy timbers in such a manner as to make the two units virtually a single building, they defy any less than a gang of fifty medium-sized boys to tip them over.

"Use your privy with safety and aplomb," is our slogan.

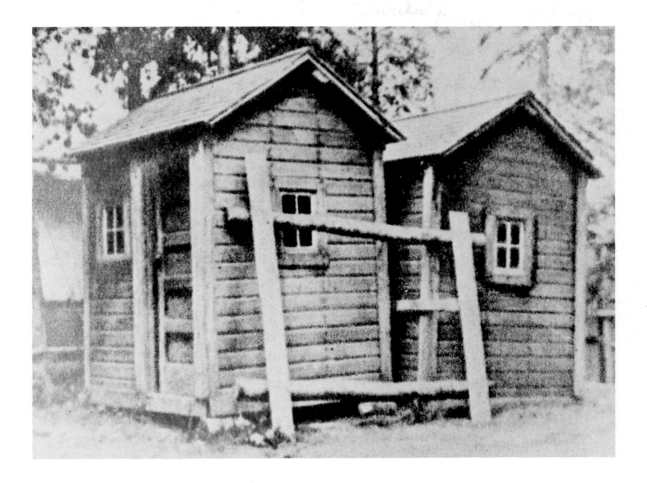